STORE PRESENTATION & DESIGN No.2

Branding the Store

Martin M. Pegler

VISUAL REFERENCE PUBLICATIONS, INC., New York, NY

Visual Reference Publications, Inc.
302 Fifth Avenue
New York, NY 10001

Distributors to the trade in the United States and Canada
Watson-Guptill
770 Broadway
New York, NY 10003

Distributors outside the United States and Canada
HarperCollins International
10 E. 53rd Street
New York, NY 10022

Library of Congress Cataloging in Publication Data:
Store Presentation & Design No. 2, Branding the Store

Printed in China
ISBN 1-58471-109-4

Book Design: Judy Shepard

CONTENTS

INTRODUCTION

Because the world now relies on imagery and image recognition, many retailers who have grown and prospered over the years are today commissioning designers to create new retail brand images for them. People don't seem to want to take the time to discover on their own; they want a sure thing—something already proven. Thus, the power of branding. Also, retailers are looking to expand their customer base and reach out to new shoppers without losing their traditional and loyal customers. That means tying in some of the old and familiar visual cues with the new ones. It might be maintaining a signature color in the logo, or incorporating some unique architectural or decorative element from the old store into the new design such as a chandelier or a classic display table. The resulting design combines old with new, traditional with the future, and still serves to identify the retailer as an entity to be reckoned with.

The presentation of the merchandise and the displays that bring the shoppers into the store are very important in creating the retail brand image. If one uses mannequins—are they distinctive? Do they represent, truly, the retailer's customer base? Do they do justice to the merchandise? Are they as smart, sophisticated and stylish as the garments or as amusing, young and trendy, as the retailer would like his wares to appear? They are the store's "silent salespeople" and they "speak" volumes about the merchandise! If the retailer uses forms, drapers or costumers—how are they different from those used by his competition? How do they make the garments look unique and distinctive? If the retailer doesn't have a big sign with the store name on it, will people still recognize the store by its window presentation? These windows are the image-makers—out on the street and in the aisles of the mall. They dare the shopper as they entice them and lure them in with a sense of newness and excitement.

But, like Janus the Roman god with two faces, branding has two sides as well. There is the brand image of the designer/manufacturer, and the brand image of the retailer who carries several nationally advertised brands or designer vendor shops within their own selling space. When the designer has his own stand-alone boutiques or the manufacturer is also a prime retailer for its branded merchandise—the branding is more simple. In these instances the store planner/architect/interior designer takes his cues from the designer/manufacturer and thus creates the desired ambiance. However, the retailer who carries several brand names has to create his own unique brand image so that shoppers will come to him for any of those same brands that are available just down the street.

Many retailers hoping to expand into multi-chain stores know the importance of that recognizable Retail Brand Image and how it plays out in the competitive marketplace. The "look" means continuity; it means good will and the store's reputation, tradition and heritage are represented by the colors, materials and the visual cues inherent in the store's design. We are a brand conscious society so it has become important that the retailer create his own personal brand image if he is to succeed.

Many of the projects selected for this book are branded designer or manufacturer stores. What we have attempted to show, in several instances, is how the store designer/architect has had to adapt that retail store brand image to suit different spaces in different locations and sometimes even in different countries—and yet maintain the desired recognizable brand image.

With Levi's branded retail design we show not only other locations but also how a completely new concept and a new market are approached and the look—the signature brand cues—are still readily recognizable. We were fortunate in procuring examples of exhibit spaces designed for Levi's appearance at trade shows. Here the brand look is introduced to the retailers who will be emulating that look in Levi's boutiques within their own retail stores. With Marni, Moschino and Timberland we have juxtaposed the documentation that shows how recognizable store brand elements have been adapted to cities in other countries where the local customs and customers have been considered. We also show how those elements have been condensed to still give off the desired visual cues when used in a store within a store.

The Speedo store designers also created the vendor shop fixtures and graphics that are used when the Speedo line appears in another retailer's store. With Coach we have two different retail areas in the same city, Tokyo, and show how the designer maintained the look and attitude yet adapted to the different special requirements and the different target market.

If you refer to Miss Sixty and Principles you can see how different designers have treated the same brand name and visualized and realized that brand image in a three dimensional selling space. The Jacques Despar project shows how the design firm took elements from the retail store and created a kiosk—out in the mall aisle—that serves to introduce the store's products and services.

We have also introduced some examples of branding as it appears in shop windows. The display window is the store's "calling card"—"the first impression"—the shopper's introduction to the retailer. It tells shoppers who you are—shows what you sell—and to whom you are selling. The mannequins or mannequin alternatives, the fashion attitude, the style and look—they all are signature notes that help add to the store's total brand image.

As you show—so shall you sell. Enjoy!! And much success.

Martin M. Pegler

STORE PRESENTATION & DESIGN No.2

Branding the Store

A CONVERSATION with JEFF KINDLEYSIDES

MARTIN M. PEGLER: It has been over 18 years since Checkland Kindleysides took over the Levi design assignment. I understand that CK is now responsible for retail design, which includes visual merchandising principles, store layout, navigation, communication, branding and window direction. When you first took on the commission were there any specific directions, requests or briefs from the client?

JEFF KINDLEYSIDES: Our brief has always been to be a partner to the brand and to continually look ahead, evolving the retail presence to be a relevant expression and experience of the Levi's® brand.

The first retail design was in 1987 and was at the time briefed by the client to major on the contemporary expression of the brand. It was quite a minimal black and white design that showcased the project in a quite clinical way. It was absolutely right for the time, consumers were more interested in labels and image than necessarily the story behind a brand. The connection to TV advertising was important and we created the facilities in our minimal store design to showcase this heavily... that worked extremely well.

By 1994 the expression of the brand was around "heritage" and specifically the origins of the 501™. Consumers questioned authenticity and looked to brands that had substance. The brief was to bring the brand to life from its origins, mixing heritage and modernity. The first store answering this brief was the London Flagship. That was the first brand experience store of its kind in the UK. It was for a time most talked about store and broke many moulds in retailing, with gallery spaces which truly captured the spirit of youth and its connection to Levi's, ways of trying and buying jeans which were innovative, and symbols and experiences of

the brand which were unique to Levi's.

Our design for the flagship store in Union Square, San Francisco in 1999 took this experience of the brand even further with the brief seeking to give real experiences to the consumer to create their own customized products through the in-store factory, body scanner and shrink-to-fit bath.

As we reached the end of the '90s "heritage" was viewed by consumers as not that important, "relevance" was the word and for Levi's the opportunity was that Levi's could appeal to almost any consumer from "cultural creative" to "mass market." The 1999 brief was a brilliant visionary document which looked to create a Levi's retail landscape which would play to the strengths of the brand and the wants of the fragmented consumer audience.

We created "icon stores" for the very top of the consumer triangle—those influential cultural creatives who would discover the non branded store

in a small street off Carnaby Street in London, 'High Street' stores which demonstrated innovation through merchandising, and a store-in-store that had an instantly recognized signature which was easy to shop. This whole project was the start of a global blueprint in store design.

MMP: How does CK go about creat-

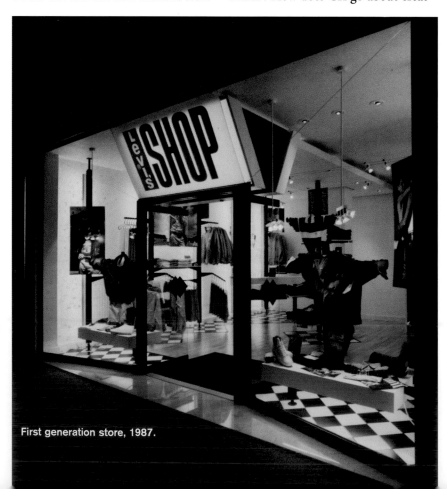

First generation store, 1987.

ing a retail setting for the recognized brand? Where and how do you start? The product? The Company's history and tradition? The targeted market?
JK: A solid, thorough understanding of all of these factors is essential in order to be able as designers, to assess where the "big idea" and point of difference is going to be. We never design the box first, in other words we are interested to understand how the consumer will interact with a brand at retail, what makes the experience of buying here so different to another retailer. Architecture is, in our thought process, the last consideration; we look for things that are immediately felt by the consumer, physically and emotionally, and are hard to copy.

MMP: Since CK is involved in so many areas of the Levi's image and it involves so many disciplines (architecture, interior design, fixtures and fittings, visual merchandise and display, graphics, signage, photography, etc.), how do you start? How do you bring in new ideas—new concepts and approaches? Do you have a group that is the "heart and soul" of the Levi's account?
JK: We do have a core group of people who absolutely understand the evolving expressions of the brand. On the one hand this takes knowledge based on a long association with the Levi's brand, but it crucially involves the views of very bright creative team members who are the target age, and who can continue to create new expressions that are absolutely relevant.

MMP: In your PR you speak about using "authentic, real and honest everyday materials which have been detailed in a premium way" for the Levi's stores. Please explain.
JK: Levi's is a genuine authentic brand with heritage; the roots of that heritage are in work wear…originally gold miners in the 1850s. The brand evolved being adopted by new pioneers of youth culture, yet the principles of the quality and enduring strength of the product remain from

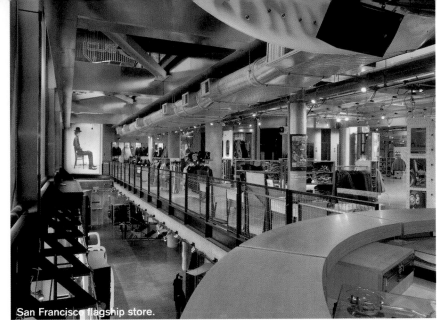
San Francisco flagship store.

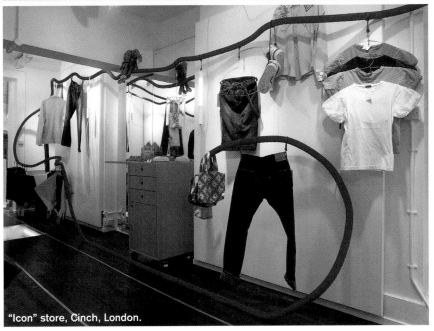
"Icon" store, Cinch, London.

its origins. When selecting materials we look to reflect these values using timeless elements such as wood, steel and leather which give a masculine strength, copper and the color red add brand relevance to the palette. But importantly, the way in which the materials are then detailed and applied make the design feel contemporary with a lasting quality. As a rule, if real is not available we would look for a genuine alternative. For example if for a reason we can't use wood on the floor, we would choose concrete, and inject natural warmth elsewhere in the store. We would never use plastic instead of leather, an alternative solution would be found that was real and natural; heavy canvas for example . We are always looking to balance tactility,

fitness for purpose and relevance to get an overall effect. The key is ultimately creating an environment that feels like the brand feels and which is relevant to the consumer and exceeds their perception of the brand.

MMP: Red is the signature color for Levi's stores and exhibits. How did that evolve?
JK: The color red is part of the brand's heritage and comes directly from the product. For example, early Levi's denim looms created a selvage edge which was identified with red stitching. The denim once manufactured into jeans appeared inside the legs of each pair. Levi's with this detail have become much sought after by collectors of vintage Levi's. But it is the

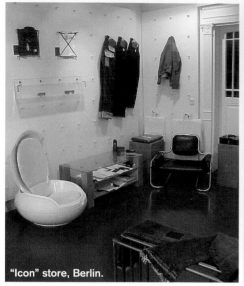
"Icon" store, Berlin.

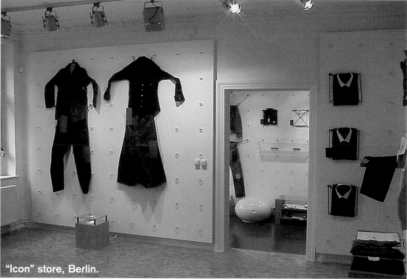
"Icon" store, Berlin.

Levi's red tab that appears on each pair of Levi's jeans, where the direct color reference comes from. We have used this red in many ways to add passion and potency to the various store designs, in some cases it may only be in the signage, in other examples we have created a 'red box' painting walls and ceilings to dramatic effect.

MMP: You have not only designed the flagship stores in San Francisco, London and Berlin but CK has also created "non-branded icon" stores such as Nimes in Paris, Cinch in London, Zinc in Barcelona. What are these "non-branded icon" stores and how do they fit into the Levi's scheme of things?
JK: The non-branded stores were created as part of a strategy that would target specific parts of the Levi's consumer hierarchy; the "icon" stores would appeal to opinion leaders in individual markets. Each is designed to have its own feel, which includes being "owned" by individuals who directly connect to a local scene and each has its own name which connects to Levi's in an oblique way. For example, "Cinch" refers to the waist adjustment device on the back of early jeans, "Zinc" is what the buttons are made of and "Nimes" is where the name for denim originates from i.e. "Serge de Nimes" and so on. In the broader scheme of Levi's retail they are important focal points for the brand

in individual markets, the stores sell limited edition and rare products, exhibit local artists and creatives' work, as well as collectables such as books and vinyl records. The Icon stores have been very successful in creating PR for Levi's products and have helped to change perceptions of the brand in certain quarters.

MMP: How did the concept for "Levi's for Girls" come about? What makes this store and its products different from a regular Levi's store? How is Levi's reaching out to this younger "girl" market?
JK: The original Levi's brief talked about "creating a retail concept which would be home to an offer catering exclusively for the young, style conscious and 'sassy' female market." Obviously they needed the design to be true to the values of the brand and be comfortable and relevant in every sense.

Our approach was to carry out some initial ethnographic design research in order to truly understand closely the lifestyle, needs and motivations of the target audience. We followed a selection of girls through a variety of retail and social spaces over separate days. Ultimately we created a vision of a space which would answer the girl's idea of the perfect shopping experience. This information was then used to design and detail the finished store.

The store has the feel of a boutique.

They wanted an independent feel and we needed to express the feminine side of what is a masculine brand, and at the same time create a personality of its own. The attitude of the Levi's brand is blended together to give an exciting, eclectic, modern, feminine feel. *(See Levi's for Girls on page 12.)*

MMP: Am I correct in assuming that Rivet is the CK concept for a vendor shop for Levi's? Why "Rivet"? What kind of fittings or fixtures have been designed for Rivet and how does Rivet further the Levi's brand image?
JK: Rivet is a result of the success of the icon stores. Selfridges, the London department store, was planning a new store in Birmingham, UK and they were impressed with Cinch in London and wanted to have "Cinch" on their designer menswear floor. As the concept of the icon was that each would be a one off. "Rivet" was born, again using a connection to the product as a name. The idea for Rivet was to present the premium end of the Levi's range in a way that was relevant to the brand and the Selfridges' consumer. We decided that it would be interesting to connect with the brand through materials and historic references done in a sort of gallery way. The main structure of rivet is a metal frame which is covered in leather and stitched. This represents the leather patch. The floor is copper which celebrates the material used in the rivets of Levi's jeans and where the metal is

exposed in the frame structure, it is made of zinc which again is what the buttons are made of. At the front of the area we used a saddle inside a glass table which acknowledges the cowboy heritage whilst an artful pile of internally illuminated timbers at the rear of rivet has references to work wear origins. Overall, we have an environment which is quality with subtle references to the brands heritage and at the same time presents products in a premium way. *(See Rivets on page 16.)*

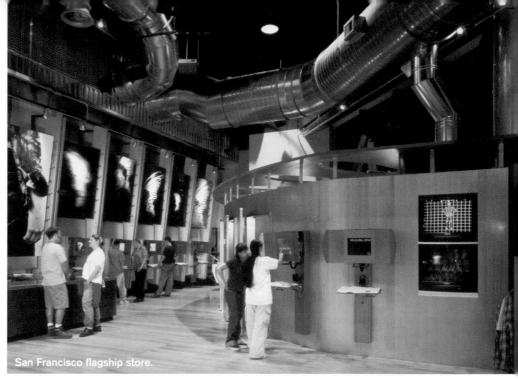

San Francisco flagship store.

MMP: CK has designed several trade show exhibit stands for Levi's as well: the Pitti Uomo in Florence, the Bread and Butter show in Berlin and the ClothesShow in London. How does designing a trade show space differ from a retail setting and how is it similar?

JK: Trade show spaces have to achieve very specific tasks in specific time frames, unlike retail where the time scales are extended both for the build and the life of the store, and the objectives are much different. What they both share is a consistency in present-

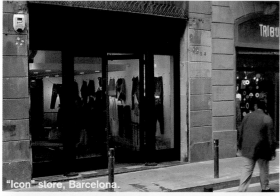

"Icon" store, Barcelona.

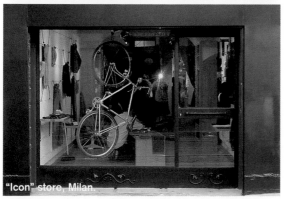

"Icon" store, Milan.

ing the brand to a mixed audience—they are both places where the brand comes to life and is open to dialogue with its consumer.

All environments where the brand presents itself should be related in some way. We talk about the strands which run through each and every representation. In this respect we do not look to create a version of a store. It is about the spirit of the brand and the experience of interacting with it within an arena. A person who visits an exhibition to buy for resell will want to feel the life, energy and commitment to the brand in a way the end consumer will. It's so important to communicate this, physically in the environment and emotionally through the brand representatives, just as we would in store.

MMP: Do you see real changes in the market for Levi's jeans?

JK: Yes real change—not just for Levi's—but for all brands is inevitable. It's what makes the market so dynamic. Levi's has been very perceptive over the years at remaining relevant to consumers. In the mid '90s Levi's presented itself at retail consistently focusing on heritage through the 501™; this was right for them. By the late '90s/early 2000s they looked hard at how the broad appeal of the brand in a more fragmented consumer market could be

relevant on many fronts. Icon stores, girls only stores, flagships, high street stores, store in stores, were all born—each with a Levi's strand running through them, but each offering something different.

MMP: What do you and your design teams do to keep up with the changing attitudes and changing styles and keep Levi's on target in the rapidly changing retail market? How do you keep fresh and up to the challenge?

JK: We have dedicated members of our team fully employed looking at consumer trends and insights; we undertake our own research into areas of the market and constantly travel seeing for ourselves what's happening. As a company we are keen to bring in young new talent to maintain a target market presence within the design team.

MMP: Where do you see Levi's in ten years? What do you think you will be doing for Levi's in ten years?

JK: I see Levi's in ten years continuing to evolve and continuing to be a part of pioneering youth culture. Who knows what form a "real" retail experience will take in ten years? I am sure, however, that Levi's will be at the forefront of it, and that we would love to be there helping to take them forward.

MMP: Many, many thanks.

LEVI'S FLAGSHIP STORE

Regent St., London, UK

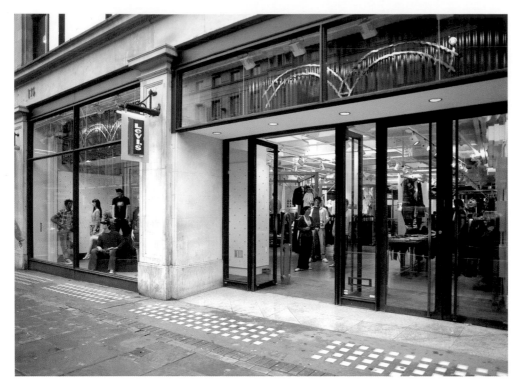

DESIGN: **Checkland Kindleysides,** London, UK
PRINCIPAL DESIGNER: **Joe Evans**
DESIGNER: **Maggie Wright**
PROJECT MANAGEMENT: **Hana Carter, Tony Bell**
PROJECT IMPLEMENTATION: **Richard Dunkin**

For Levi's®
STORE DESIGN & PLANNING MANAGER:
John van Dorst

PHOTOGRAPHY: **Adrian Wilson**

It really wasn't that long ago that Checkland Kindleysides designed Levi's® flagship store on Regents Street in London and here it was getting an "innovative facelift." Based on work that was done in the Girl's store in Paris and other recent concept innovations, Levi's felt "pushed creatively to produce an altogether clearer and more relevant concept that was fitting to the flagship store." The designers at CK were called in and "the store was reviewed in its entirety and it soon became apparent some major structural changes were necessary in order to improve navigation in the store and increase the available floor space to produce an enhanced retail experience."

Two hand-crafted steel "arcuates" (the double curved stitch detail from the back pocket of Levi's jeans) are applied to the red corrugated steel in the store's windows—as "the major branding piece of the store's façade." Inside the store, the two-tiered DJ

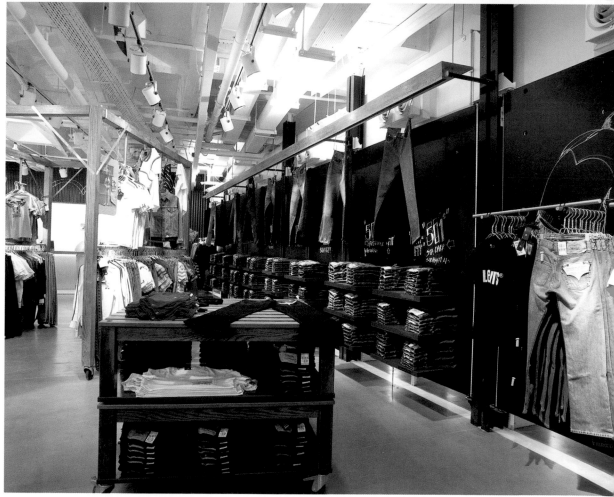

15

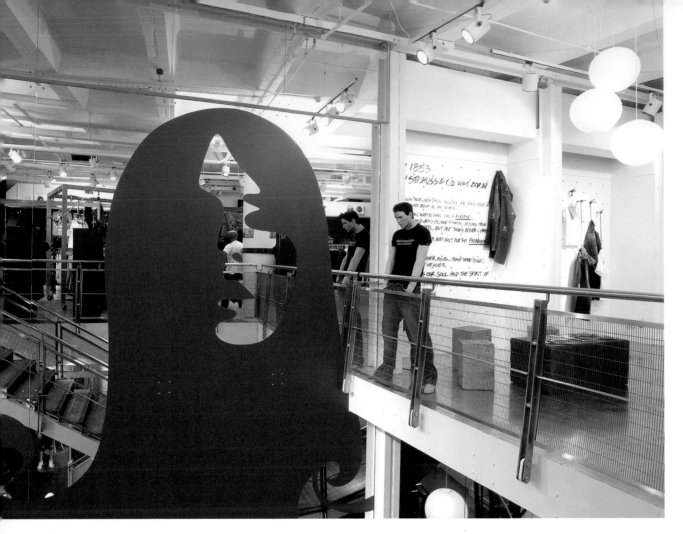

tower and gantry were removed and thus opened up that space on the sales floor. There are now three distinct "concept kiosks" that become the defined destinations and they provide "clear and concise product presentation." The materials used here are "brand triggers": brushed stainless steel and solid oak structures that reinforce the "heritage and modernity" theme of Levi's. The existing "gate system" is now whitewashed timber for a "warmer look." The all-important "Fit" and "Finish" area gains in importance through the focus on the "Fit Wall." Blackboard clad gate systems clearly identify Levi's denim fits by means of hand-drawn chalk graphics while the actual jeans are suspended from a rail above. Similarly, sizes can be easily found chalked onto red shelving set below each "Fit" display.

Levi's red signature color gets a real workout in this renovation. Red metal locker doors with metal strap handles and solid oak posts serve to divide the

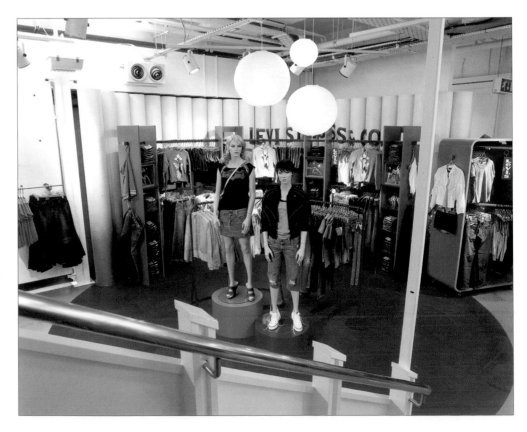

changing rooms on the main level while the cash/wrap desk has been relocated to the rear of the store where it is backed up by a red corrugated steel wall that features the "arcuate" branding. It mirrors the façade treatment and also serves to draw shoppers to the back of the space.

Girl's clothing is on the lower ground floor and is introduced by the lifestyle display at the top of the stairs. This area is really identified by the giant Medusa graphic on the mirrored wall that spans the two levels of the store. A motif introduced at the ClothesShow Exhibit, where the Girl's line was introduced, appears here as well. Over 9 ft. tall sprayed cylindrical tubes are used to section off areas and add "an entirely curvaceous feel" to this space. Full height red rubber cord curtains are viewed upon entering the Girl's sales floor where they create "a decompression zone" in the sociable changing area. They provide a sensed of privacy for those who are trying on garments while friends are just outside ready to offer advice, criticize or "OK" the outfit. The concept fixtures and color scheme on this level creates an affinity with the Girl's store in Paris—"ensuring brand consistency."

On the main sales level, adjacent to the changing area and the cash/wrap is the "chill" area where friends can relax while they wait. Solid oak block seats and a leather clad table sit on a copper floor (see Rivets entry). "Overall, the new look store highlights product as key, through a clear and focused product presentation on fixtures produced in 'real' and 'premium' materials reflecting the core values of the Levi's brand." Fewer fixtures and less product on the floor and more stock behind scenes "ensures clearer navigation and a more relaxed shopping experience."

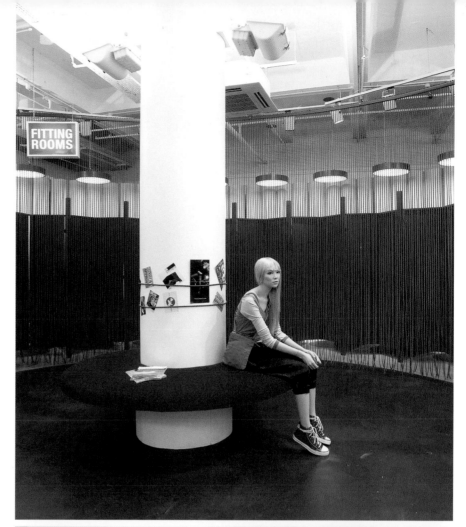

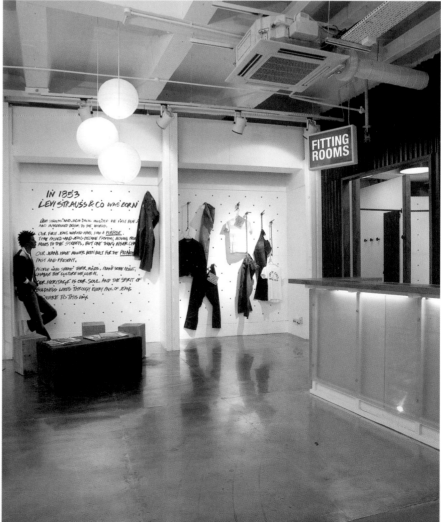

LEVI'S FOR GIRLS

Rue Pierre Lescot, Paris, France

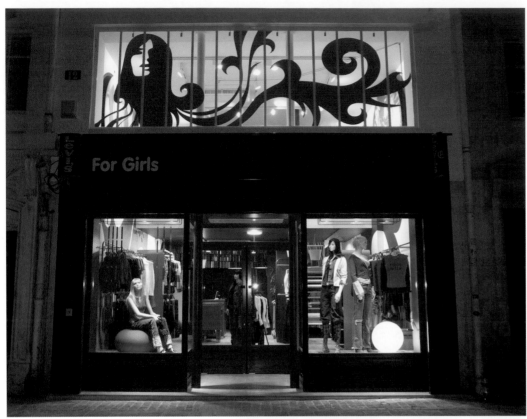

DESIGN: **Checkland Kindleysides,** London
ACCOUNT DIRECTOR: **Henry Barnes**
PRINCIPAL DESIGNER: **Joe Evans**
DESIGNER: **Maggie Wright**
PROJECT MANAGEMENT: **Hana Carter,
Tony Bell**

For Levi's®
STORE DESIGN & PLANNING MANAGER:
John van Dorst

PHOTOIGRAPHY: **Luigi Aprosio**

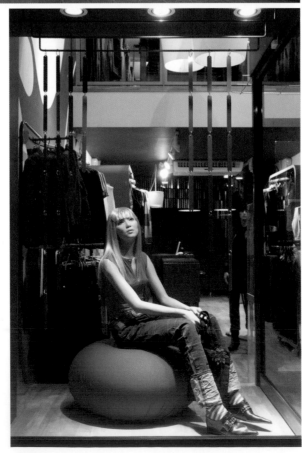

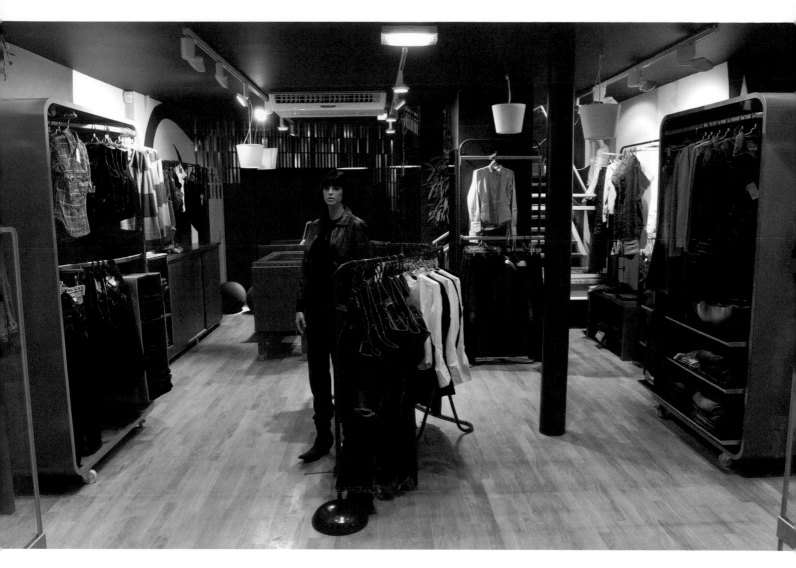

The store on rue Pierre Lescot, in Paris, is the first store of its kind designed for Levi's® by Checkland Kindleysides. The aim was to create "a retail concept that would be home to an offer catering exclusively for the young, style-conscious and sassy female market." As Jeff Kindleysides explains, "The store has the feel of a boutique. We wanted an independent feel; we needed to express the feminine side of what is a masculine brand and at the same time create a personality of its own." To create this concept CK did ethnographic research to truly understand the lifestyle, needs and motivations of the target audience. "Drawing from the variety of retail and social spaces that a teenage girl encounters upon a daily basis, a

space was created that is somehow familiar upon sensory levels."

It all starts with the two level storefront painted in bold and distinctive Levi's red. Uniting the two levels of merchandise is a hand painted mural of a girl's face with flowing hair (Medusa)—"encompassing the store and providing a visual pull through the store. The effect of the hand painted mural gives an artisan feel which is both personal and hand-crafted." The fixturing throughout carries through the easy, informal and non-conformist attitude of the product. The fixtures are basically simple rail constructions but re-interpreted into more sculptural and fluid shapes of red steel that either hang or stand on the wood laid floors. According to

the designers, "The store fixtures provide good views of the product range and generate real involvement." Simple wardrobe units, with rounded corners, combine hang rods with shelves for folded denims and though they are finished in red and stand against white walls, the product still stands out. In addition to the white walls there are wall areas finished in Levi's red. Used as an accent throughout are "curtains" of linked pieces of red, orange and magenta-pink metal. These see-through dividers appear in the front window, framing the dressing rooms at the rear of the store and cascading down through the void of the stairway connecting the two levels. A folding screen of red panels serves as the divider between the

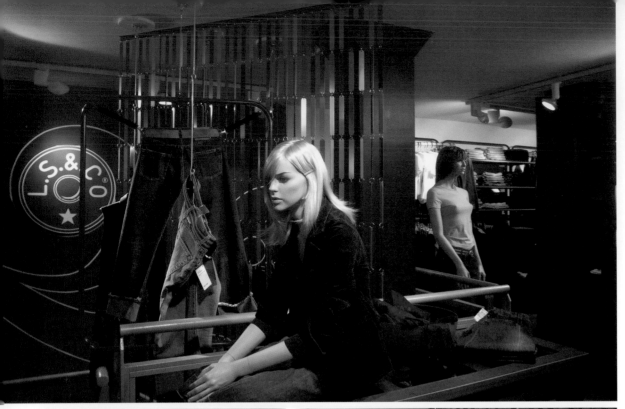

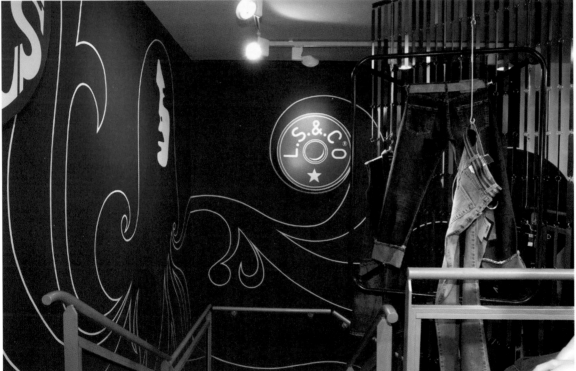

changing rooms and the rest of the shop. A "meet" area, in front of the dressing rooms, is an important part of this design concept because it ties in so much with the lifestyle of the teenage girl shopper.

Contrary to the way consumers traditionally shop two-level stores, "the new store design succeeds at many very real retail challenges, including encouraging almost half of all shoppers to go upstairs and thus minimizing quick in-and-out shopping" Don't be surprised to see a Levi's for Girls boutique opening somewhere nearby in the very near future. Vendor shops for this concept have already taken root in Galeries Lafayette, Printemps and the Etam chains.

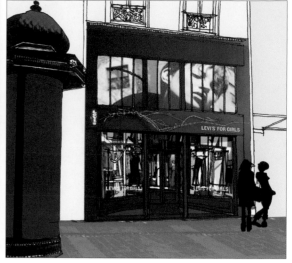

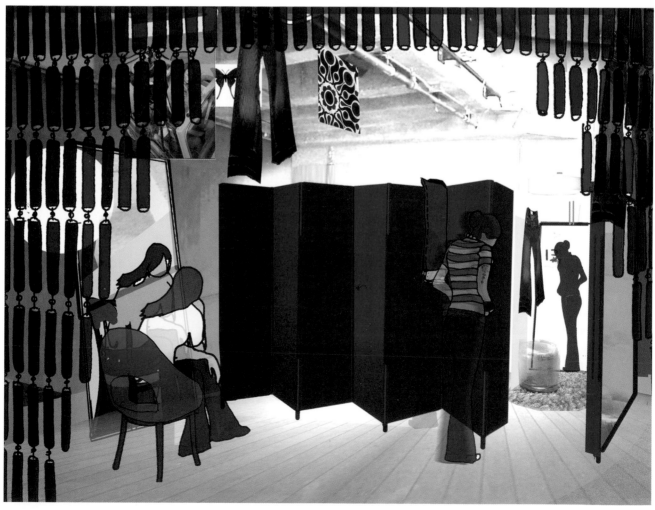

RIVET

Selfridges, Bullring, Birmingham, UK

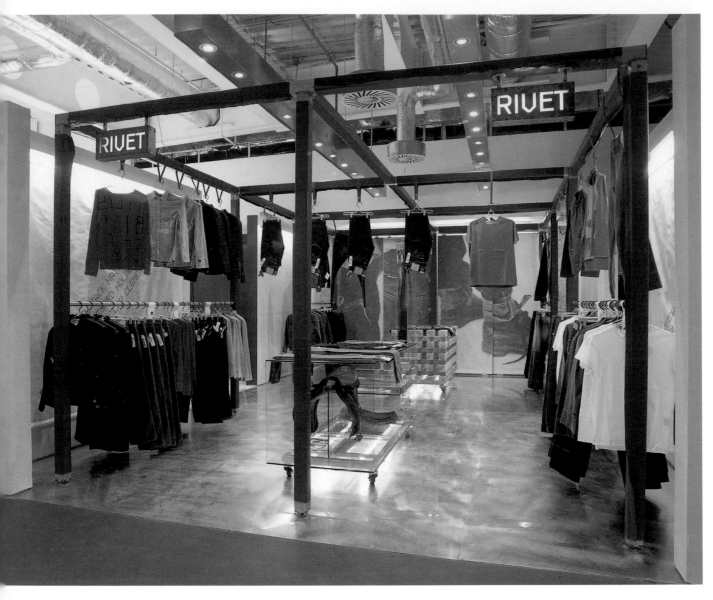

Rivet was designed by Checkland Kindleysides as a new concept for a Levi's® vendor shop. This design serves as an umbrella for two Levi's lines. Levi's Red and Levi's Vintage clothing concepts are equally split in the space and they are bridged by a display of Levi's 501. This is the seventh "icon" store concept developed for Levi's and it is shown as it is here on the men's floor of the new Selfridge department store in Birmingham.

The designers have evolved a flexible merchandising infrastructure "that defines the floor space with perimeter walls which are viewed as a blank canvas." This allows "graphic expressions to evolve in line with future clothing concepts." High level space is reserved for presentation (display) while on simple hang rods below the garments are stacked by style, size, fit and finish—"allowing confident self-selection by the customers."

The unit is self-contained and self formed and completely independent of walls. Where there are walls they become the "canvas" upon which the Levi's graphics appear. The stainless steel frame is covered in leather that has been stained Levi's red and the unusual floor is finished in copper. Together they "reflect the heritage and authenticity of the Levi's brand."

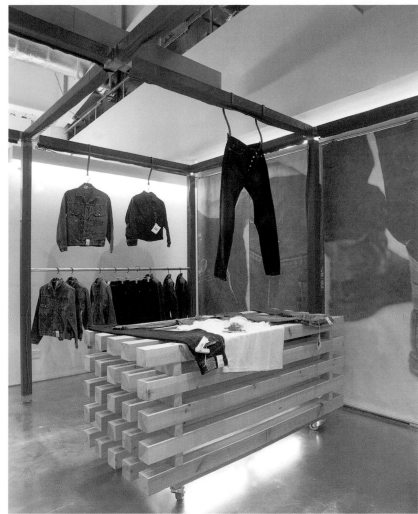

DESIGN: **Checkland Kindleysides,** London, UK
DESIGNER: **Russel Ashdown**
PROJECT MANAGEMENT: **Hana Carter**
PROJECT IMPLEMENTATION: **Richard Dunkin**

For Levi's®
STORE DESIGN & PLANNING MANAGEMENT:
John van Dorst

PHOTOGRAPHY: **Adrian Wilson**

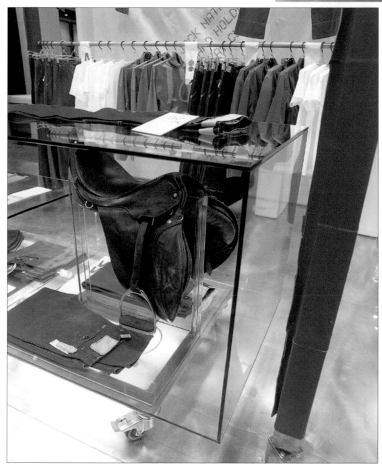

LEVI'S EXHIBIT @ CLOTHESSHOW LIVE

London, UK

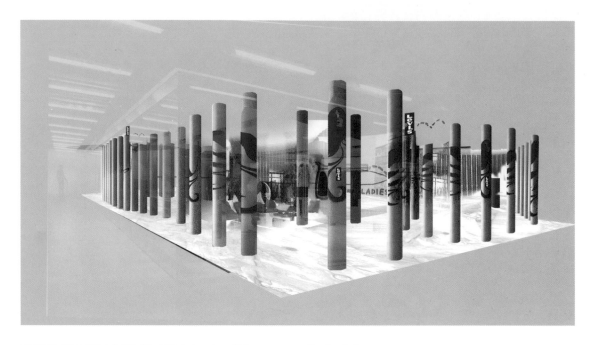

DESIGN: **Checkland Kindleysides,** London, UK
ACCOUNT DIRECTOR: **Henry Barnes**
PRINCIPAL DESIGNER: **Joe Evans**
DESIGNERS: **Carl Murch, Clare Orrell**
PROJECT MANAGEMENT: **Hana Carter, Richard Dunkin**

For Levi's®
STORE DESIGN & PLANNING MANAGEMENT: **John van Dorst**
PHOTOGRAPHY: **Adrian Wilson**

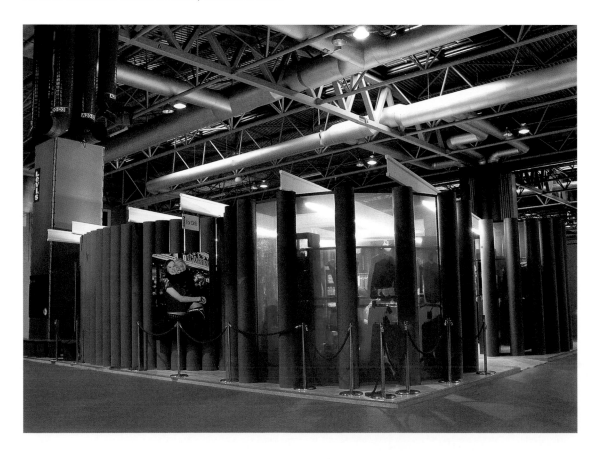

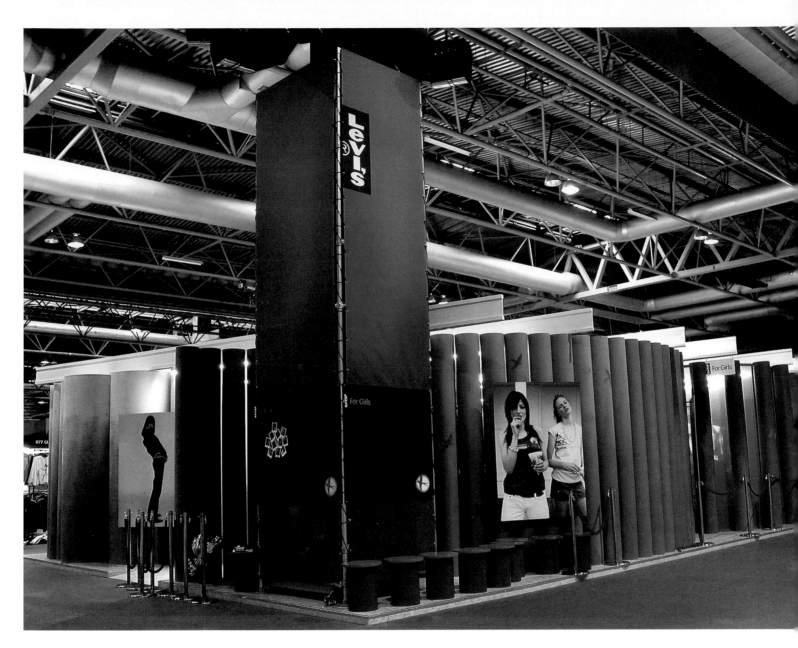

Sue Childer, Levi's® European Retail Marketing Director, feels that the design of an exhibit stand must incorporate not only the company's brand image, but must also enable visitors to experience and interact with the product in the way that the customer will in the retail store. In order to achieve the desired effect, Levi's commissioned Checkland Kindleysides, who does so many of their retail stores, to create a series of exhibits: the UK ClothesShow Live in London, Pitti Uomo in Florence, Italy and Bread & Butter in Berlin in Germany.

For the London show, entrance to the exhibit space was by invitation only and this "exclusivity" was reflected in the design of the space. According to Ms. Childer, "This gives the retailer time to show the production line properly. People go to ClothesShow Live to buy, so the retail element was a big part of the stand." She goes on to explain, "We wanted to raise awareness of our Levi's for Girls business and one objective was to talk to more females. Levi's brand color is red, so we drew from that and combined it with a magenta-pink to feminize the brand. We also included graphics of a girl's face (Medusa). The stand needed to be a beacon in a very busy environment, so the color combination worked well."

For the design firm, Jeff Kindley-sides said, "We had to be innovative with how we used the space and still fulfilled the brand image. The challenge for us was to combine public visible access and private physical access. We used a reception desk and a meeting area where visitors could meet and chat with a Levi's representative. We had a height restriction of 3 meters (9 ft. 9 in.) so putting a cat-walk around the stand meant we were still able to elevate the brand presence while not revealing every-thing to everybody." The Levi's for Girl's store in Paris is the first expres-sion of the Levi's brand of "the femi-nine side of what is traditionally viewed as a masculine brand." This exhibit was the introduction to this

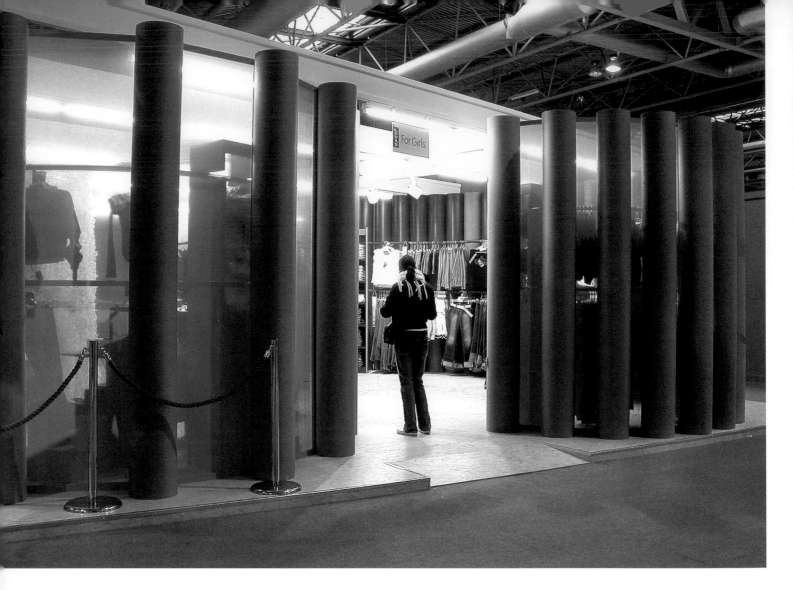

concept and it was rendered in a curvaceous style that included handcrafted and hand stenciled graphics.

Once the visitor was past the "forest" of columns and the glimpses of what was partially hidden by these columns that sprouted up throughout the space, she entered the "meet" area: a social space with a DJ, seating, a bar and an introduction to the new garments. The "forest" was made up of 9 ft.+ cardboard cylinders—spray stenciled—and arranged to affect "a curvaceous and unique shape." 1200 mm diameter tubes were used to form the changing rooms while 300 mm tubes were cut down to serve as seating. For the product viewing, the space was divided into different product concepts: Lady Levi's, Levi's Red Tab Jeans, and a special ClothesShow Live discount area for show buyers only. Each area was highlighted with

its own unique signature and sprayed stencil artwork. Garments were displayed on "simple, wardrobe styling on low levels" with featured items and branding above. The curved hang rails, in red, were supported by shelved product towers that allowed for folded garments.

In addition to creating the unique exhibit design CK also was responsible for press invitations, press packs, and in-store promotional windows including those in the Regent St. flagship store. The take-away souvenirs were specially stenciled T-shirts in red cardboard tubes.

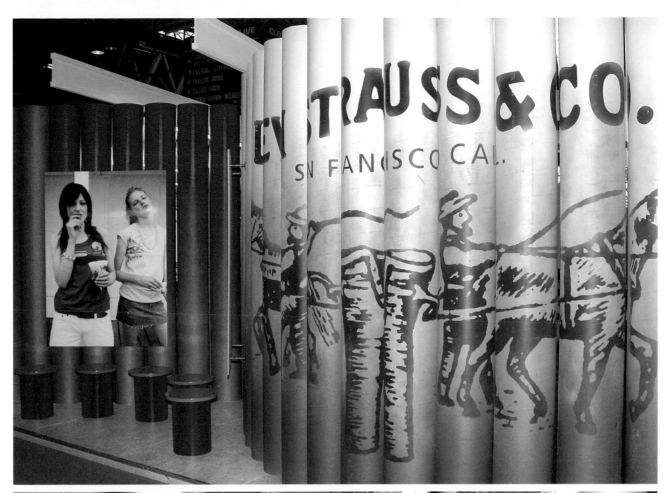

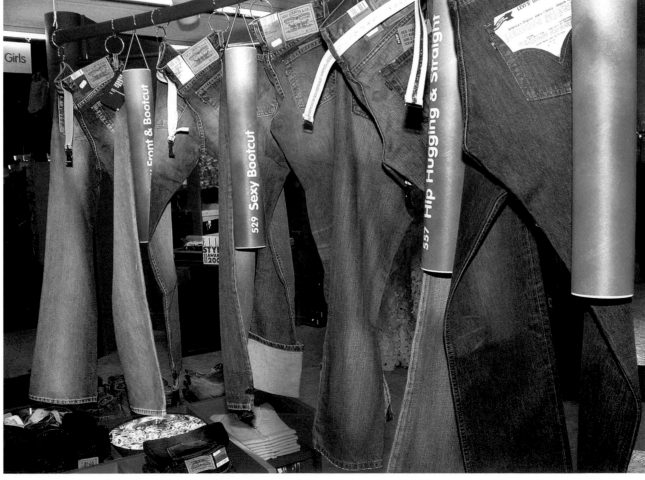

MOSCHINO BOUTIQUE

Via Sant Andrea, Milan, Italy

A CONVERSATION with SEAN DIX
Designer of Moschino Boutique

"My goal for the whole project has been that one's impression should be that it is a very minimal space—then one realizes that this 'minimalism' is built up out of millions of little elements, obsessively assembled"

—Sean Dix

MARTIN M. PEGLER: From what I understand, Moschino, the fashion designer, already had a shop on the Via San Andrea in Milan and he commissioned your firm, Dix Design/ Architects of Milan to come up with a new design concept for his boutique. In accepting this challenge what limits, boundaries or expectations did Moschino set for you?

SEAN DIX: The brief from Moschino was, as before, very open. It was agreed that anything could be possible, as long as I remained true to the spirit of irony and humor of Franco Moschino. They asked simply that I create what I believe to be the best solution, keeping in mind that they were very happy with the initial showroom project and wanted to stay near to that in feeling. No compromises were asked for or given, and their level of trust is very high. They are the kind of client that most architects only dream about— open to experimentation, enthusiastic, generous with their time and input, eager to do something new and personal, willing to take risks. Exactly the kind of company you'd expect, looking at the clothes they produce.

MMP: Your new concept was based on a showroom you had previously designed for Moschino. What was it?
SD: The overall concept for the space retains the same irreverent approach used for the initial project for Moschino—ironic juxtapositions between old and new, hard and soft, baroque and minimalism, materials

used in very unlikely ways.

MMP: What physical problems existed and how did you overcome them?
SD: Because the existing shop is relatively small, my first priority was to create, as much as possible, the impression of space. So I joined the very small existing space and two adjoining spaces

DESIGN: **Dix Design,** Milan, Italy
Sean Dix
GENERAL CONTRACTOR: **Sice Previt,** Milan
RESEARCH & TRANSPARENT LOGOS: **BISK**
"CROSS CHECK" CHAIR DESIGN: **Frank Gehry for Knoll**
ALL OTHER FURNITURE, ELEMENTS, LIGHTING AND DISPLAYS: **Dix Design**
PHOTOGRAPHY: **Santi Caleca**

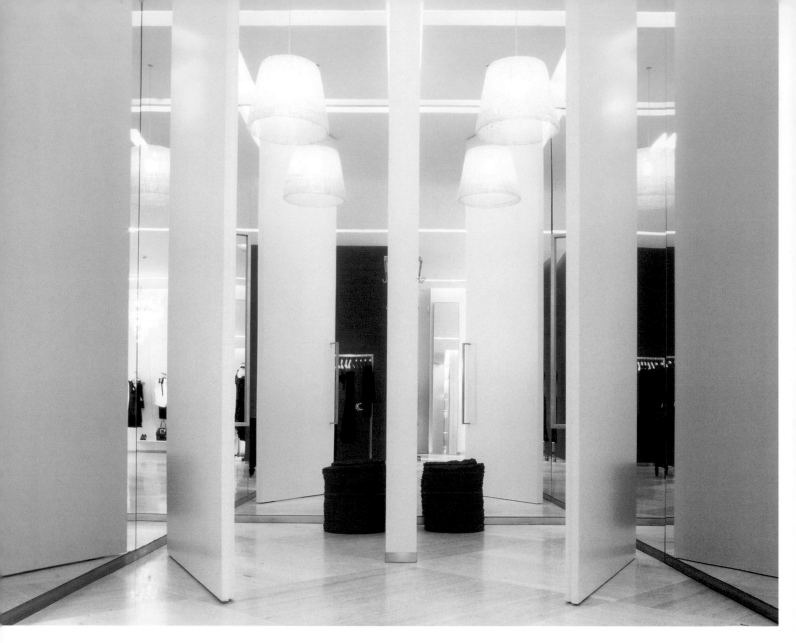

to create one very open, airy, beckoning shop. For this, my first architectural project, I became almost the opposite of an architect—I knocked down far more walls than I built.

MMP: You also reworked the facade?
SD: The facade originally consisted of a tiny doorway and a closed shop window. We ripped out all of that and created a new facade which has three matching, huge arched modern windows, juxtaposing the traditional, refined wrought iron ornamental arches at the top. The left and center arches are wide open to the shop, allowing a view all the way to the backlit laser cut lace wall across the back of the shop and the third window is dedicated to the outrageous shop windows for which Moschino has become so

famous. These change every month. The logos are very discreet—a small "MOSCHINO" applied in transparent letters on each of the three shop windows. We have found that the company image is so identifiable INSIDE the store that big logos were redundant.

MMP: Did you save anything from the original shop?
SD: The polished brass heart handle is the only element retained from the previous project, an appropriate homage to Franco Moschino, for whom the heart symbol has become synonymous.

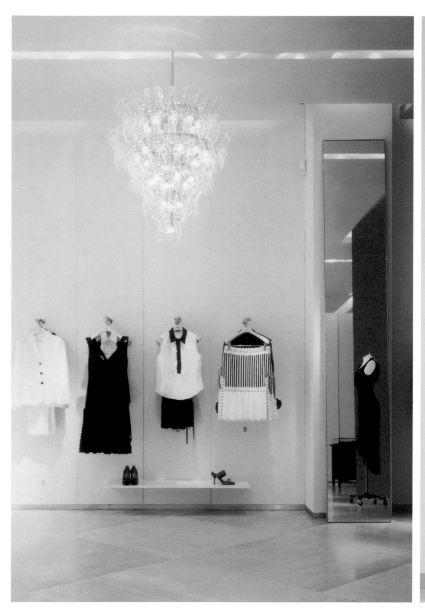
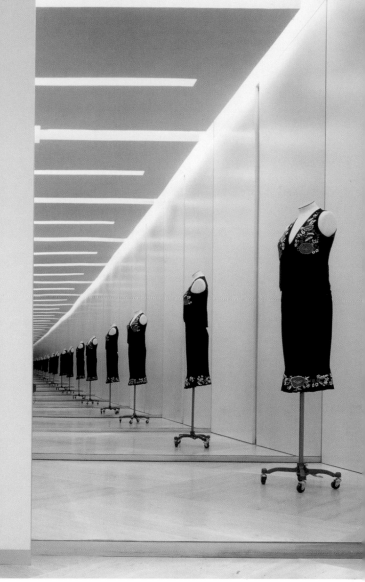

MMP: Tell me what you think is the Moschino brand image and how did you "visualize" it in your shop design?
SD: Moschino has built its much deserved success on its irreverent sense of humor. To get that across I have used Hans Christian Andersen's "The Emperor's New Clothes" as a predominant text element—a very ironic choice. It is the famous fable—the story of a vain king who is so enamored of clothing that he allows himself to be hoodwinked into buying "invisible"—non-existent—clothing from a couple of crooks.

MMP: In your description of the project you said that "Architectural materials are used to make fashions and fashion materials are used to make architecture." Could you explain that?

SD: In this new concept for Moschino's worldwide group of stores, there is an additional twist: we have used the materials usually associated with the "construction" of clothing—fabric, felt, ribbon, lace, pins—and used them as architectural building elements.

The central load-bearing column in this space, for example, is built out of a huge stack of fabric—three different colors of red, 40 kilometers' worth. It is a simple form—though highly complex on inspection—and obsessively constructed. This immense volume of fabric becomes an important focal point to the whole shop, and it is impossible to pass by without yielding to the satisfaction of running one's hand across the tight stack. The impact is that of a colossal stack of red fabric holding up the ceiling. Even the walls are fabric—

each panel printed with the Andersen fairy tale, raised white letters on ecru.

One huge wall, open floor-to-ceiling to the courtyard behind, is covered with small, interlocking pieces of wood cut into elaborate lace. These "puzzle" pieces have been cut with laser, and it is only as one comes closer that it becomes clear that it is not fabric but perforated wood that creates this effect. Sunlight streams through the tiny holes in the "lace" and creates beautiful lace patterns on the floor.

The floor is made from two types of Italian travertine—Savona and Romano. They have only the most subtle difference in tone, and are treated with a special transparent resin "stucco" to allow the millions of holes in the marble to remain visible. The tiles of alternating travertine are enormous—120

players and such?

SD: There are two types of display tables—rare, pure black marble into which has been etched the white pattern of a lace tablecloth, and a very simple wooden table with a gauze tablecloth. On the gauze tablecloth is printed an obsessive drawing of a exaggerated baroque table, but the cloth is so transparent that one can see the simple, minimal table underneath.

All of the different clothing rails and display systems in brushed stainless steel and white lacquer were designed by me especially for Moschino.

The mirrors are extremely tall—shallow, polished brass boxes leaned up against the walls.

MMP: What did you do about illumination in the shop? Any special concepts on lighting?

SD: Because generally I like to reduce the visual importance of spotlighting—what's important is the light—the spotlights in the ceiling have been concentrated into two tight slots that run down either side of the red column. There is a perimeter gap between the ceiling and the walls which is also illuminated. This approach has allowed us to keep the ceiling completely clear of extraneous detail. What's below, after all, is the important stuff.

There are two enormous chandeliers made from glass "slippers" and each shoe is hand-blown by the same woman, a master Italian artisan. The lamps in the changing rooms are made of madly wound string, creating a fantastic play of light inside the mirrored room.

cm. x 120 cm.—it took six men to lay each one. They, happily still have all their fingers and their toes.

There is one enormous display wall that is completely illuminated, in front of that is a bench made from stacks of rectangular red felt. The stools in the changing room are also made from stacked felt—in this case, dark red discs stacked one on top of the next.

There is another wall, near the changing rooms, which is completely covered by gold pins—millions of them. The effect from a slight distance is almost that of gold fur—the lights from above throw the shadow of each pin diagonally across the wall.

MMP: How about the merchandise presentation—the fixtures—the dis-

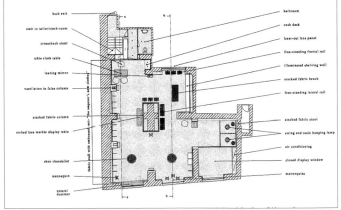

MOSCHINO

Paris, France

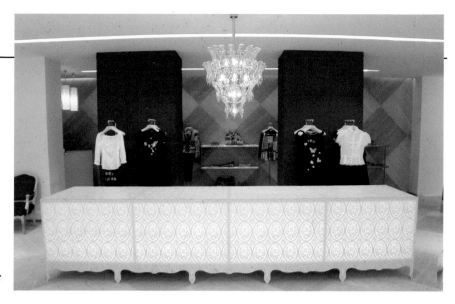

MMP: What was your design approach for the Moschino boutique in Paris?
SD: The overall concept for the space retains the same irreverent approach used for the boutique in Milan: using materials in a very unlikely way.

MMP: I see you included the columns built of stacks of three different colors of red fabric as well as the chandelier with the glass slippers. What is new?
SD: There is an enormous glowing display wall in front of the which is a bench made of stacks of rectangular red felt. The stools in the changing room are also made of stacks of felt—in this case, dark red discs stacked one on top of the next.

MMP: I notice that you used the same clothing rails and display system you created for the Milan shop. You also repeated the Emperor's New Clothing theme.
SD: Yes! Even the walls are fabric covered and each panel is printed with the Andersen fairy tale: raised white letters on the ecru base.

MMP: In the Milan boutique you did

extensive architectural renovation. What did you do here—architecturally?
SD: For this project we created a completely new seven window façade—the all glass has been pushed forward to the sidewalk, eliminating completely the support structure.

MMP: What about that large—really large—piece of furniture up front?
SD: The first thing one sees, even from outside the store, is a remarkable piece of furniture. This huge, illuminated display case—an exaggerated four meters long — is covered with 600 small, interlocking pieces of steel cut into an elaborate lace. Also, the display cases are minimal cubes of mirror-polished stainless steel with photographs of antique 18th century furniture applied to every surface.

MMP: Now that this project has been completed and adapted to other Moschino boutiques what do you think you have accomplished that makes the design unique?
SD: Our goal for the whole project has

been that one's impression should be that it is a very minimal space. Then one realizes that this "minimalism" is built up out of millions of little elements—obsessively assembled.

MMP: Many thanks for your time, your effort and for sharing these projects and your thoughts with us. We look forward to seeing and printing more in the very near future.

Sean Dix, the creative and guiding spirit behind Dix Design & Architecture is an American industrial designer who was raised in Fiji, Saigon, and the Philippines. He is a graduate of the School of Art Institute of Chicago where he studied sculpture and industrial design as well as literature. He has been working in Europe since 1994 with such design luminaries as Tom Dixon, James Irvine and Ettore Sottsass. Dix established his own design firm in 2000 and Moschino was one of his first major clients. Dix's design for Byblos, in Moscow, appeared in our January issue.

DESIGN: **Dix Design**, Milan, **Sean Dix**
PHOTOGRAPHER: **Benoit Teillet**

MOSCHINO CHEAP AND CHIC

Via Spiga, Milan, Italy

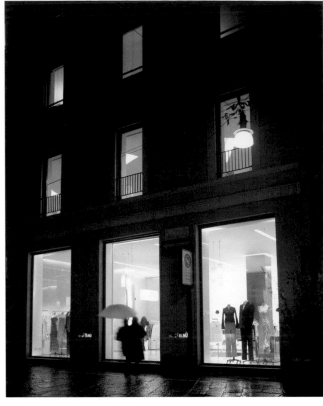

DESIGN: **Dix Design,** Milan
Sean Dix
PHOTOGRAPHY: **Ramak Fazel**

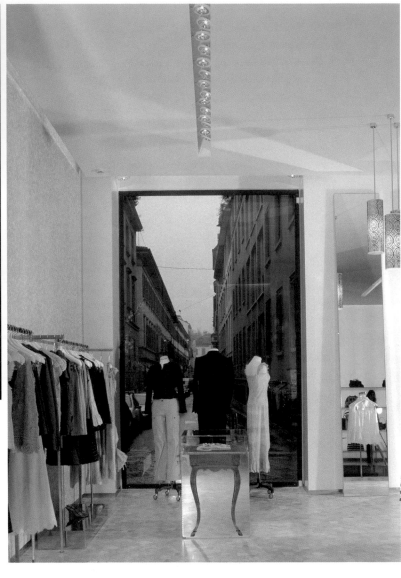

"The overall concept for the space retains the same irreverent approach used for the initial projects I've done for Moschino: ironic juxtapositions between old and new, hard and soft, baroque and minimalism, materials used in very unlikely ways." Thus speaks Sean Dix, designer of this Moschino CheapandChic shop on the Via Spiga in Milan.

It all starts with the new, enlarged and enhanced street presence with a new facade consisting of three matching, huge modern openings. The cen-

tral one serves as the entrance into the shop while the other two become "the outrageous shop windows for which Moschino has become so famous." Through the central opening the shopper can see back to the 13 ft. illuminated shelving across the rear wall of the shop. As in the other Moschino shops, the updated, mirror-polished chrome heart handles are used "as an appropriate homage to Franco Moschino for whom the heart symbol has become a potent symbol." The new space is on two levels:

CheapandChic on ground level and Uomo, Jeans and Bambino on the lower level. The two levels are connected by a red-carpeted stairway—"a high impact element which allows an extensive view from one floor to the other." Also unifying the two floors are the two load-bearing columns that are now covered in mirror-polished stainless steel.

Though the designer again references the Hans Christian Andersen tale of The Emperor's New Clothes— as used in the boutiques, here he adds

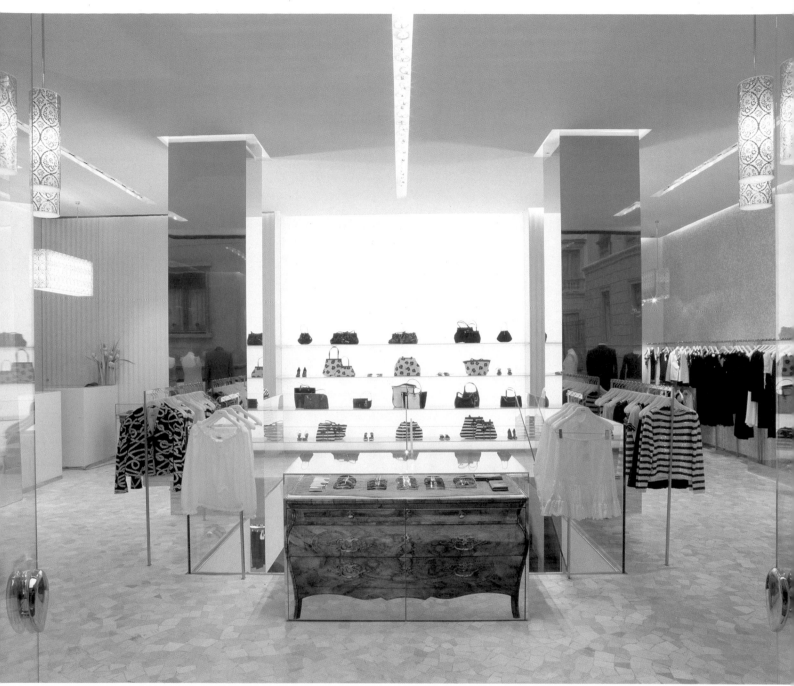

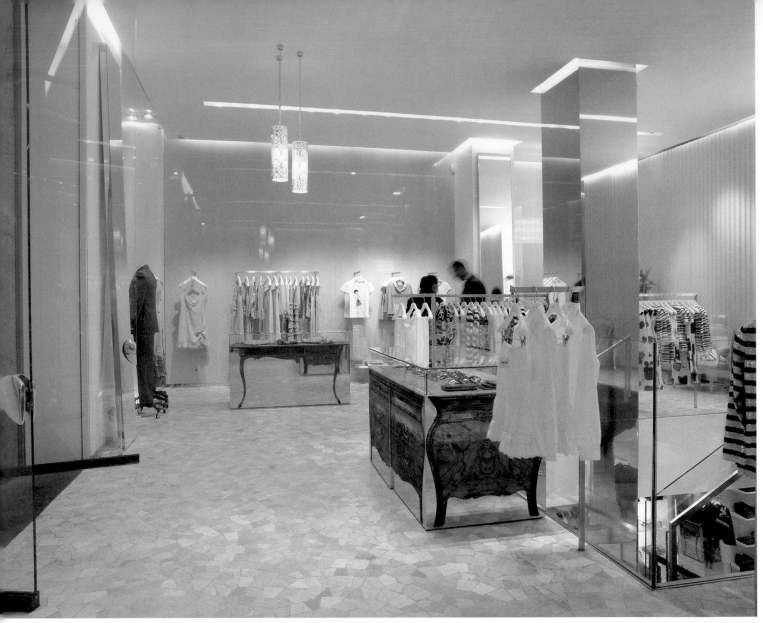

a new twist. "We have used the materials usually associated with architecture—steel, marble, wood, stone—and used them in ways that refer to the 'construction' of clothing—as 'fabric': pleated, woven, and draped—as silk, moiré and lace." One full wall is "dressed" in high-gloss, polished maple—the flame of the wood mimicking silk moiré. The diagonally-laid, statuary marble tiles on the opposite wall gives the effect of a "woven tapestry"—13 feet by 48.75 feet. A "curtain" of lacquered corrugated sheet metal—across the back of the ground floor space—is drawn back to expose 13 ft. of glowing display wall. The floor is made a palladiano "a subtle joke of 'cheap and chic.'" The fine marble is broken into pieces and then care-

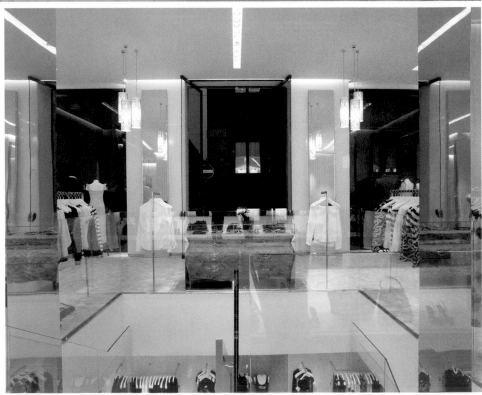

fully positioned" again, a beautiful, labor-intensive technique largely forgotten for decades."

As in the boutiques, the display tables are minimalist cubes of mirror-polished stainless steel with photography of antique furniture applied to all surfaces. All the clothing rails and display systems, in brushed stainless steel and white lacquer, as well as the furniture were designed by Sean Dix for Moschino. Also, relating back to the Moschino Boutiques, the mirrors are extremely tall, 13 ft., and are set in shallow polished steel boxes that lean up against the wall. The approach to lighting is also the same in concept and execution and here the chandeliers are made from glowing cylinders of polished stainless steel lace—"light sparkling from the tiny gaps in the steel."

Sean Dix reiterates, "My goal for the whole project has been that one's first impression should be that it is a very minimal space—then one realizes that this 'minimalism' is built up of millions of little elements obsessively assembled."

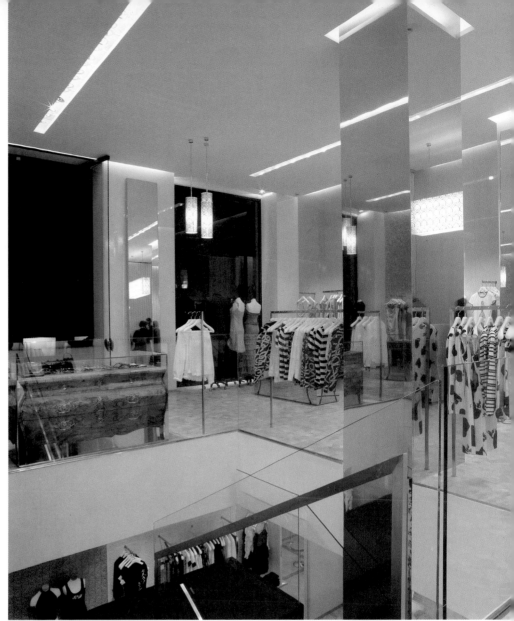

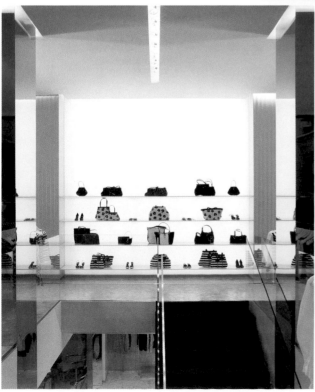

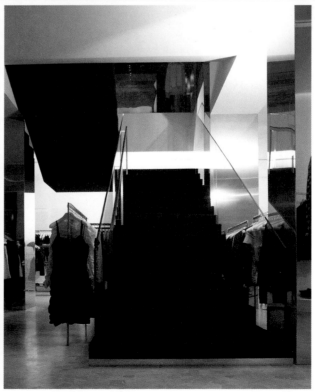

LA MAISON HERMÈS

Ginza District, Tokyo, Japan

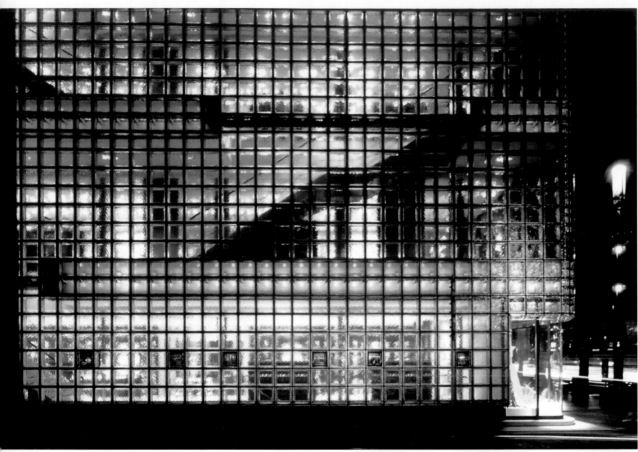

ARCHITECTURAL DESIGN: **Renzo Piano Building Workshop,** Paris Office
PARTNER IN CHARGE: **Renzo Piano**
ASSOCIATE IN CHARGE: **Paul Vincent**
PROJECT MANAGER: **Loic Couton**
DESIGN TEAM: **Giorgio Ducci, Pascal Hendier, Frank La Riviere, Christopher Kuntz**
INTERIOR DESIGN: **Rena Dumas,** Paris
DESIGN TEAM: **Rena Dumas, Denis Montel, Dominique Hebrard, Nathalie Lucaora, Maud Girard**
EXECUTIVE ARCHITECT: **Takenaka Design Department,** Tokyo
PHOTOGRAPHY: **Courtesy of Hermès,** Paris

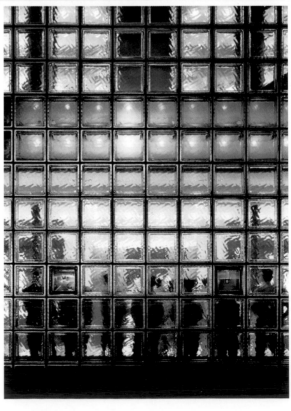

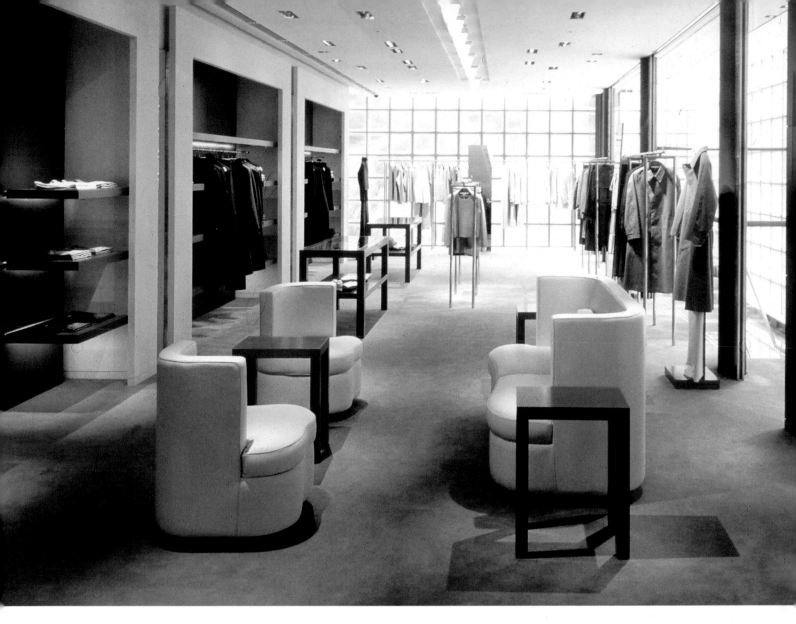

Located amid the glitter, neon lights and hectic activity of the Ginza District in Tokyo is the new, elegant, 12-story La Maison Hermès. Designed by the Paris office of Renzo Piano Building Workshop, the slim, 6,000-square-meter retail space carries a complete collection of Hermès' luxury items in leather, silk and ready-to-wear. The site measures 12 meters wide (39+ feet) by 456 meters long (1496 feet) and a courtyard sits in front of the building. It leads to a ground floor entrance into the retail establishment and there is another entry into the Hermès Museum and offices. This also leads to the subway station below ground.

A 50-meter (164 feet) void rises up the height of the building "creating a vertical shaft separating the structure into two distinctly proportioned volumes clad in glass block." The stairways on the first three levels—where the retail activity is centered—are set up against the glass block facade thus "animating the facades with activity and differentiating between the shopping floors and the working floors above." The construction of the building, under the direction of the world-renown architect Renzo Piano, created an almost column-less retail space in which Rena Dumas, the interior designer, was able to work.

In contrast to the cool, sleek exterior is the warm and rich interior design of Mme. Dumas. Though understated and furnished with simple square and rectangular forms, the interiors exude the familiar Hermès signature look. The counters are rectangular shaped and constructed of deep, dark woods accented with areas of glass and touches of stainless steel. These contrast with the custom blocks of glass that cover the exterior of the building. These blocks are 45 centimeters square (almost 18 inches) and the exterior faces are mirror-finished by hand while the interior surfaces are textured, thus adding another tactile element to the design and a complement to the sleek marble-paved floors.

Deep recessed "cabinets" with floating shelves and/or hang rods—also finished in dark mahogany—line the interior walls of La Maison Hermès. The ready-to-wear fashions and signature Hermès leather prod-

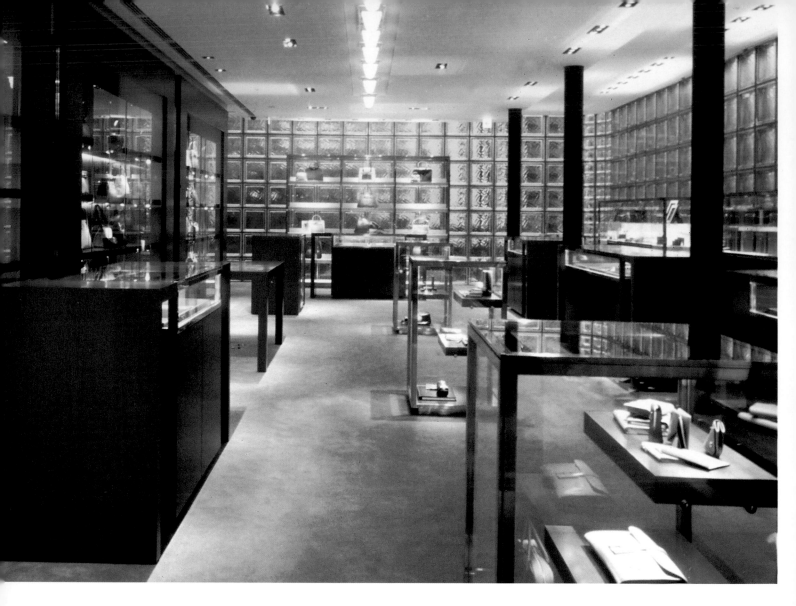

ucts are showcased in these wall indents. A free standing wall/partition separates men's shoes from men's wear while also supporting some of the merchandise. Squared-off barrel chairs in pale blue and peach leather reappear throughout the three levels of product display to provide touches of customer comfort. In the women's clothing area, the faces of the recessed "cabinets" are painted a light neutral color and the dark wood paneling becomes a background for the garments hung in front of them. Creamy colored carpeting covers the floor.

Rena Dumas, the designer—who is also the wife of the president of Hermès, Jean-Louis Dumas—has been designing the Hermes interiors for more than 20 years and she says, "the concept is constantly changing."

Working within this unique building was a challenge. "So as not to spoil the magic lantern effect, we kept a space about one meter wide between all the internal elements and the facade." To be "in harmony" with the building's design, Mme. Dumas replaced the signature mosaic on the first floor with a light colored stone. "The mosaic crops up here and there in little touches around the building and this intimate touch comes as a pleasant surprise."

"Hermès will be a bit like a French Cultural center: a sensual, erotic, round and curvaceous building that lets the light slide around it."

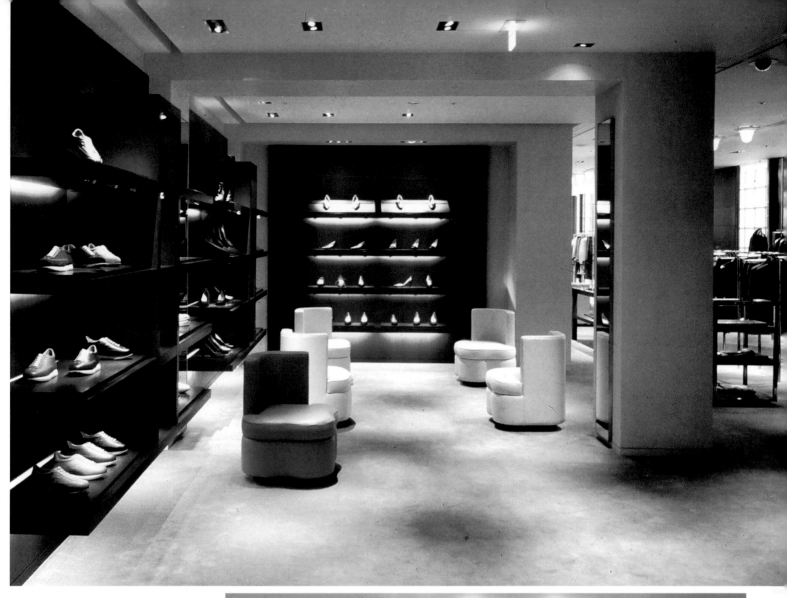

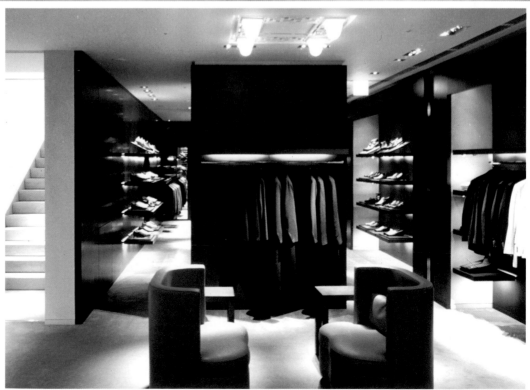

HERMÈS

LIAT Tower, Singapore

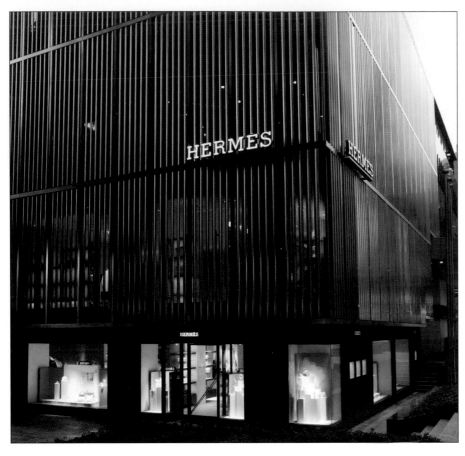

ORIGINAL DESIGN: **Rena Dumas Architect Interieure,** Paris
EXECUTION: **Atelier Pacific,** Hong Kong
PHOTOGRAPHY: **Courtesy Hermes South East Asia PTE.**

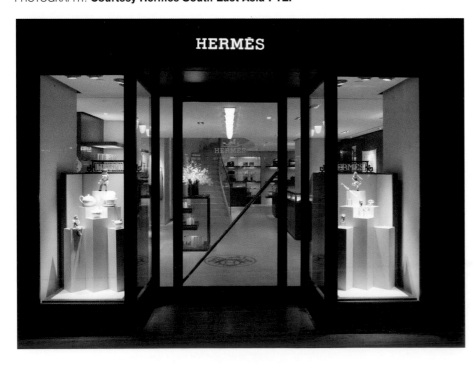

At 485 sq. meters, or approximately 5,000 sq. ft., this Hermès boutique, located in the LIAT Tower on Orchard Road in Singapore, is one of the largest in this region. The space includes two levels of retail as well as a VIP/exhibition area. The original design is by Rena Dumas of Paris, the original Hermes design firm. Atelier Pacific was called upon "to arrange for site surveys, collating background site information, sourcing and coordinating local consultants, and product managing the tender award and construction process through to a successful completion and store opening." Since so many fixtures and fittings were produced overseas "our coordination role was of the utmost importance to ensure the smooth realization of the store."

The exterior facade is "the most visible and unique aspect of the store." It consists of numerous strips of aerodynamic aluminum fins that can be adjusted, per floor, to suit the user's requirements." This multi-faceted façade conveys the idea of protecting the inner private space while—at the same time—providing an openness to the outside also allowing light to flood into the store as required. The shop's interior is warm, rich and quietly elegant. It follows other Rena Dumas designed shops in the use of fine cherry wood fixtures, fittings and cabinetry accented with nickeled brass hardware. These are set off by the light colored Armourcoat polished plaster walls.

A sweeping staircase leads shoppers from the ground level up to the first

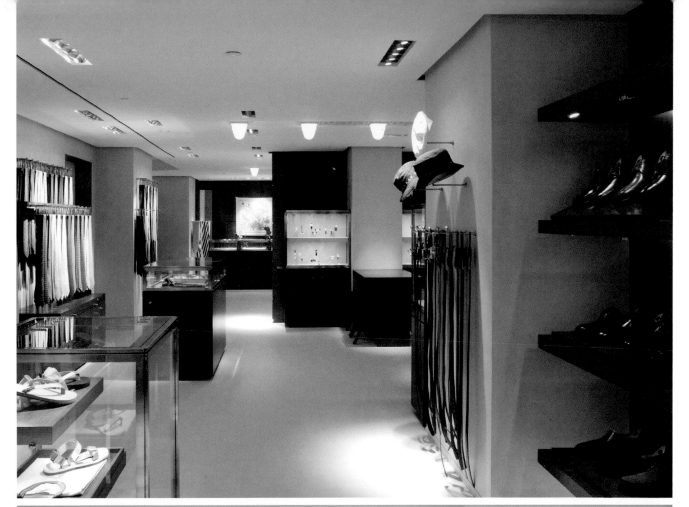

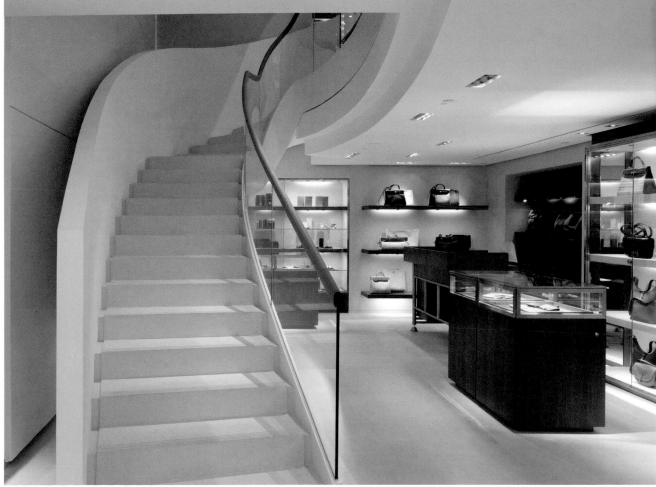

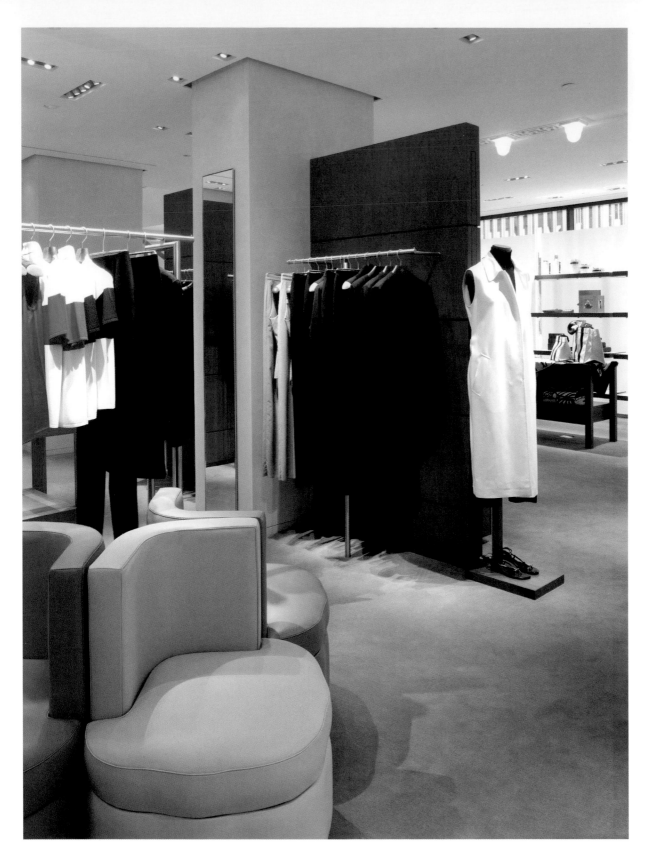

level where the ready-to-wear fashions are on view. Though the ceilings are low, the off-white floor, walls and ceiling enhance the feeling of spaciousness. Leather chairs and stools in deep, burnished red-brown are scattered throughout the men's area while white and red leather seating in the women's sector creates friendly groupings. Throughout, the colors and materials "enhance the luxury of the space within the shop and the merchandise on display."

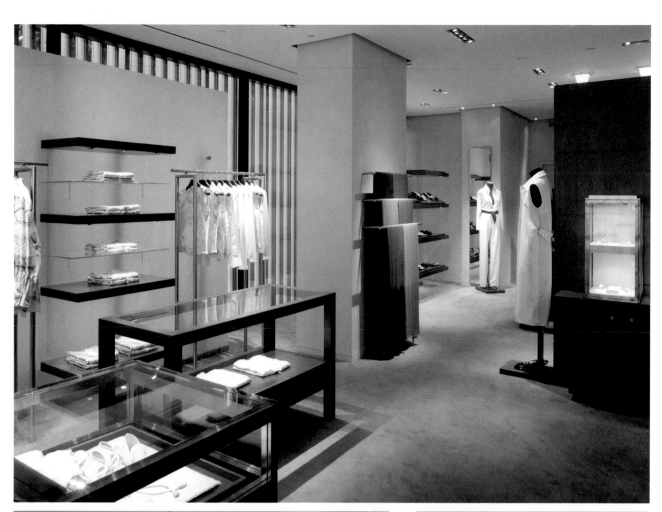

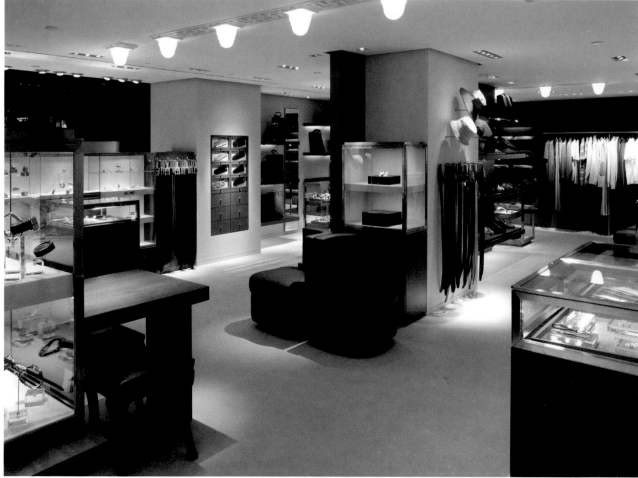

EMPORIO ARMANI

Madison, Ave., New York, NY

The Madison Avenue Emporio Armani store, in New York City, is the latest in the evolution of the EA brand store environment that began four years ago with Janson Goldstein's design of the Emporio Armani store in the Soho area of New York City. With that store the designers introduced "a clean, modern aesthetic, a new materials palette and—working with Johnson Schwinghammer—a

DESIGN: **Janson Goldstein,**
New York, NY
Hal Goldstein, Mark Janson
PHOTOGRAPHY: **Lydia Gould Bessler,** New York, NY

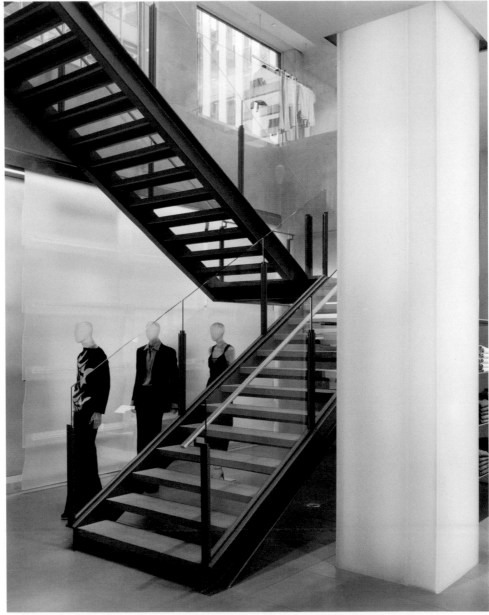

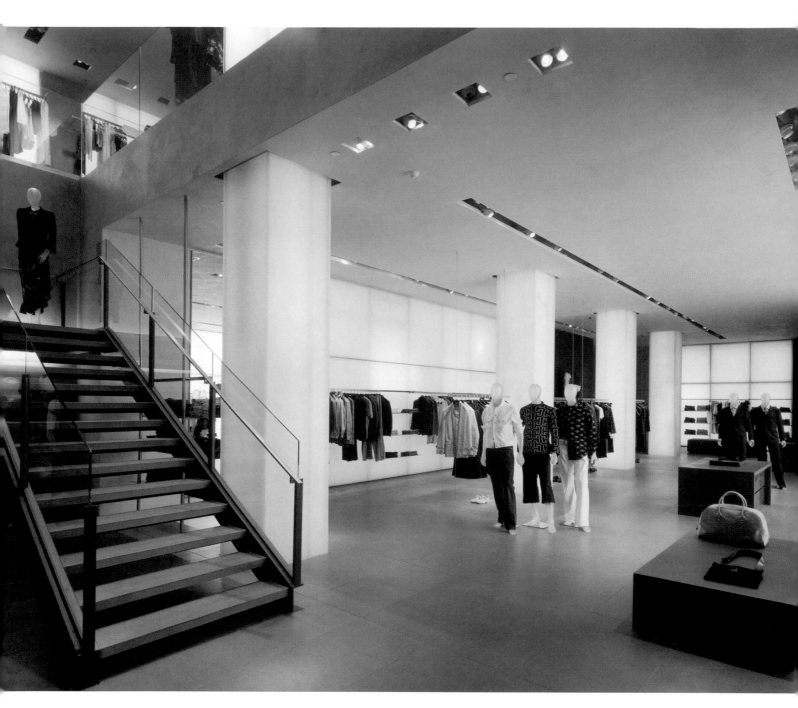

GROUND FLOOR

SECOND FLOOR

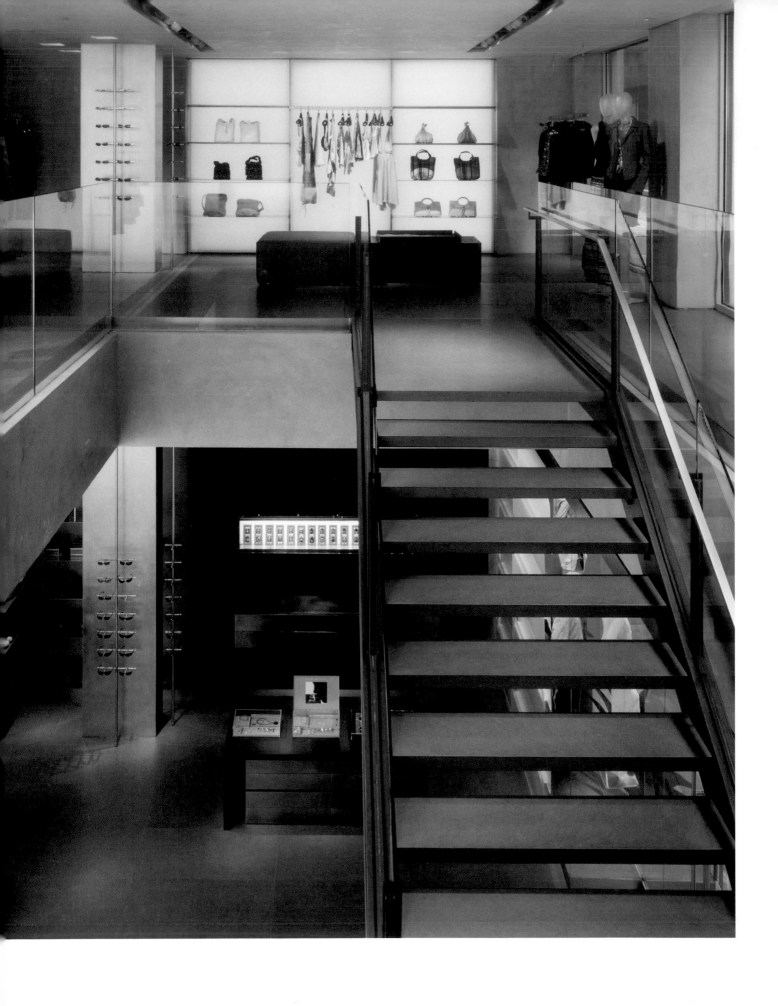

new approach to the EA store environment's lighting design."

The renovated Madison Avenue store has been condensed from six levels to two levels. Even though the square footage has been reduced, the store still contains the complete Emporio collection. "The new configuration is much more user-friendly, as the two-level space makes the collection easily accessible and understandable." A new staircase composed of structural steel C channels, Pietra Serena limestone and low-iron glass connects the two levels, and the staircase is visible through the butt-jointed, low-iron glass fenestration in the stainless steel and limestone façade. The stairway seems to "float" within the space.

The envelop of the selling area is created with dark, raw plaster on the walls and ceilings, and with charcoal-colored cement fiber tiles on the floors. Contrasting with these dark elements are the backlit acrylic panels supported by a stainless steel grid system that also acts as a wall fixturing support structure. The wall fixturing is "a fully flexible hang/fold system, while the freestanding hang bars that are not on the perimeter wall are supported by Arakawa cables. The fixtures throughout are "evolutions of the forms and palette" first introduced in the Soho store.

GIORGIO ARMANI BOUTIQUE

Three on the Bund, Shanghai, China

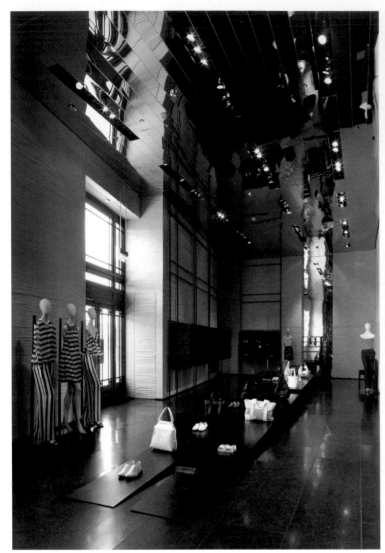
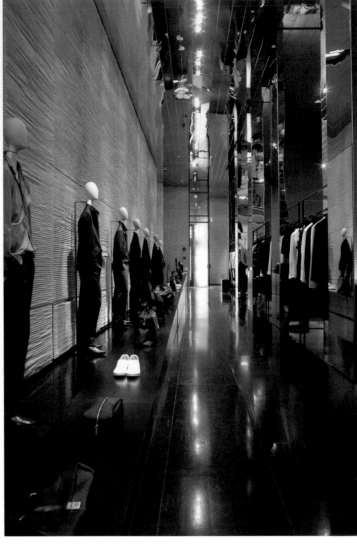

The Union Insurance Building, almost a century old, stands on Shanghai's river Huang Pu Bund. After being deserted for many years, it has been remodeled according to a master plan by Michael Graves, though the facade and key historical elements have been retained. Atelier Pacific, a Hong Kong-based architecture and store planning firm took on the design and coordination of all the retail floors in this structure—a space of almost 1500 sq. meters or about 16,000 sq. ft.

Located on the ground floor of this historic building are the Giorgio Armani Boutique and the Emporio Armani shop. Atelier Pacific facilitat-ed and oversaw the realization of the Armani boutique based on a design provided by Claudio Silvestrin of London. In the boutique the material palette includes stained wenge wood, folded fabrics and mirrored steel. Soaring panels of mirrored steel accentuate the high ceiling that is cov-ered by more panels of the reflective steel. The lights, set in the ceiling, play over and over again to add sparkling spots of light throughout the interior. The floor is covered with a deep, dark recycled wood while the counters, floor fixtures and the raised display runway that runs along one side of the space is finished in the

ORIGINAL DESIGN: **Claudio Silvestrin Architect,** London, UK
INTERIOR EXECUTION AND FOLLOW THROUGH: **Atelier Pacific,** Hong Kong
PHOTOGRAPHER: **Andrew J. Loiterton**

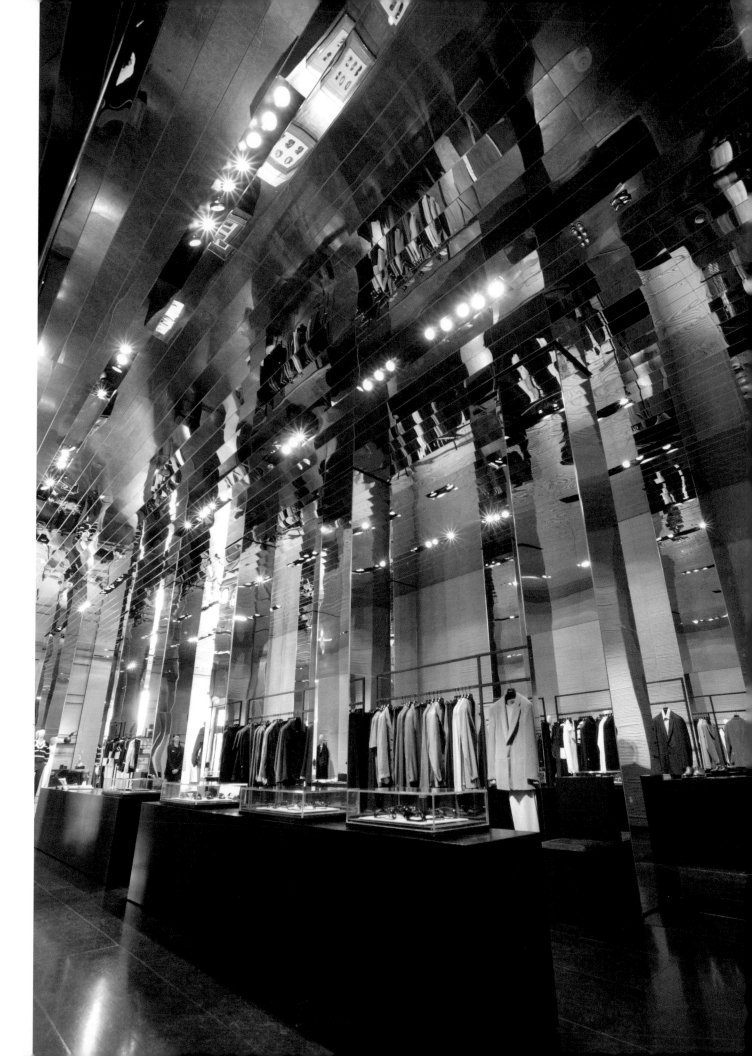

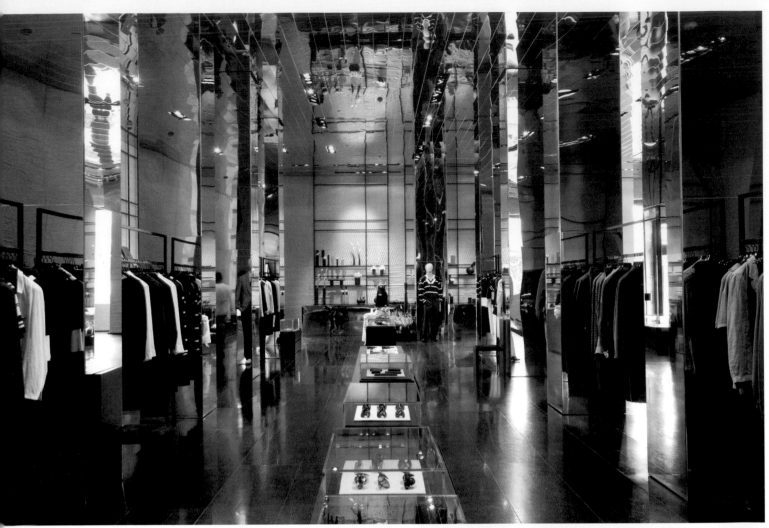

deep stained wenge wood. The tall
wall, behind the display of draped
hanger forms, has an unusual effect
produced by folded fabric that looks
like many vertical unfolded blinds.

The women's gallery appears more
open and lighter in feeling than the
dramatically illuminated men's area,
though the polished steel appears here
as well. Acrylic museum cases run the
length of the space and the rear wall
repeats the folded fabric treatment seen
in the men's gallery. A pair of runways
of the wenge wood create an effective
opening statement near the main
entrance and they carry the Armani
fashion accessories. Abstract hanger
head forms on dark bronze stands wear
some of the featured garments. The
columns that run the length of the shop
are also faced with the mirrored steel so
that they all but disappear into the mix
of what is real and what is a reflec-
tion—or a reflection of a reflection.

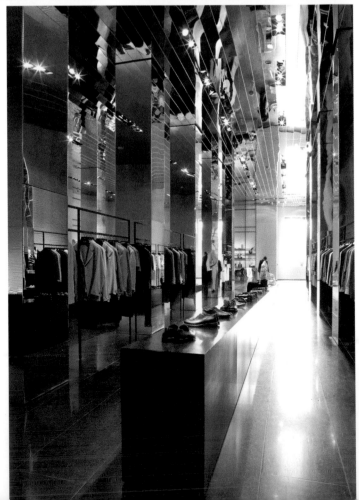

EMPORIO ARMANI

Three on the Bund, Shanghai, China

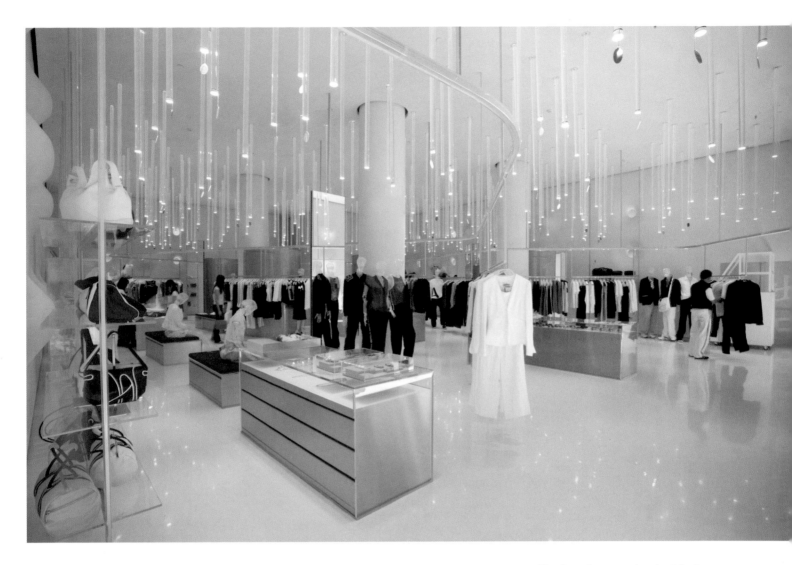

ORIGINAL DESIGN: **Massimiliano Fuksas,** Rome
INTERIOR EXECUTION AND FOLLOW THROUGH: **Atelier Pacific,** Hong Kong
PHOTOGRAPHER: **Andrew J. Loiterton**

Sharing the street level with the Armani Boutique in this rehabbed building is the Emporio Armani shop that is based on interior designs provided by Massimiliano Fuksas of Rome. "The men and ladies gallery spaces seek to complement and contrast with these stores by offering open plan environments sympathetic to the historical building fabric, yet flexible enough to allow changing mini-boutiques that emulate some of the life of the street outside."

This shop, in sharp contrast to the Armani boutique, is white, light and startlingly bright. The design created by Fuksas called for the use of undu-

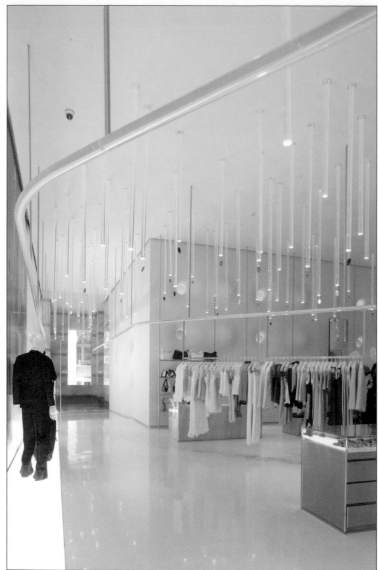
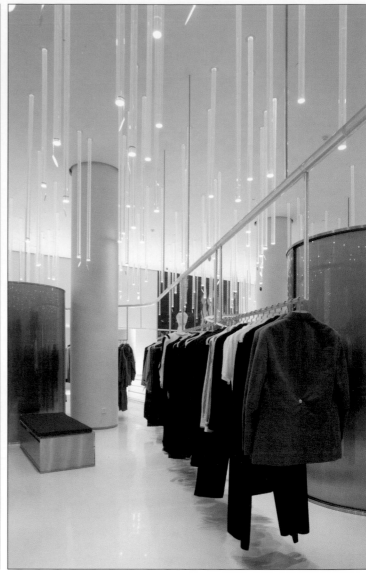

lating GRP, acrylic light tubes and an epoxy floor. A shower of acrylic tubes are suspended from the ceiling and bring the light sources closer to the garments hung on curving fixtures that are also suspended from above. The shiny, white floor is complemented by the white walls and ceiling and here the "reflection" is from the polished mirrored steel used to cover the counters and cases set out on the floor. Circular drums of the same reflective surface serve as the on-the-floor changing rooms and those rounded shapes echo the massive circular columns that rise up to meet and pierce the ceiling. Stainless steel covered cubes, topped with bright red pillows, become the seating while the red accent reappears to highlight panels and curtains in the shop.

A free-form hanging rod fixture snakes its way through the space breaking up the space into separate areas. Here too, a fashion "runway" extends along one long side of the shop and abstract, translucent plastic mannequins—both male and female—parade in the contemporary fashions. "The custom-designed display furniture provides an eclectic backdrop" for the product presentation in Emporio Armani.

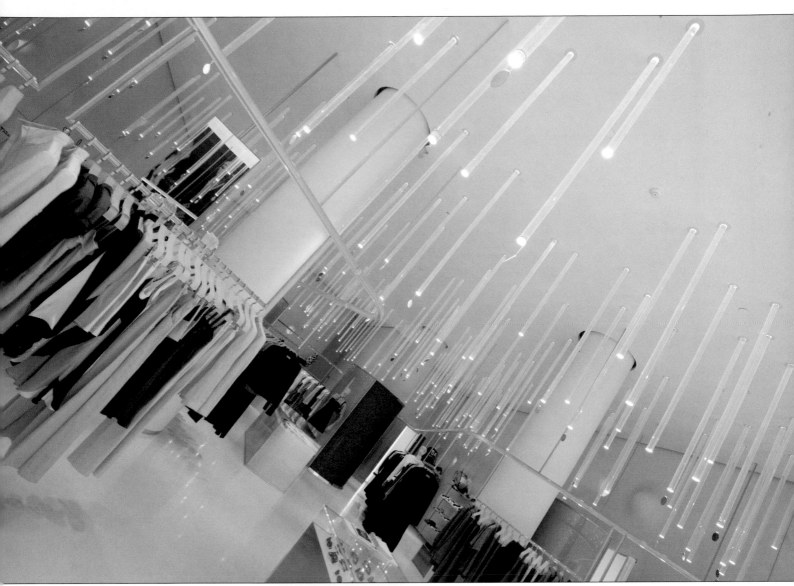

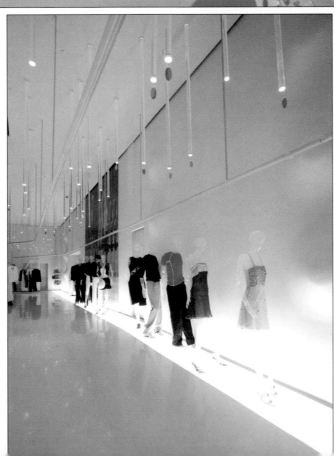

EMPORIO ARMANI

Edinburgh, Scotland

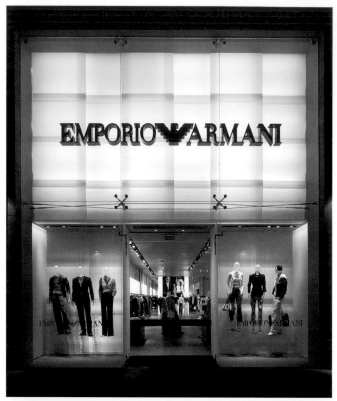

CONCEPT DESIGN: **IVANA INVERNIZZI** of Italy
DESIGN IMPLEMENTATION: **FOUR IV,** London, UK
PHOTOGRAPHY: **Keith Hunter,** Renfrew, Scotland

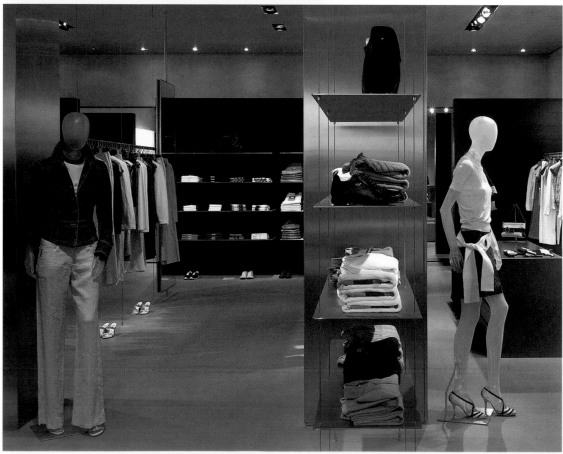

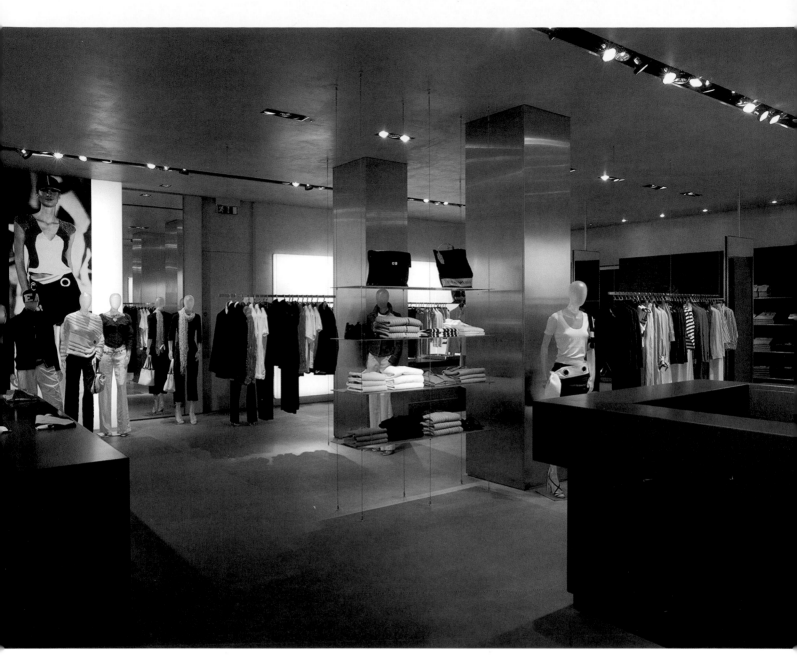

The spectacular new Emporio Armani is located in the heart of Edinburgh's new retail development—Multrees Walk—and the concept idea was originated by Ivana Invernizzi and implemented by FOUR IV, the London-based design consultancy. "FOUR IV's role has been to interpret the design concept created in Italy and deliver it in the Scottish store using the highest spec materials and craftsmanship."

The new concept accentuates the double height façade by using a horizontal wire truss to support the six large sheets of laminated glass thus creating a striking vista on the street. The dramatic black extruded signage is bonded invisibly to the glass and appears to just float on the ceiling. Curved acrylic panels can be seen behind the glass and they are central to the overall interior scheme. On the street level of the two level store, all the elements of the Emporio range are displayed in an L-shaped space. Up front are the fashion accessories (jewelry, watches, sunglasses, shoes) and the shopper is drawn to the rear of the space by a brilliantly illuminated image on the rear wall. The image is from the current brand advertising and the scale serves to emphasize the height of the ceiling.

Menswear and womenswear collections are presented against large

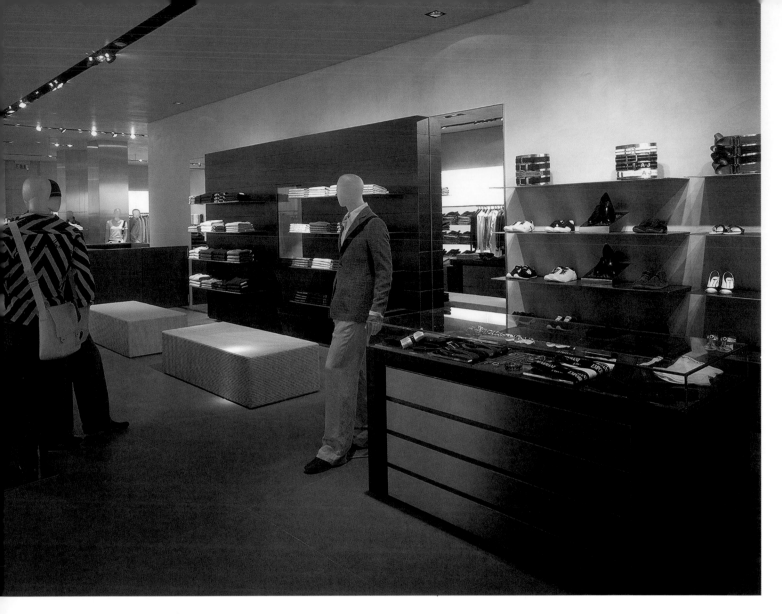

illuminated acrylic panels set into a dark gray, marmorino plaster wall "creating mood and drama." The central merchandising system is suspended from tensile rails that are hung floor to ceiling. Full height pivoting mirrors, made of wenge wood, add texture and color to the accessories wall.

The upper level is given over to the "back of the house" facilities and the ceilings here are made from two black slots that follow the L-shaped plan. They serve also to house all the services and lights. Chris Dewar Dixon, Managing Director of FOUR IV, said, "Armani is all about quality and style. It has been our challenge to interpret Italy's new design vision and deliver it with finesse to the UK market."

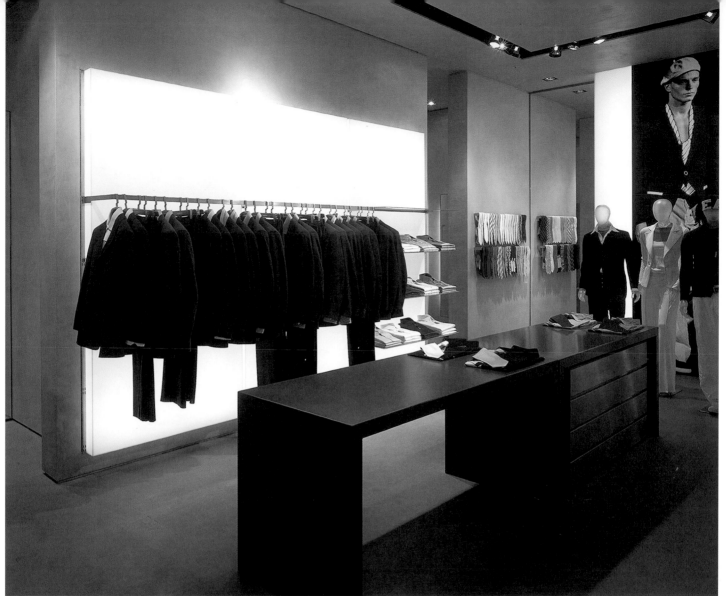

A/X

The Shops at Columbus Circle, Time Warner Center, New York, NY

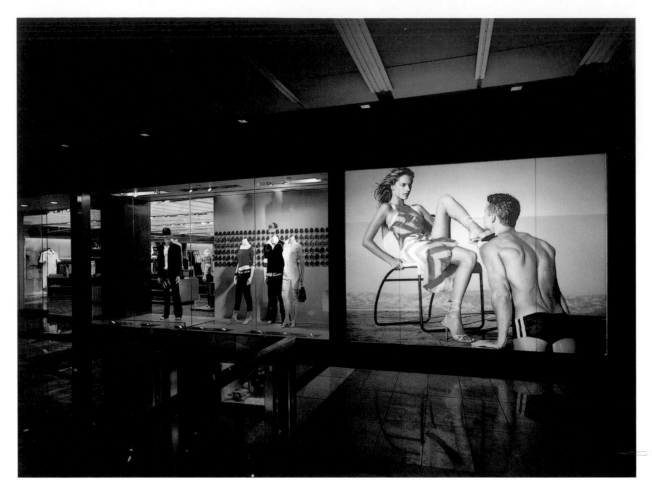

DESIGN: **In-house, Armani Exchange**
VISUAL MERCHANDISING: **Michael Fazakerly**
PHOTOGRAPHER: **James Lattanzio**

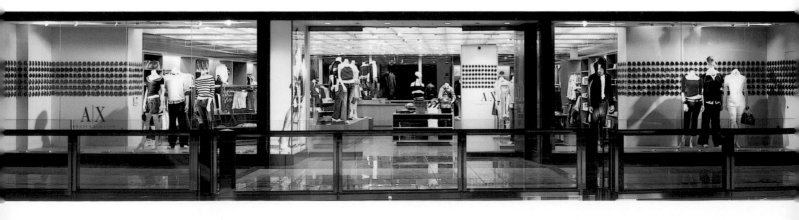

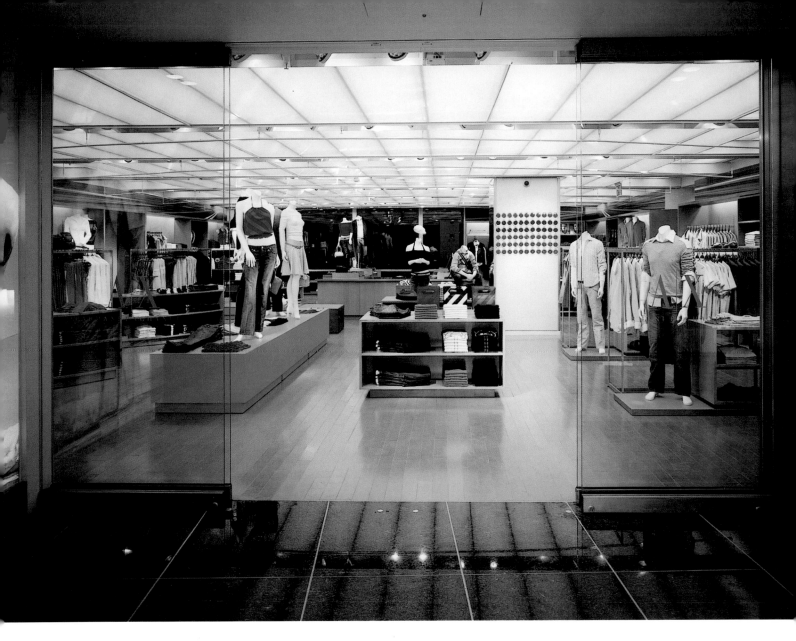

One of the new must-see attractions in New York City is the newly-opened Shops at Columbus Circle and when there one shouldn't miss the 4,500 sq. ft. A/X (Armani Exchange) store on the third level. Armani Exchange "continues to reach new heights by taking their downtown style uptown" with this launching of their sixth store in the NY Metro area.

The rear wall of the space is windowed and offers breathtaking views of the city—"creating an ambiance with the unmistakable elegance that is Armani." The store has an easy-to-navigate plan, warm lights plus natural light during the daylight hours, and a "sleek mix of materials with interesting textures that serve as a clean canvas that mix with clear hues consistent in the edgy but urbane A/X collection."

The slick black façade frames giant display windows and offers a partial view of the store beyond. A truly gigantic illuminated photomural—right of the entrance—stops the traffic coming up the escalator and leads the shoppers to the well lit and attractively-themed windows. The interior is mainly neutral in color: pale grayed wood floors, soft gray walls and floor fixtures, and a dropped ceiling all aglow with light behind the frosted translucent plastic panels that cover the ceiling. Gently arced "bridges" of lights, attached to the ceiling, traverse the width of the space adding a gentle vaulted effect. Facing the store's entrance is a raised "runway" in taxicab yellow upon which headless white mannequins parade some of the store's newest looks. Some coordinates and accessories are set out on the raised floor of the runway. Other headless forms stand on lower platforms, also highlighted in yellow, that show off the garments available on the floor fixtures to which they are adjacent. Some of the wall units, on the left, are angled towards the windows thus creating individualized areas of interest where particular looks or colors are featured. Gently-bowed floor fixtures, in front of these angled wall units add another softening element to this otherwise angular and crisp design as they also

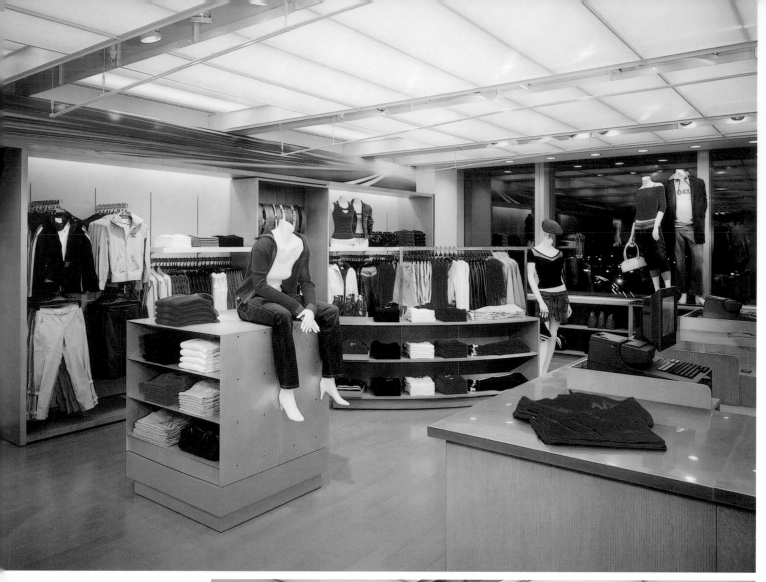

fan out an array of merchandise for easy viewing and combining. Even the open square cash desk near the windows serves as a platform for more standing and seated forms.

Below the bridge-like span of silvery lighting on the illuminated ceiling—an A/X signature look—and running along the fascia over the wall cabinets is a multi-colored graphic of streaking colors suggesting cars moving at high speeds along a highway. The use of colored reflector disks as a decorative trim on the white column and in the display windows carries through the sense of traffic and movement that is the essence of getting around NYC.

"A/X Armani Exchange is the incubator for Giorgio Armani's new ideas and the street barometer of his fashion directions. A/X directs Mr. Armani's pure sense of discovery to an innovative collection for the young, sexy, urban chic." According to Lee Byrd, Armani Exchange Executive VP of Operations, "The Time Warner center is the perfect place for A/X because of its unique mix of technology enhanced amenities and lifestyle experiences offered to the shopper."

BURBERRY

Milan, Italy

The very British—once the most typically British—retailer, Burberry, has been changing its image. Virgile & Stone was commissioned by Rose Marie Bravo, in 2002, to create a new store for the luxury fashions and accessories brand in Italy. The new store, located in a 16th century palazzo in Milan's fashionable "Quadrilateral district"—recently completed—is decidedly contemporary but like the design philosophy of Christopher Bailey (Creative Director at Burberry) it is drawn from the heritage of the established brand. As Frances Williams, the Project Director at Virgile & Stone, explains, "We wanted to create a unique destination which encapsulates the new and progressive spirit of Burberry today. We had, therefore, to be rigorous in making extensive use of authentic English handcrafted materials, whilst presenting them in a totally fresh and innovative way."

Contrasts appear throughout the three floors: the contrast between the rough look of the natural materials used for the facings (English oak and Welsh slate), and the shiny, slick contemporary finish of the display fixtures (nickel and lacquer). "The floors are enlivened and differentiated by particular furnishing solutions that evoke and re-interpret the English domestic atmosphere." Two excellent examples are the fireplace in the lounge area on the first level and on the second level is a dropped 65 ft. long ceiling upon which is back-projected the sounds and sights of British weather with rain predominating. It makes a dramatic arcade to walk through as the "typical British weather" reigns above while the shopper remains safe and dry beneath the "sky." "In London and Milan we have fierce winds, drizzle, and clouds," says Frances Williams. That explains why Burberry umbrellas are prominently featured in this area.

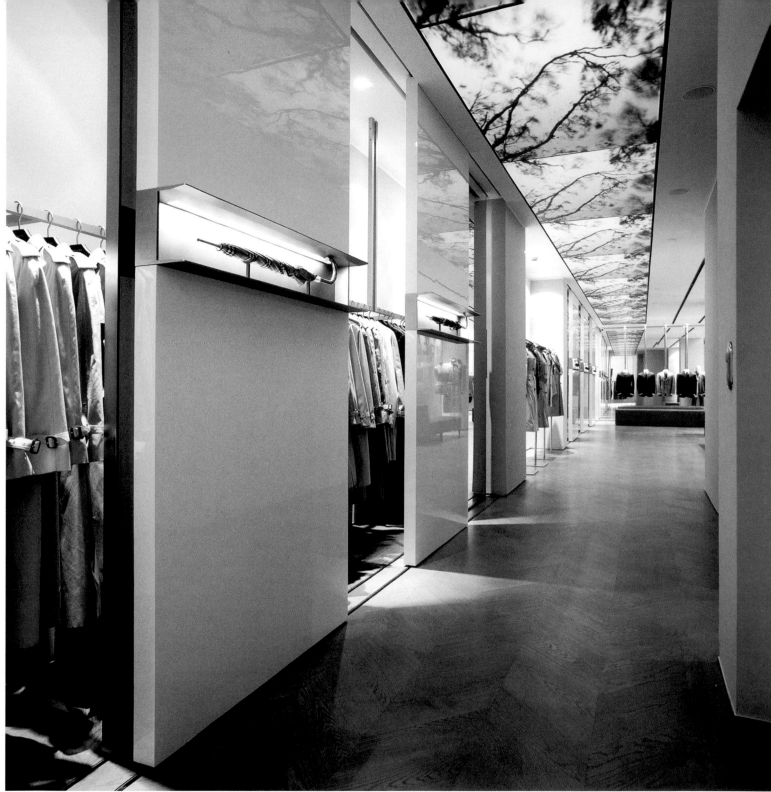

DESIGN: **Virgile & Stone,** London, UK
Nigel Stone, Carlos Virgile
PROJECT DIRECTOR: **Frances Williams**
PHOTOGRAPHY: **Matteo Piazza**

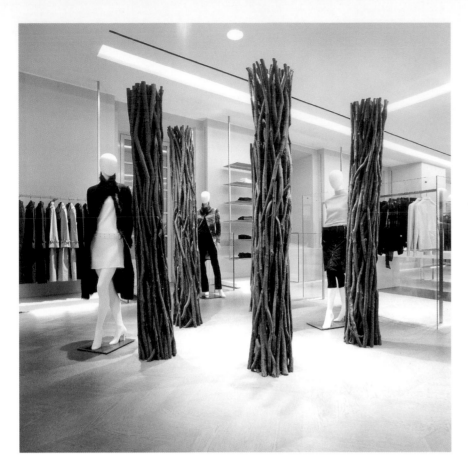

The Britishness of Burberry, according to Ms. Williams, is to take what is associated with upper class residences and reinterpret it in a retail setting: leather covered furniture, oak paneling, parquet flooring—and then combine it with contemporary elements such as nickel, glass and lacquered surfaces. Then, there are the unexpected touches like the niche stacked with firewood near the fireplace and the woven willow sculptures (by Jakku Pernu) that make a bold statement amid the glass and mirror in the Women's Collection area. Throughout there are paintings on natural themes and stylized displays or furnishings that use colorful translucent materials. "Reminders of nature, colors and atmospheres of English landscapes are underlined by an eclectic selection of artworks by emerging talents who live and work in Great Britain."

An amusing take on the Burberry brand appears in the central courtyard of the Palazzo where an "English Garden" is re-interpreted with grass and pebbles "to create the deconstructed form of the Burberry plaid. The overall spirit is one of a skillful combination of contemporary style with traditional elements." The showrooms and offices that are also housed here retain many of the original features such as arches and frescoes. These contrast, again, with new materials such as black slate flooring, brown glass and lacquer—with integrated, state-of-the-art lighting systems

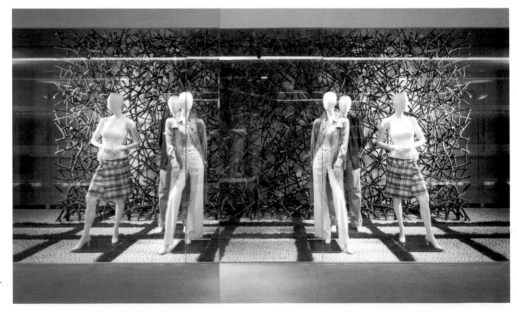

BURBERRY

Via Condotti, Rome, Italy

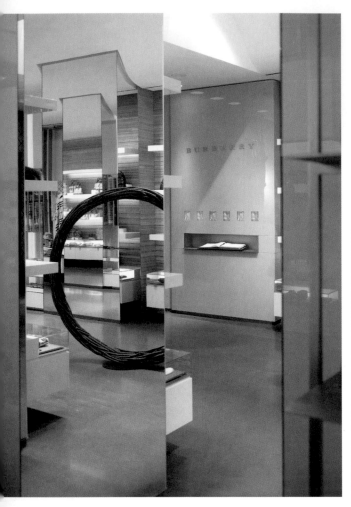

Design: **Virgile & Stone,** London, UK

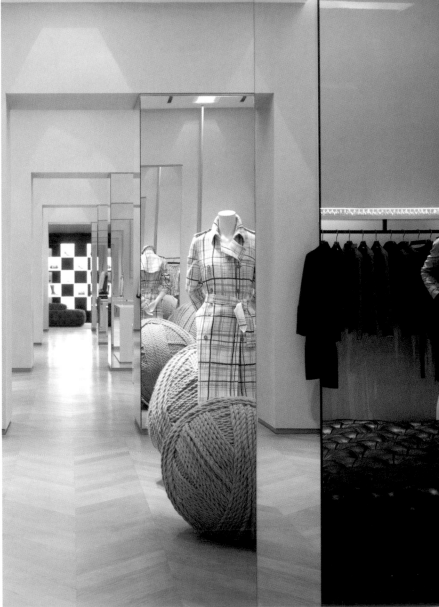

The truly London look of Burberry and the talents of the London-based design firm of Virgile & Stone turned a 16th century palazzo on the famed Via Condotti, in Rome, into Burberry's newest flagship store. The 700 sq. meters (almost 7500 sq. ft.) of retail space takes up two levels of this venerable structure.

As conceived by Virgile & Stone, the ground floor is designed to create a series of intimate spaces—"relying on reflective surfaces such as painted glass, lacquer and mirrors to open it up." The striking curved vault, in the middle of the ceiling, creates a natural "pull through" to the back of the space. Reminiscent of British country hedgrow is the custom sculpture of woven wil-

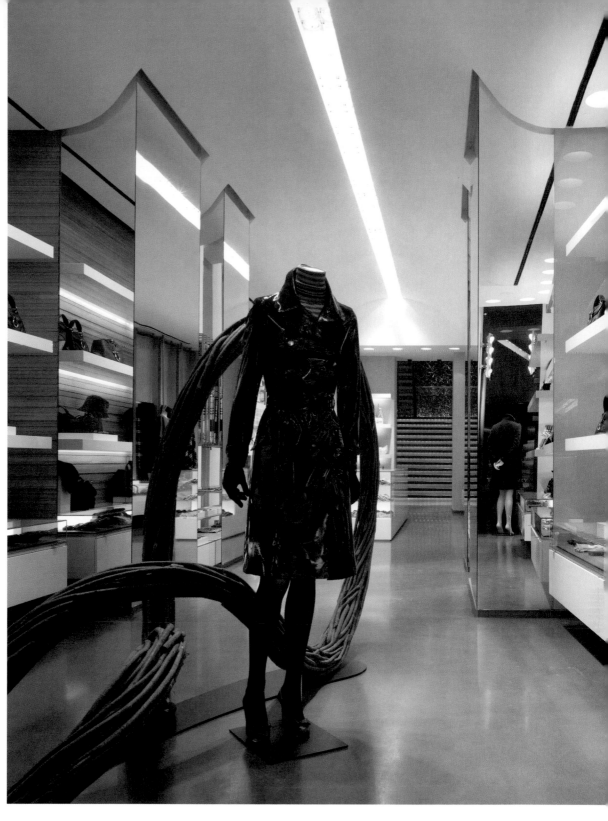

low canes by the London artist, Jaakku Pernu. This piece appears in a stair void. The "Rain Room" ceiling projections of the look and sound of a springtime shower, as conceived on film by the design team, dominates the 65 ft. long bridge that extends over the stair void up on the first level. This is where the iconic Burberry trench coats and umbrellas are on display. "The

audio visual tool is being used here to instill the Britishness and individuality of the brand."

The overscaled "buttoned" ottomans in polished brown leather are a contemporary take on the traditional British Chesterfield sofas and chairs. The deep brown wall paneling has been cast in scagliol (an imitation of marble made of gypsum or plaster of

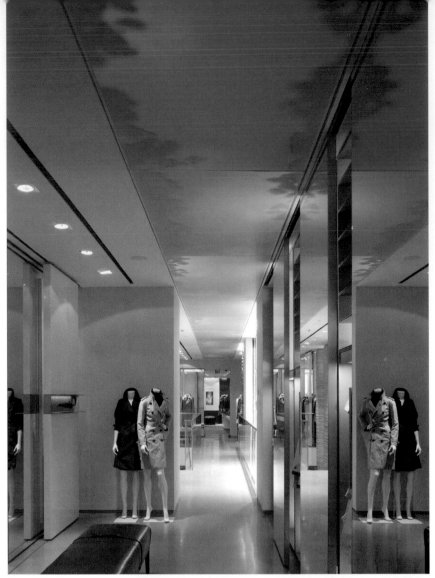

Paris, chips of marble and coloring matter) and patterned to resemble "an abstracted plaid design." Large slabs of the same material were also produced for future merchandise displays.

The original grand proportions of the first level have been restored and natural light floods this space. The herringbone patterned oak floor and gabardine paneled walls are offset by vast white lacquer hangings for lighting and merchandise. Further slabs are suspended through the store to serve as screens for showing runway collections. During the refurbishment "dazzling frescos" were uncovered. They have been restored and the colors of the suede ottomans, wall surfaces and floors reflect the subtle palette of the painted ceilings.

"The combination of this Italian palazzo's restored assets such as natural light, vast ceilings, frescos and open spaces have provided Virgile & Stone with a very exciting design challenge in which to house the very British Burberry in the heart of Italy."

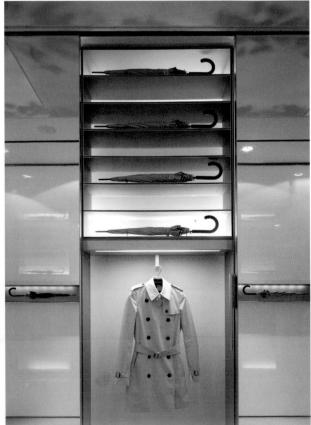

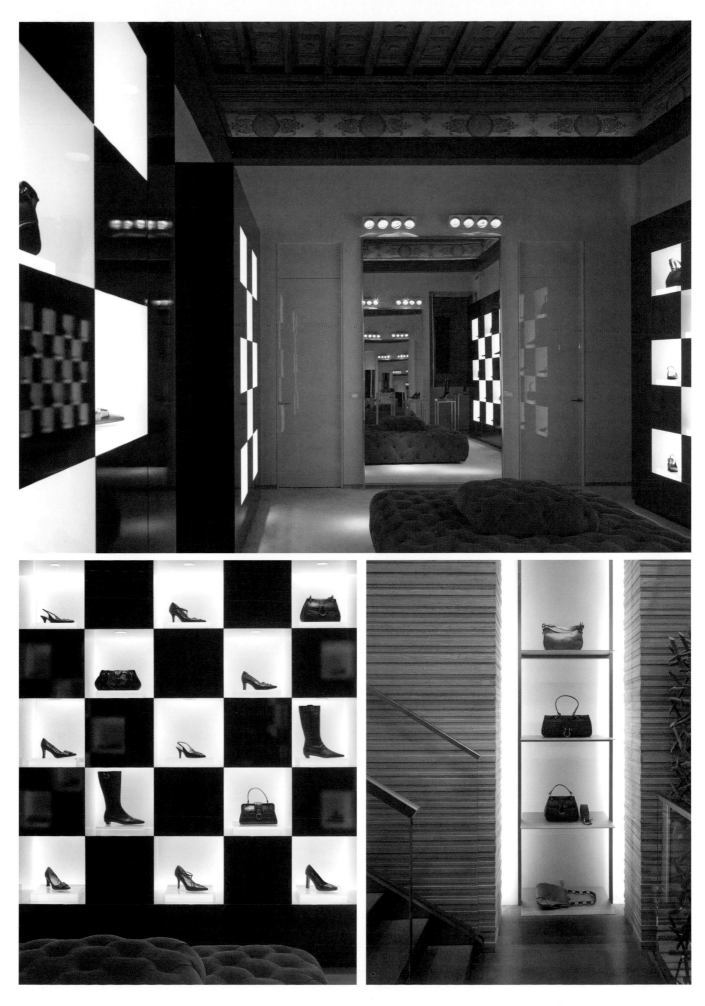

COACH

Ginza, Tokyo, Japan

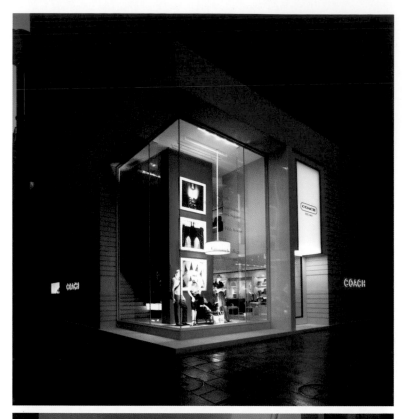

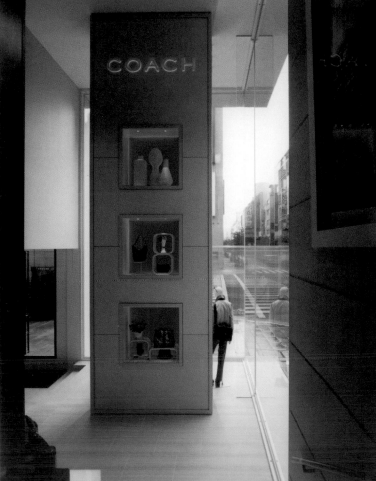

This two-story, 5800 sq. ft. shop—on a prominent corner in the Ginza, Tokyo's premier shopping district—was Coach's first flagship store in Tokyo. The challenge for the designers, Michael Neumann Architects of New York, was "to architecturally reinforce this classic American brand within a more inviting environment for a modern, style-savvy audience, introducing innovation in materials, details and presentation without becoming tricky or overwrought. The design, the palette and the spirit "evoke New York's post-war modernism and Coach's roots."

A dramatic overhanging soffit sets off a 16 ft. high display window of ultra clear museum-type glass—the largest panels ever installed in Tokyo. Creating the impression that customers occupy the front window are the monumental display wall and the travertine staircase that dominate this display space. "The pedestrians in the street, the mannequins in the front window, and the customers in the store all interact within the same visual space." The flooring is unfilled Persian white travertine laid in an ashlar pattern. It steps up to form the window display platform and then rises in large slabs to become the steps of the colossal stairway to the second level of the shop. On one side of the staircase is a wall of walnut paneling while a 19 ft. wall of horizontally-coursed limestone is on the other side. Stainless steel escutcheons embossed with a contrasting Coach signature "C" support the solid walnut handrails.

The walnut stairwall, on ground level, becomes an elongated display wall with multiple glowing white display boxes offset by the dark wood. "Simple display boxes with glowing white interiors provide striking con-

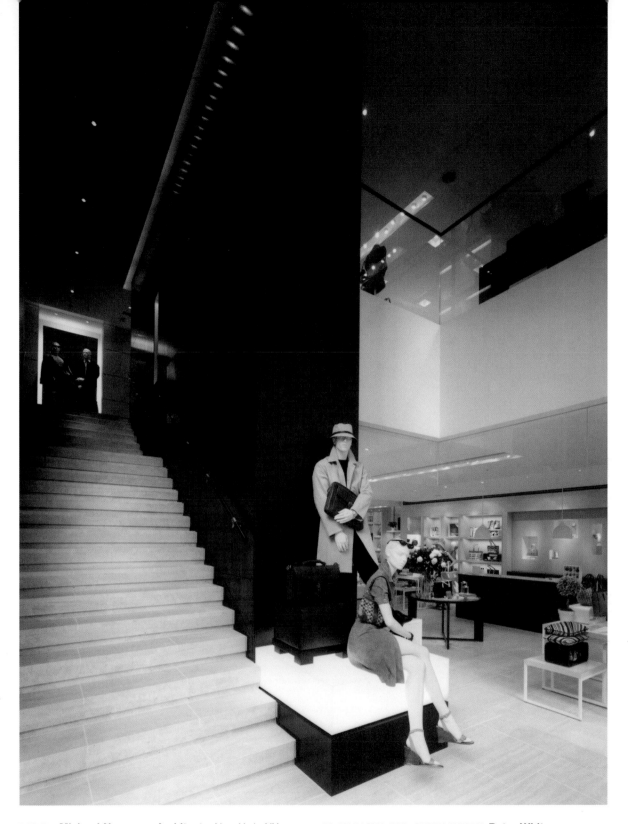

DESIGN: **Michael Neumann Architects,** New York, NY
PRINCIPAL: **Michael Neumann**
PROJECT MANAGER: **Jairo Camelo**
SENIOR DESIGNER: **Talin Rudy**
DESIGN TEAM: **Alexander Olsen, Tracy Look Hong,
Jason DePierre**

For Coach:
PRESIDENT/EXEC. CREATIVE DIRECTOR: **Reed Krakoff**
SR. VP, GLOBAL VM & STORE DESIGN: **Patrick Wade**
DIV. VP, STORE DESIGN WORLDWIDE: **Michael Fernbacker**
DIV. VP, VM CREATIVE WORLDWIDE: **Karin Cole**

SR. MANAGER, INTL. STORE DESIGN: **Peter White**
DIR. OF V.M, INTL. AND WHOLESALE: **Joy Bruder**
DIR. OF DESIGN SERVICES: **Julie McGinnis**
DIR. OF VM, JAPAN: **John Gunter**
DIR. STORE OPERATIONS, JAPAN: **Chris Amplo**
MANAGER VM INTL.: **Kyoko Hasagawa**
SR. MANAGER RETAIL & VISUAL DESIGN: **Greg Caputo**

PHOTOGRAPHY: **Nacasa & Partners, Inc.** Tokyo

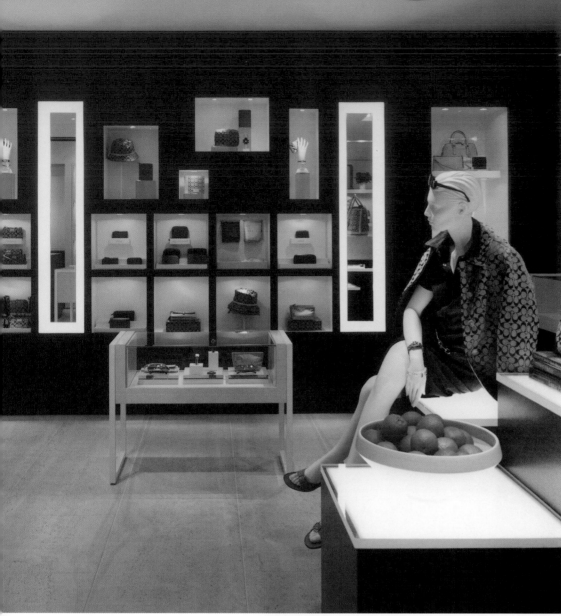

trast to the rich color and texture of the product." Adding "warmth" that is" both fresh and familiar" are American woods; dark walnut and white milk painted maple. The rear feature wall shows the exterior limestone wrapping inside the store—punctuated by square display vitrines (display cases).

Display tables are white washed maple, white powder coated tubular metal and have museum glass tops. The feature tables are custom made and feature hand-cast green glass tops imported from Brazil.

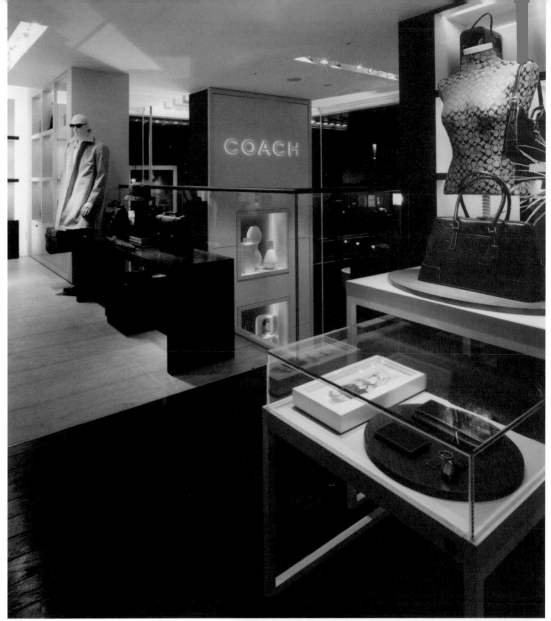

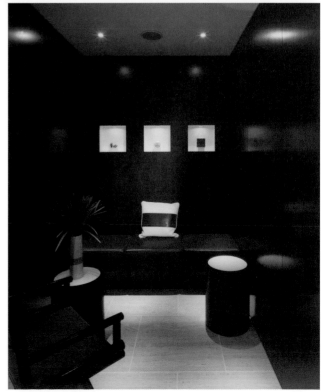

COACH

Shibuya, Tokyo, Japan

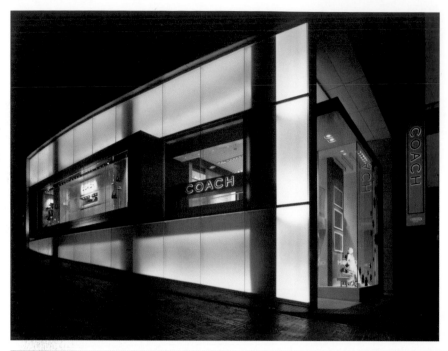

The Shibuya district in Tokyo is "Japan's busiest shopping area for its trend setting young clientele." Thus, Coach established its second flagship store in a central spot in this highly competitive area and again called upon the design talents of Michael Neumann Architects of New York for the design of the 7,300 sq. ft. space. The design, according to the architects/designers had to address several of the client's key issues. For one thing, it had to respond to "its lively retail context" with a fresh and innovative take on the company's prototypical American image. The design also had to attract the fast-moving, passers-by into the store and induce them to venture up to the second level and thirdly, the

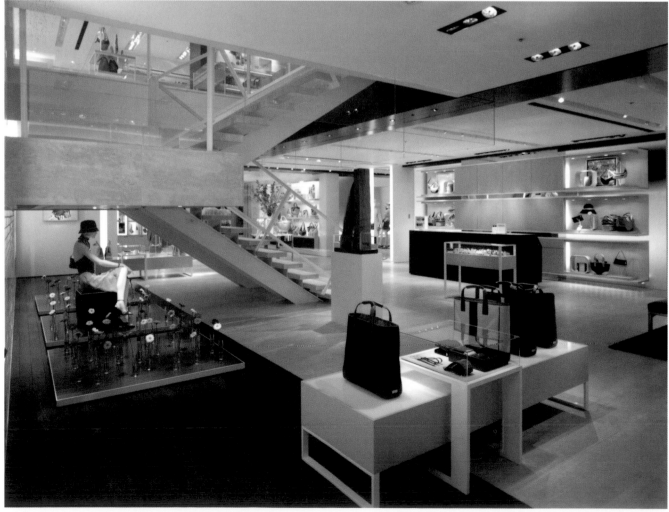

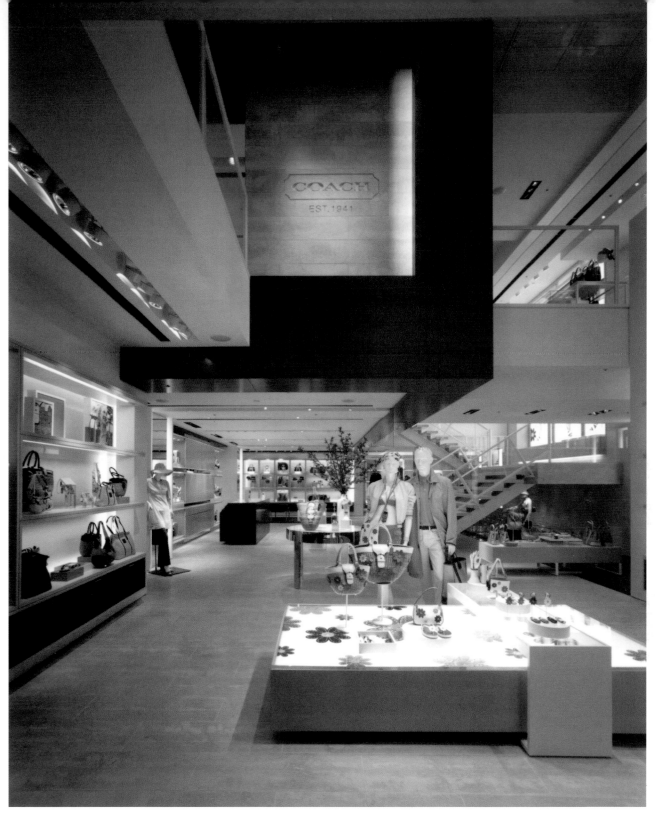

designers had to further develop prototype furnishings that would reflect the upbeat tastes of the young customers being targeted.

Part of the "fresh response" was to turn the façade into "a lit, three dimensional billboard." The existing façade was stripped down and reclad with backlit, etched glass. "It is punctuated by volumes which push out to the pedestrians and then open in to reveal the interior." One such "push out" is a large rectangle covered in American walnut that extends out over the sidewalk and so too, does part of the second floor. "A window in this volume reveals to the pedestrians a glimpse of the space and product on the second floor. On the front façade, a double height display/entry window volume opens a view into the multi-level interior."

The previously mentioned walnut "volume" is suspended in the double height space and a sweeping open stair of floating limestone treads leads into the interior. "The strong presence of the walnut 'display box' compels the customer up the stairs to explore what is within. Inside the

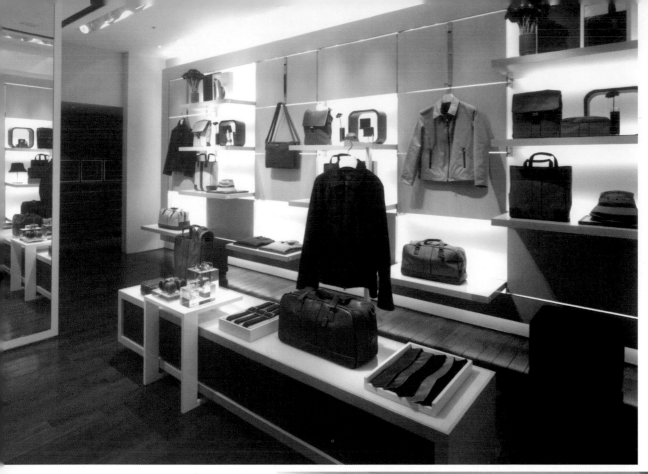

box, travertine flooring wraps up the walls to provide a rich display surface for cantilevered shelves and 'floating' wall cabinets in white washed maple." A flexible wall system of individual hinged panels, that may flip down to become shelves or remain up and serve as a background for hanging displays, was especially designed for and is used in the Men's and Women's outerwear areas. Variations in finish distinguish the different zones.

Floor fixtures "are fewer but larger" with a "single grand gesture in each area." "Free standing furnishings are forms that are aggressive in structure; cantilevers and bent metal shapes pervade the floor." The glowing white display platforms seem to float and larger display surfaces consolidate display for maximum visual impact, with cantilevered and nested trays highlighting featured merchandise. Polished stainless steel adds sparkle to the white powder coated and white milk paint maple finishes. The display cases are open sided "minimal and unencumbered—with gracious access to the product."

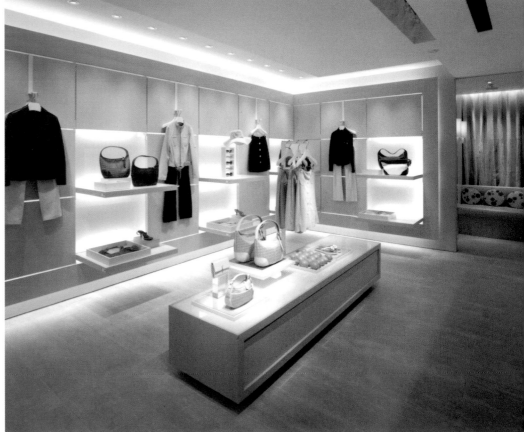

DESIGN: **Michael Neumann Architects,** New York, NY
PRINCIPAL: **Michael Neumann, AIA**
PROJECT MANAGER: **Jairo Camelo**
SENIOR DESIGNERS: **Jeff & Talin Rudy**
DESIGN TEAM: **Mika Raja, Jason DePierre,
Tracy Look Hong**

For Coach:
PRESIDENT/EXEC. CREATIVE DIRECTOR: **Reed Krakoff**
DIV. VP STORE DESIGN WORLDWIDE:
Michael Fernbacher
DIV. VP, VM CREATIVE WORLDWIDE: **Karin Cole**
SR. MANAGER, INTL. STORE DESIGN: **Peter White**
DIR. VM, INTL. & WHOLESALE: **Joy Bruder**
DIR. DESIGN SERVICES: **Julie McGinnis**
DIR VM, JAPAN: **John Gunter**
DIR. STORE OPERATIONS, JAPAN: **Chris Amplo**
MANAGER VM INTL.: **Kyoko Hasagawa**
PROJECT MANAGER JAPAN INC.: **Tsugio Kurosawa**
PHOTOGRAPHY: **Nacasa & Partners Inc.,** Tokyo

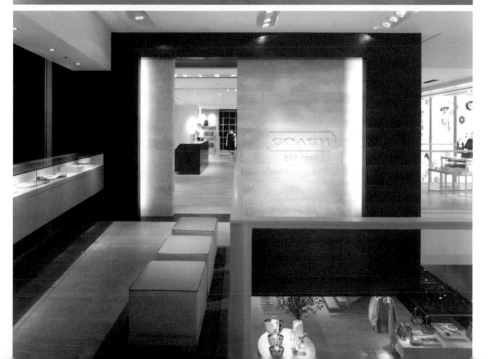

MARNI

Sloan St., London, UK

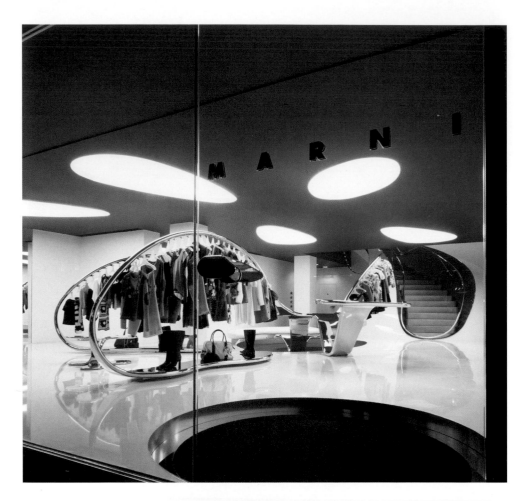

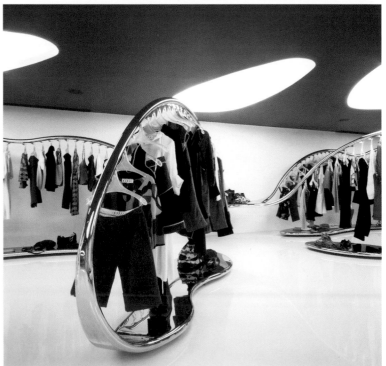

Sybarite UK Ltd. was formed by Torquil McIntosh and Simon Mitchell in 2002. "Sybarite is an architectural and design practice whose aim it is to tease all the human senses and to sculpt architecture into the living environment in which it exists, whilst retaining complete functionality. The practice draws its passion and inspiration from organic forms of nature as well as technologies transferred from other industries." The name—Sybarite—encapsulates the firm's design theory: voluptuous, luxurious and pleasurable.

The firm places great emphasis on a close working relationship between the architect/designer and the client and that relationship is evident in the three Marni stores we are presenting in this issue. Torquil McIntosh, one of the founders of the design house said, "We have made this shop (Milan) much more feminine in design to previous shops. This is obvious when compared to the Marni on Sloan St. in London (shown here) which is more bombastic. The idea is for each flagship store to have its own unique and individual flavor depending upon the city." Thus, the London shop is swathed in passionate red while the Marni in Milan is all elegance and sophistication and the one in Tokyo (not shown) has been inspired by Zen gardens. The motif that is carried through from one Marni shop to the next is the use of curves, arcs, ellipses and petal shapes, and these have become the signature notes of the brand's retail settings. In the London store the main design aim was to "form a visible identity" between the ground and first levels of the shop. The designers achieved their goal by stretching the white resin floor to form a "very unique staircase that is 'cut out' from this stretched floor allowing the two floors to be molded together as one continuous floor plate." There is also something very dramatic—and

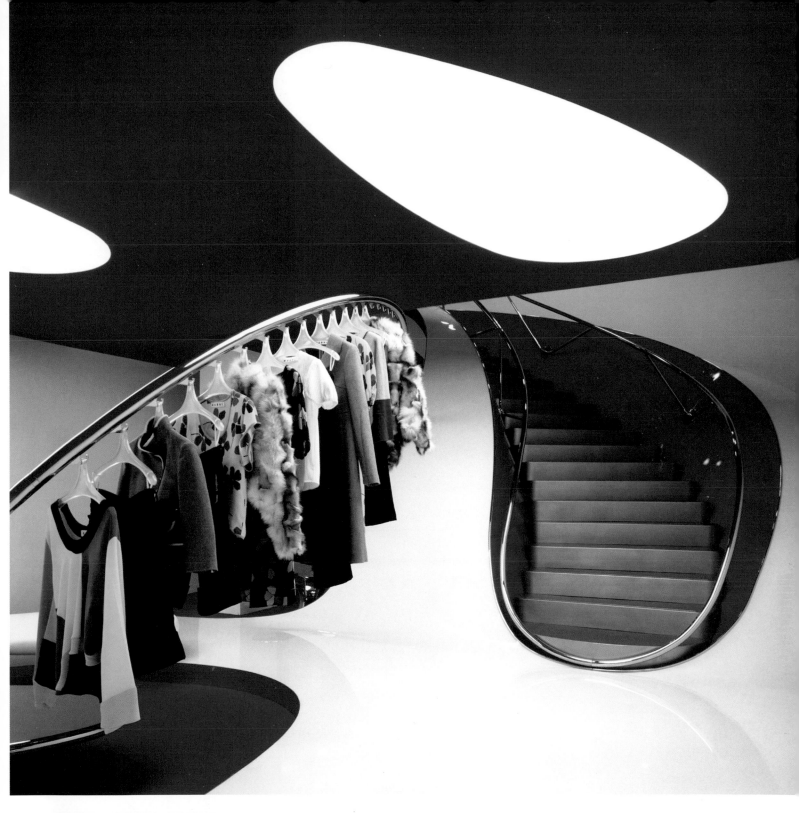

DESIGN: **Sybarite UK Ltd.,** London, UK
Torquil McIntosh & Simon Mitchell
PHOTOGRAPHY: **Richard Davies**

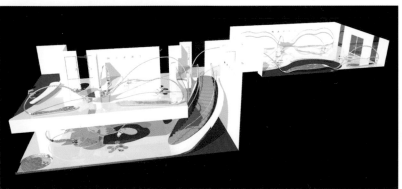

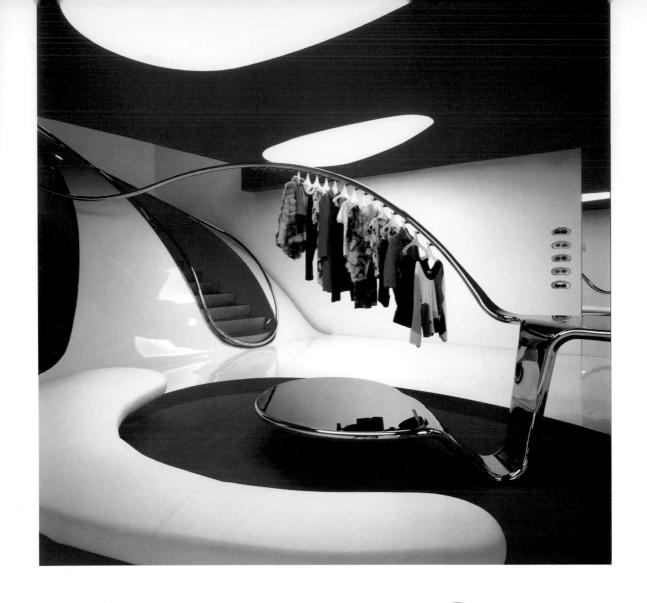

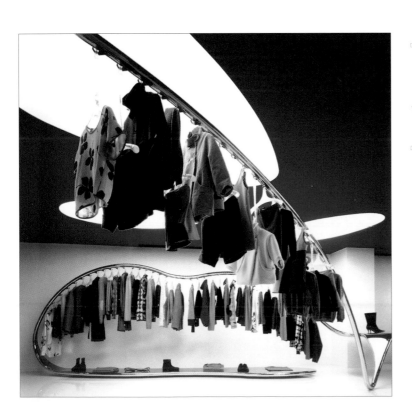

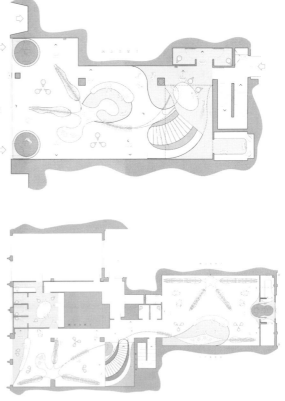

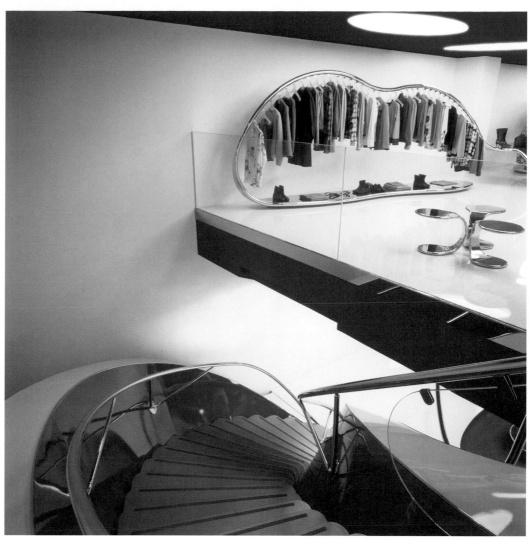

theatrical about this focal stairway that makes the shopper look "framed" as she ascends or descends—"as if making a special appearance."

The vivid red color of the ceiling and areas of the floor "allow the custom light pod units to hover over the space like scattered petals (a signature motif) across the ceiling." "The design principle is echoed within the floor areas by 'cut out' shapes which form sunken, soft seating areas. The space—as a whole—is a-swirl in curving, sweeping and rounded elements. The connected steel display fixtures between the two levels, as well as on the floor fittings become "living fluid elements." The fixtures sweep up and down in lines that complement the architectural envelop and carry the various Marni garments at a variety of viewing levels. The basic fixture concept and design is reinterpreted in each of the Marni boutiques though the environment designs will vary.

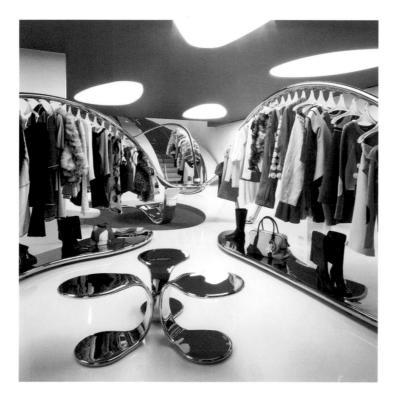

MARNI

Via Della Spiga, Milan, Italy

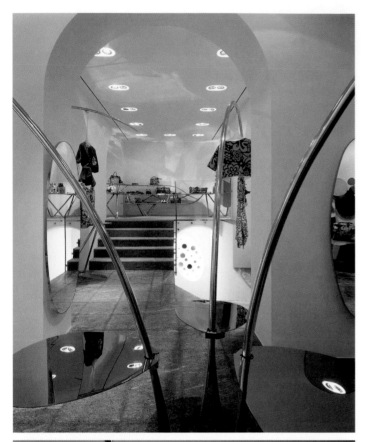

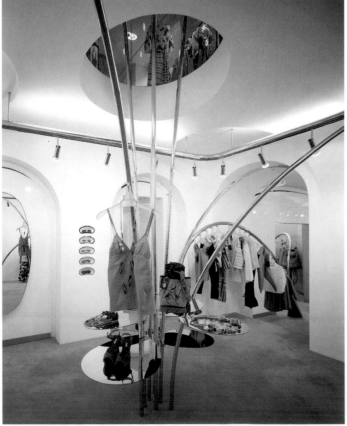

The two story Marni boutique of almost 2500 sq. ft. is located within a quiet courtyard off the designer boutique filled via Della Spiga in Milan. "Drawing on the classicism of the existing 19th century building interior together with the unique vocabulary of the Milan aesthetic, Sybarite has created a space that is rich in contrast and faithful to the playful spirit of the brand." There is a juxtaposing of the old and the new with the restored stone flooring, granite columns and the vaulted ceilings contrasted with the polished steel "trees" that "have an impressive length and effortlessly lean across the shop floor."

This is an important visual connection for customers and staff between the floor levels with its shape beautifully interlaced within the existing vaulted basement." The shopper is met, upon entering the shop, by a meandering and flexible accessory wall composed of wood and Perspex "petals" of varying sizes that can be slotted into a highly modular lacquered wall. This same merchandising concept—on a smaller scale—is used for the elliptical jewelry display cases recessed into the staircase walls. They also serve to illuminate the stairwell and "offer the customer an enticement to the lower floor." An elliptical opening was introduced within the Venetian floor that opens up to a view of the vaulted space below. "The twelve meter (about 40 ft.) stainless steel trees elegantly stretch through both floors like a cluster of mature bamboo. The ground level of the shop is dedicated to women's wear and

accessories while the lower level has a VIP room for evening wear and limited edition pieces. The balance of the space is taken over by menswear, lingerie, baby wear and the fitting rooms.

Throughout, the designers have reinterpreted their signature stainless steel rails for hanging clothes that seem to float around the perimeter of the room, and the floor fixtures that grow up from the floor on flared legs. "The connecting display surfaces of stainless steel are dissected with different materials and colors of timber, resins and Perspex that neatly slot into the surface maintaining the overall shape and are directly inspired by the Marni clothing collection by Consuelo Castiglioni."

The walls, ceiling and floors are white, beige and natural and accented by mosaic tiles—all soft and gentle and classically in keeping with the store's architecture.

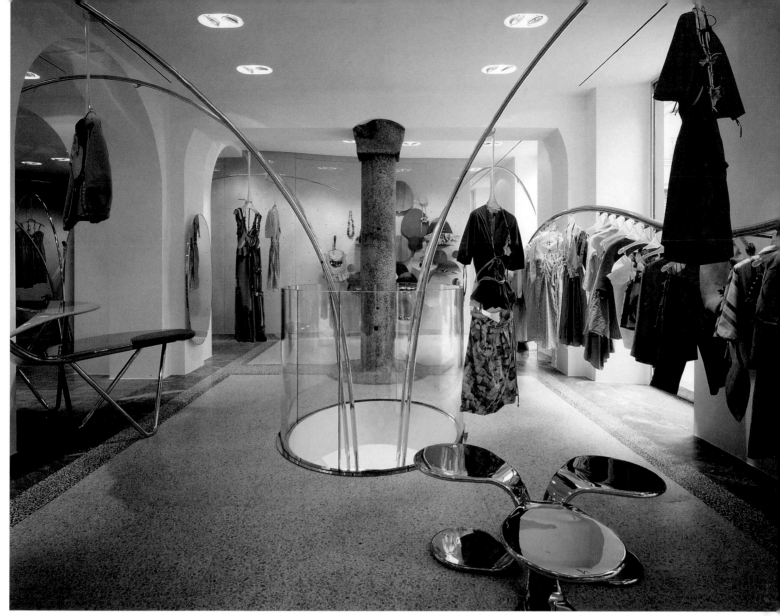

DESIGN: **Sybarite UK Ltd.,** London, UK
Simon Mitchell, Torquil McIntosh, Iain Mackay
SITE ARCHITECT: **Studio Perduca**
PHOTOGRAPHER: **Andrea Martiradonna**

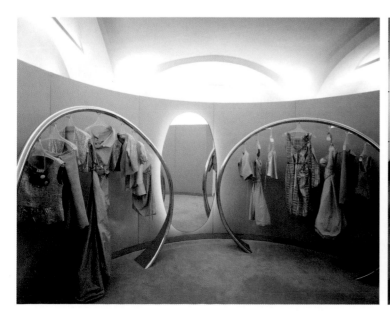

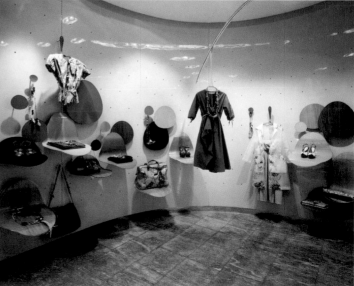

MARNI

Melrose Place, Los Angeles, CA

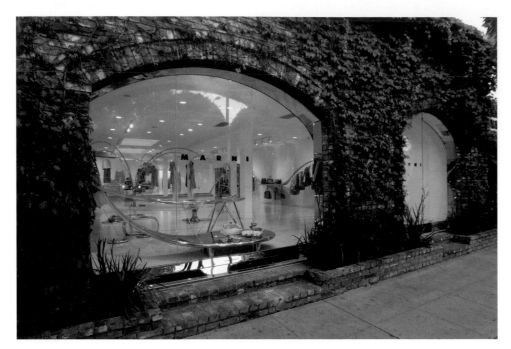

The 2000 sq. ft. shop on Melrose Place in Los Angeles is Marni's second flagship store in the U.S. and according to the designers at Sybarite UK of London, has been "given its own individual and unique identity, whilst at the same time keeping to the core design principles of the Marni philosophy."

The shop is located on "a quaint, quiet and tree-lined street"—a "perfect setting for a very calming and relaxed store design." "Emerging through the ivy clad and natural clay brick faced exterior, two large mirror polished stainless steel curved façade frames which—like a giant 'eye' to the shop—support the clear glazing and entrance door." Inside, the simple

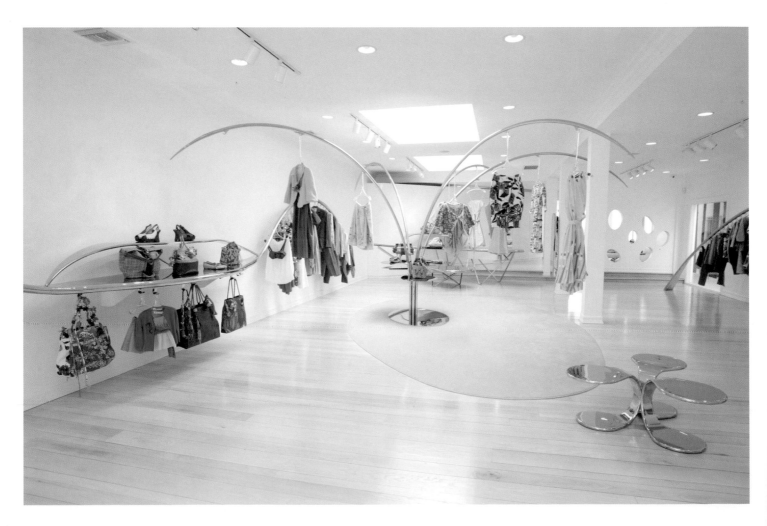

white walls and bleached white wood floors highlighted by soft pastel colored area rugs complement the sinuous and curving stainless steel display rails that are signature elements in all the Marni shops. A glossy lacquered curved wall of wood wraps around to create the fitting room, cash and stock areas. In order to conform with the Los Angeles building codes regarding earthquakes, "the necessary shear wall halfway into the space is punctuated with elliptical shapes to create a semi-private shoe and accessory display whilst at the same time allowing glimpses through the store and also for the passage of natural light. The California climate provides an endless supply of good natural daylight and it penetrates the interior through glazing on three sides of the property as well as the roof lights that hover over the tree hanging display areas."

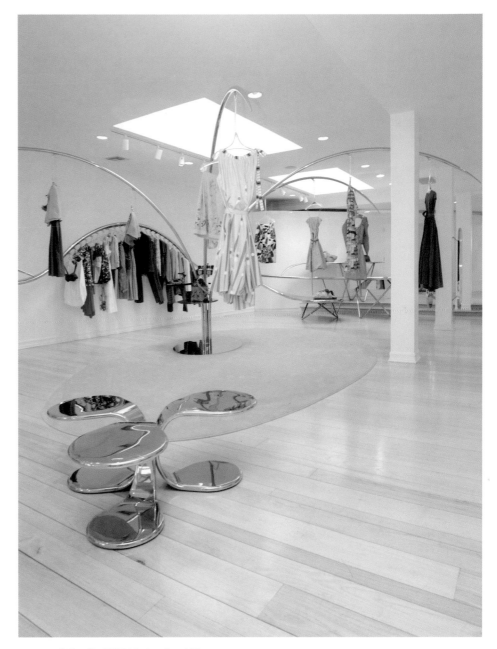

DESIGN: **Sybarite UK Ltd.,** London, UK
Simon Mitchell, Torquil McIntosh, Iain Mackay
PHOTOGRAPHY: **Donald Sardella**

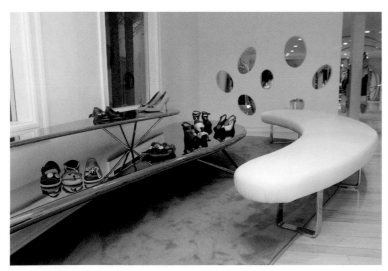

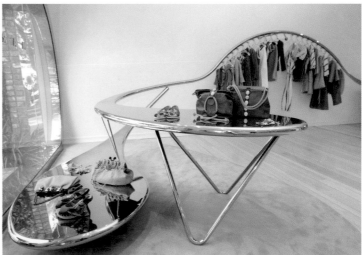

RAOUL

Millenia Walk, Suntec City, Hitachi Towers, Singapore

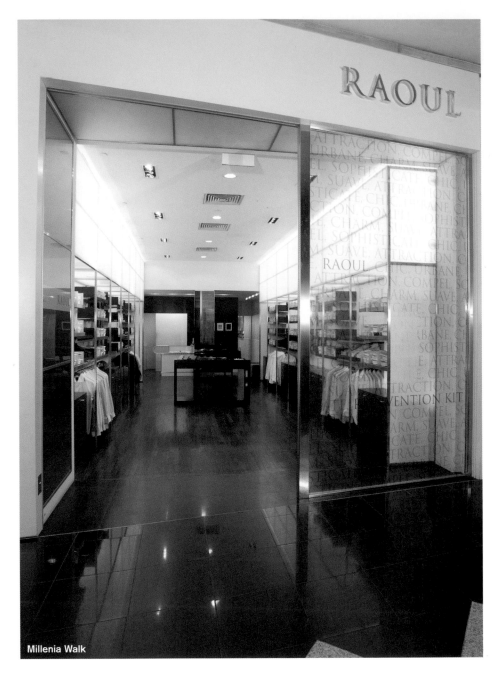

Millenia Walk

DESIGN AND PHOTOGRAPHY: **Kingsmen,** Singapore

Raoul is a high fashion retailer and it is the in-house brand name for FJ Benjamin PTE of Singapore. Raoul is noted for providing "good quality fabric and reasonable cuts for men on the street who appreciate good value for the money."

What Kingsmen of Singapore attempted and carries through in the three stores shown here, which vary in size from 800 to 1000 sq. ft., is to create "a one-stop shop that represents Raoul's way of life." The store design projects a sense of space and a "clean simplicity" that is seen through the use of stainless steel, clear and sandblasted glass and plexiglas, and dark wood flooring that is complemented by the all white surroundings. Strong geometric forms are used throughout wall and loose fixtures and these add to the distinctive look of the shop. In addition to the warm, bright ambient lighting from the ceiling lamps, light emanates from the white translucent plexiglas panel above the display wall. The design team enhanced all the physical elements with a well-coordinated visual merchandising program to "stimulate the consumer's imagination and to appeal to his lifestyle."

We are showing the first three Raoul stores so that the reader may see how—with subtle variation in space restrictions or plan layout—the designers have carried through the Raoul store brand image. The

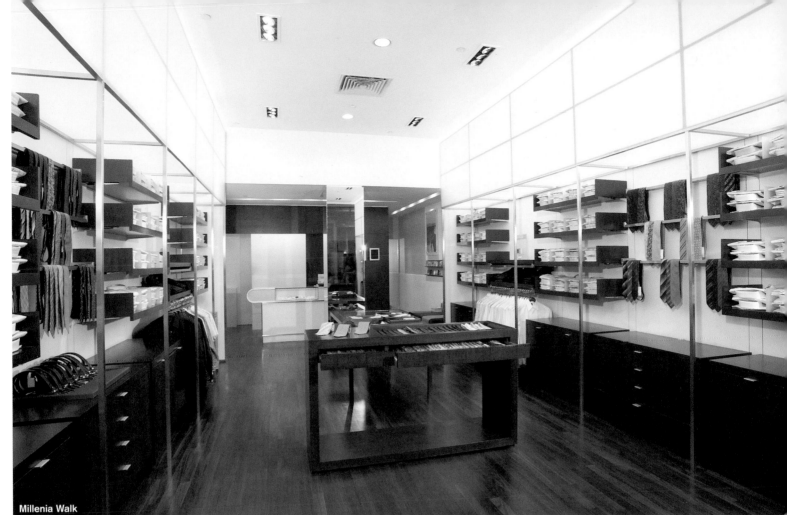

Millenia Walk

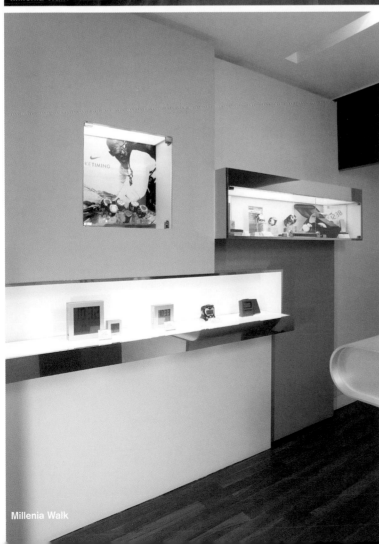

Millenia Walk

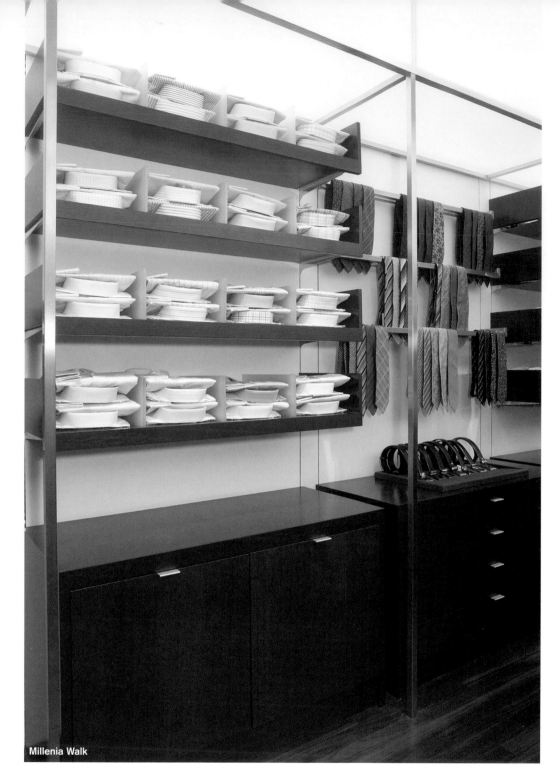

Millenia Walk

"theme" of this brand image is that "the man of Raoul is someone extreme and career minded yet a fun-loving individual. He wants no frills and a no confusion approach to everything he does." Thus, this clean, contemporary design is targeted at men 25-40 years old and the fun, lifestyle approach is carried through in a comfortable "boutique" with "acid jazz music" and high tech gadgets for the men to play with.

The design concept in natural woods and a neutral palette of off-white, beige and brown with modular wall and floor fixtures was planned to be rolled-out in different countries in the Pacific Rim. Therefore, the challenge was to keep the design of the store and the fixtures "tasteful yet simple for buildability." Materials were selected that could be found in other countries by the fit-out contractors there who could bring the projects in on schedule—and on budget. So far there are nine stores open across Southeast Asia.

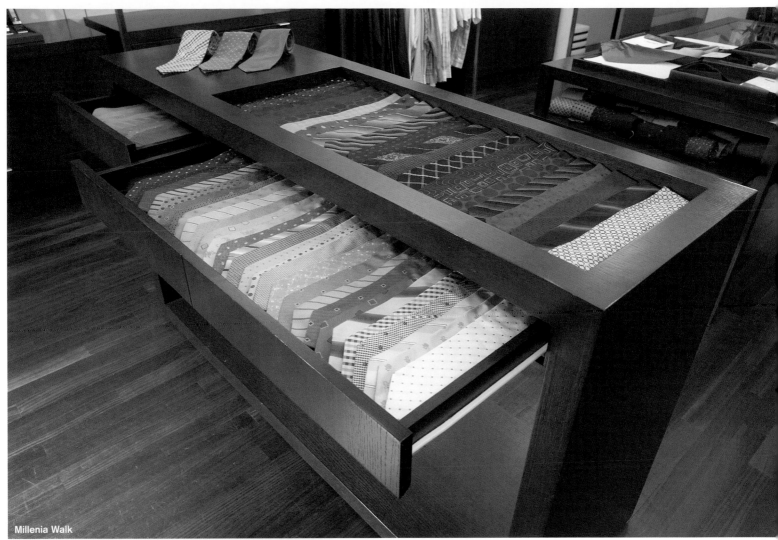

Millenia Walk

Hitachi Towers

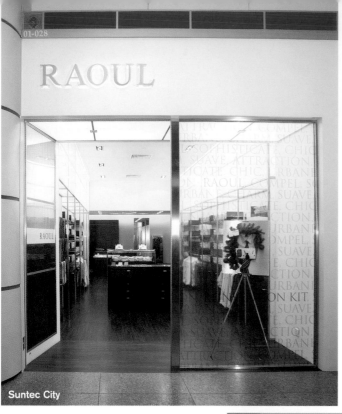

Suntec City

Suntec City

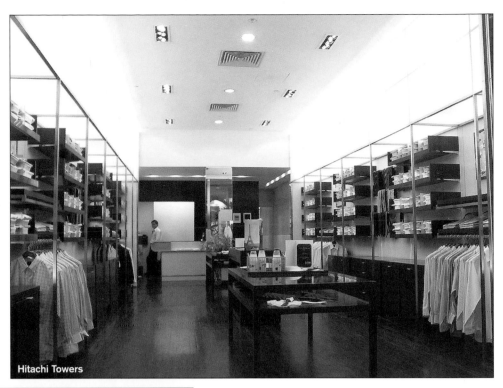

Hitachi Towers

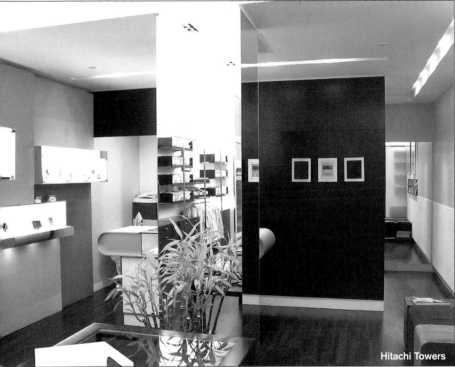

Hitachi Towers

Hitachi Towers

MISS SIXTY

Aventura Mall, Aventura, FL

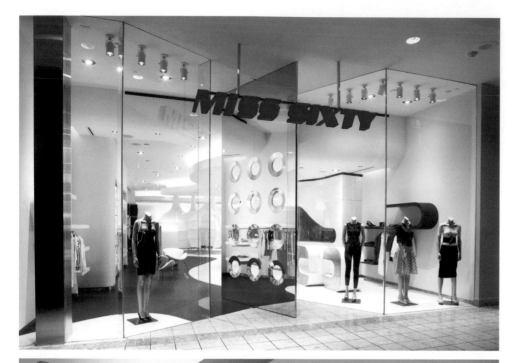

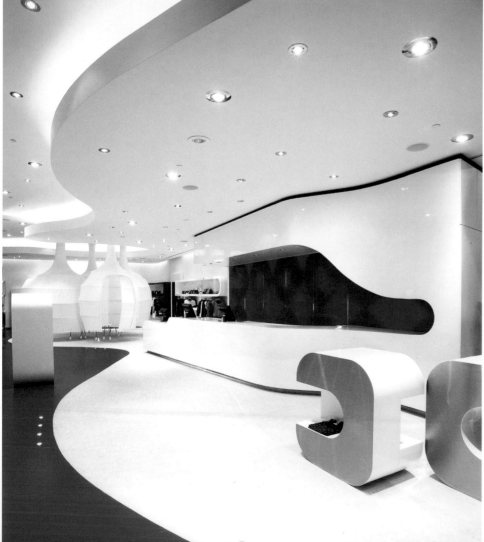

Giorgio Borruso strikes again with another unique and involving shop interior. Several years ago we were pleased to show his retail branding of Miss Sixty in the Costa Mesa, CA shop and here is his updating and further refinement of that Miss Sixty design. Miss Sixty is a high end, Italian line of jeans and other garments for affluent young women. This shop is located in a 2300 sq. ft. space in the Aventura Mall near Miami, FL.

There is a great similarity between the façade here and in the Costa Mesa store. The 7 ft. by 12 ft. stainless steel, polished mirror door has 12 conical portholes and it is "the perfect result of a geometric calculation, utilizing regular elements, the rectangle and the circle, symbols of symmetry, order and simplicity."

Inside the shop, "simple forms, circles, squares—the iteration of elements in an echo of the Panton style from the '60s—are combined with sinusoidal curves that become more complex and organic, in the floor as

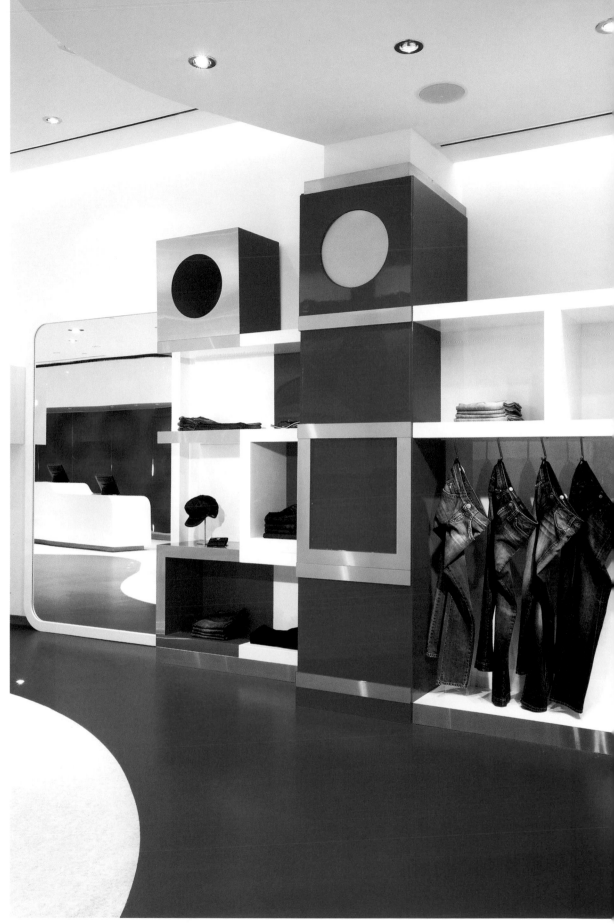

DESIGN: **Giorgio Borruso & Associates,** Marina Del Rey, CA
PRINCIPAL DESIGNER/ARCHITECT: **Giorgio Borruso**
ARCHITECTS OF RECORD: **Brand + Allen**
PHOTOGRAPHY: **Benny Chan**

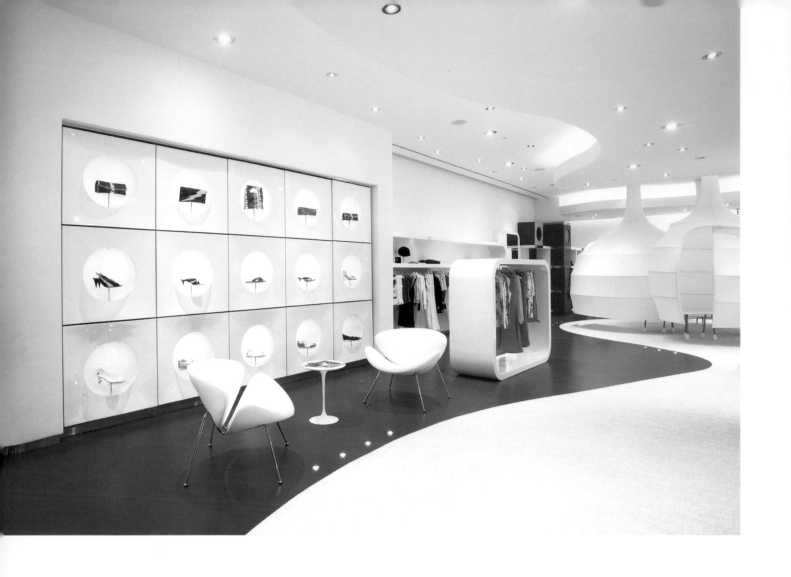

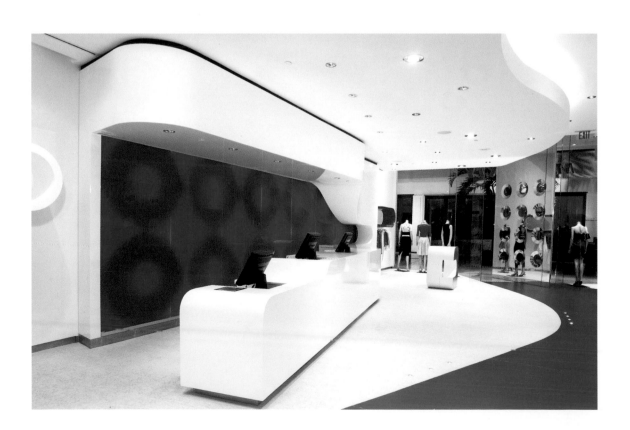

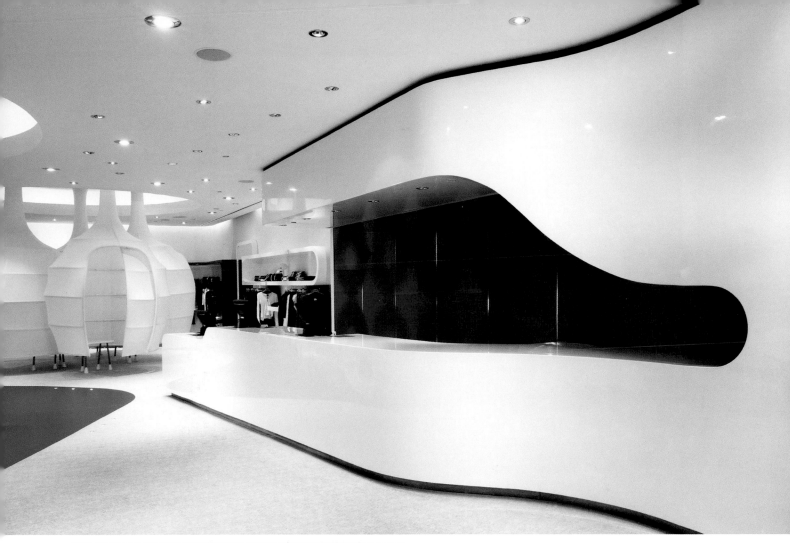

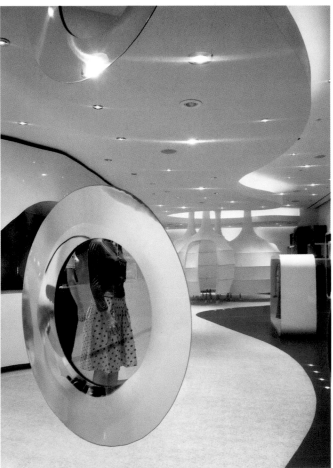

well as the ceiling." The floor is divided by flowing curved shapes: two different colors, materials and surfaces. The signature red and white color scheme once again dominates: "one cold to the touch, but with the irony colored red. The other, pearl and lucid python surface, warmer, softer but pointed to the touch. Where the two materials conjoin along this curve, points of light mark the borderline. The light softens the distinctions, spilling across the surfaces, reminding us of play across the boundaries."

As one walks further into the space there is a grouping of "cocoons" of varying heights suspended from the ceiling. These "cocoons" are the dressing rooms and they are circular frames made of ultra-light aluminum covered in an elastic, translucent fabric—"representing the corruption of the purity of the door." "The perfect geometry of perfect form, the sym-

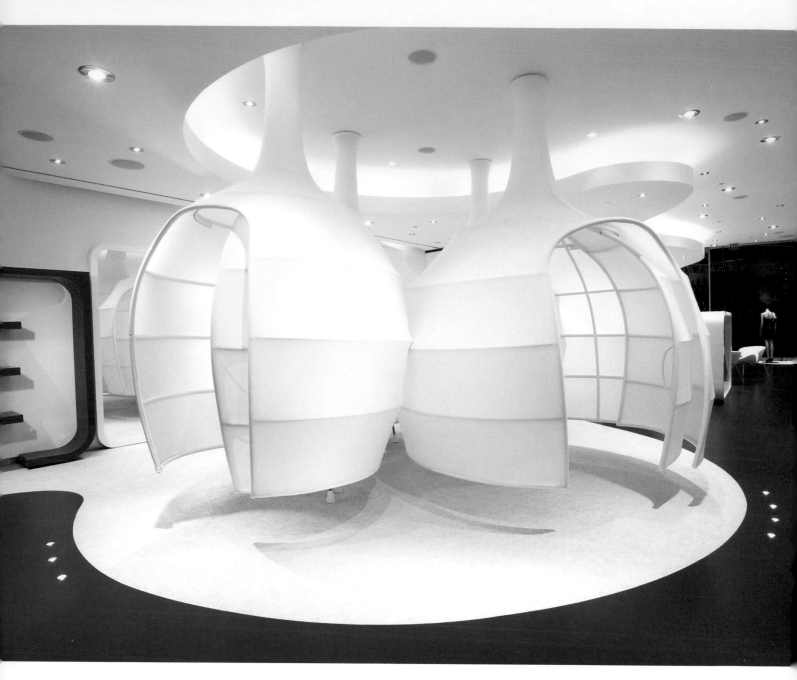

metry, the repetition of pattern represented in the free-standing furniture—as well as the other along the walls—is definitely corrupted." In order to optimize the floor space, at the rear of the store the jeans wall conceals full-height, hidden roll-out units that carry additional stock. The "hidden stock" is revealed when the wall units are moved.

The cash-wrap is a long, seamless curved form. "You read two different curves as the cash/wrap splits, like a wound, opening and curving in different directions, revealing a background of red glass retro-illuminated with hypnotic shadowy disks, which frame the occupants." The curved, multi-leveled ceiling is filled with spotlights that illuminate the space.

For readers who would like to compare the spaces we direct them to the June 2003 issue of *Retail Design.*

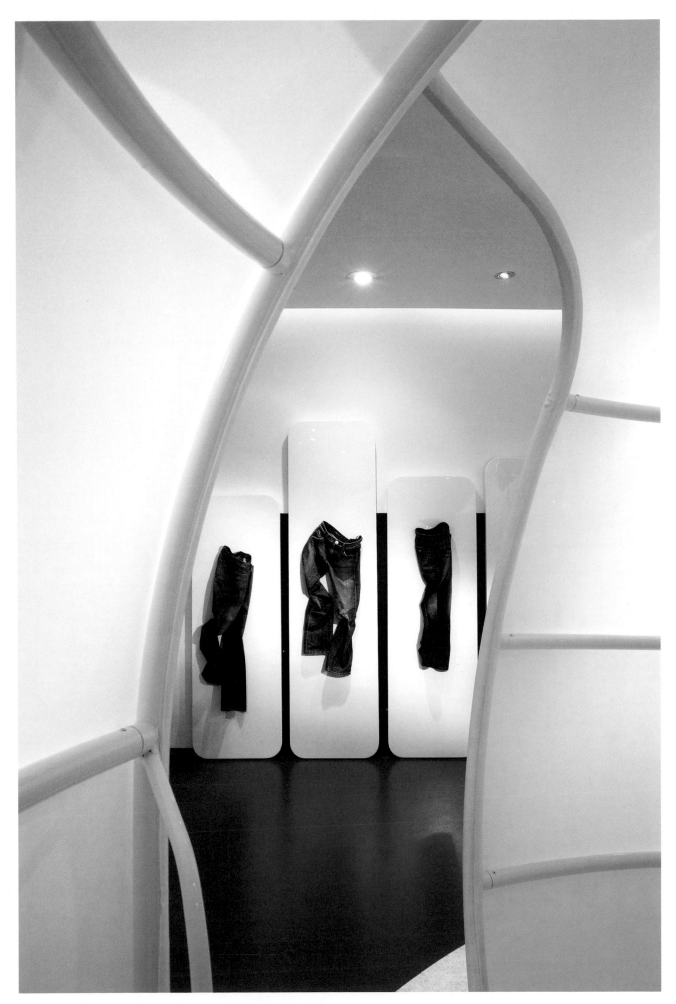

MISS SIXTY

Cologne, Germany

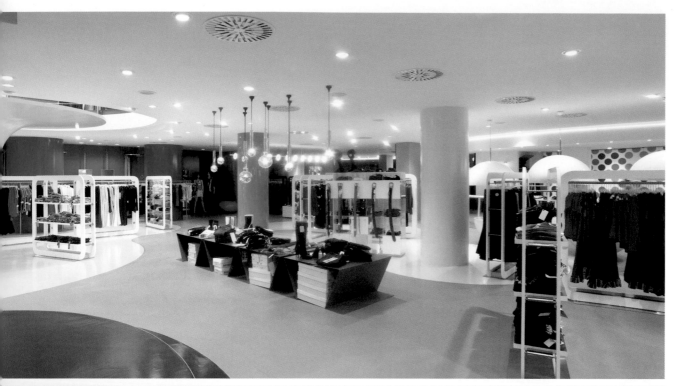

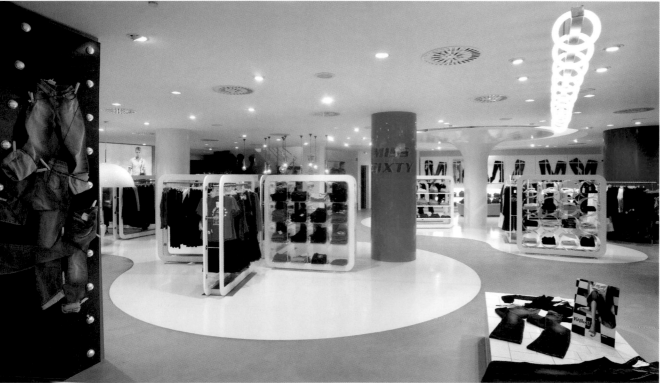

DESIGN & FITTINGS: **Umdasch Shop Concepts, gmbH,** Amstetten, Austria
PHOTOGRAPHY: **Courtesy of Umdasch**

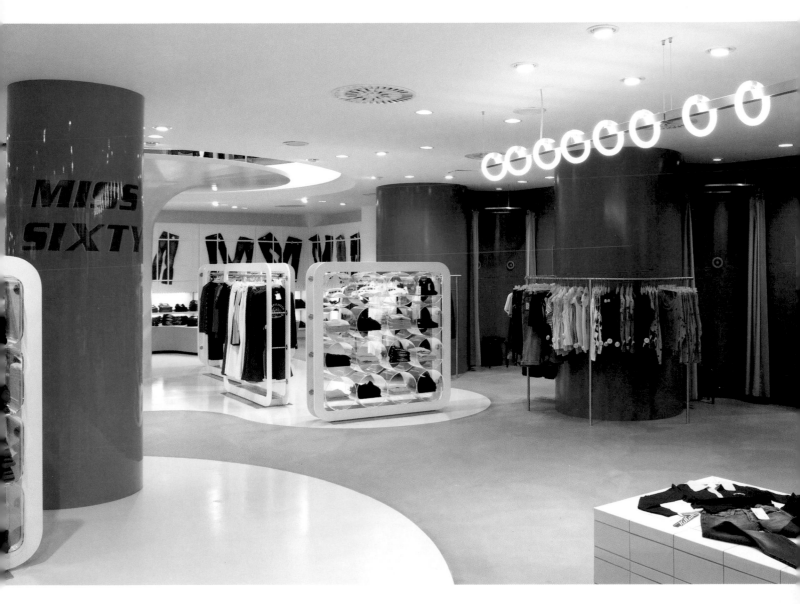

Another look at the retail brand image of the Miss Sixty shop as designed and fitted by Umdasch Shop Concepts in a 3000 sq. ft. space in Cologne, Germany. This new "shop in shop" is described by the designers as "impressive with very clear and concise colors and shapes."

Yellow and green plus other bright accent colors dominate the space that is filled with sweeping curves, circles and arcs. "Different colors and organic shapes lead the customer into the world of style and fashion. The modern environment inspires curiosity—and shopping." The soft, neutral gray flooring is interrupted by highlighted areas of yellow flooring.

Growing up from these bright puddles are round columns covered in yellow and green laminates and some of the perimeter walls are finished in the same strong, clear color. One of the central columns fans out on top and through the circular cut-out in the ceiling shoppers are allowed a look up to the level above—or from the upper level down to the main floor. The wall fixtures are used specifically to display the jeans while Umdasch's CL-Conformist fixtures are used free standing on the floor—"enabling a perfect division in concerns of goods presentation." The various fixtures that were used are all distinguished by their rounded cor-

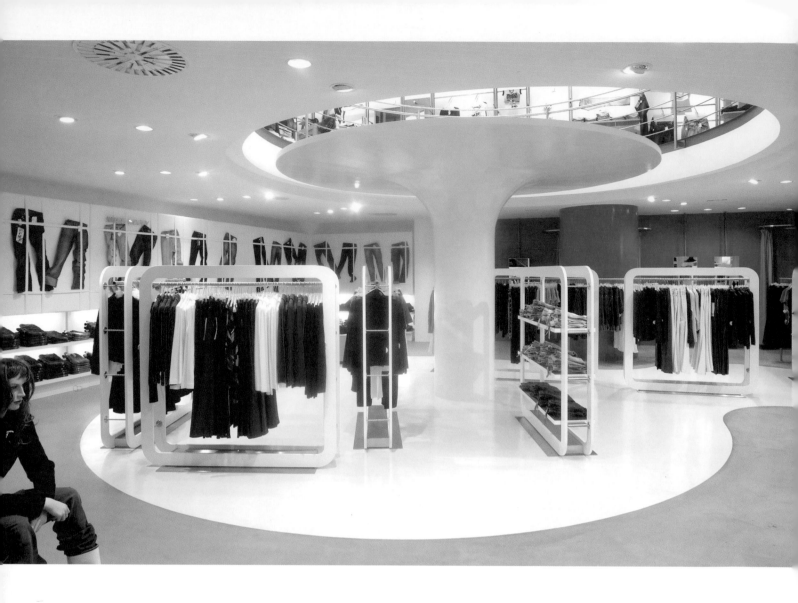

ners and softened shapes. The white rectangular units are clustered in right angled twosomes or as trios or as squared "U"s. Unique half round tables—like half grapefruits—are finished in yellow or green laminates and are used to feature lay-down arrangements of outfits. Some of these are further accentuated by the half round dome light shades that hang over these circular tables. One wall is distinguished by an irregular pattern of dots in green, orange, and red on a white background.

In addition to the dropped half dome lights, the space is illuminated by the incandescent spots recessed in the white ceiling. Some recessed fluorescents illuminate the curved walls as they reach up to the ceiling. Near the dressing rooms in the rear—a series of roomettes with green fabric pull draperies for privacy—is a decorative track system that combines focusable spots with round neon tubes. This line up of circular forms complements the circles and rounded edged rectangles that appear throughout this Miss Sixty shop.

PRINCIPLES

Harlequin Centre, Watford, UK

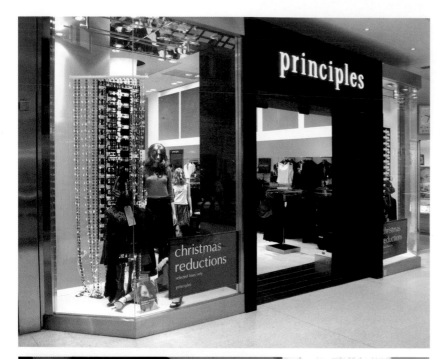

Principles is one of the leading women's fashion brands in the United Kingdom with a "great history." However, the company felt the need to "re-engage "with their customers" and Caulder Moore, a London-based design consultancy, was called upon to review the brand and "deliver a 360 degree revitalization program to reconnect with the consumer through tone of voice, in-store communication and environment."

Working with Principles' creative team, the designers "unveiled a strong, emotive, creative inspiration at the heart of the brand." "Our aim was to communicate the immense level of passion and energy in Principles' design studio to their customer—translating this in a way that created a unique brand personality and brand experience on the high street." Thus, Caulder Moore got involved with the retail interior concept, the window design, in-store graphics and packaging—as well as the art working and print management. "The first step for us was to communicate the Principles personality and the beautiful fashionable product to the customer on an emotive and creative level, with impact and refreshed aspiration and we developed a fantastic A/W 2004 photography style that translated into a look book, window displays, and in-store graphics and communication."

A new, more feminine, emotive boutique hotel flavor was created for the fixtures and furniture, light fittings, New partitions were layered in on the perimeter along with the new center floor fixtures and these were all combined with the window presentations and the graphics to reflect the more informal, accessible and fun personality of the Principles brand.

The interior was now warmer and more accessible and added "a sense of individual style and energy to the shopping experience." A warmer palette was created, rather than corporate colors, allowing more flexibility and freedom for trends and it also gave a more distinctive feeling to the brand. The photography

DESIGN: **Caulder Moore,** London UK
CREATIVE DIRECTOR/DESIGNER: **Ian Caulder**
PHOTOGRAPHY: **Media Wisdom**

style was also "set to capture a warmer, more appealing connection—recapture youth, fun and beautiful clothes." The photography team created a unique personality and style for the brand that was "more informal, layered, textured, accessible—creating a mood that customers would aspire to but also connect and identify with." "Our key achievement was to create a language for the brand and brand guidelines that the in-house design and marketing team use as a starting point for all their creative executions across the brand experience."

According to Ronny Helvey, Principles' Marketing Director, "Caulder Moore helped us translate our thoughts from an idea to an environment with personality. We wanted to own a concept that was fluid and could evolve with the fashions and capture a boutique and individual style while making sense to our customers." Over 100 stores and concessions based on this new design have been rolled out since its inception.

PRINCIPLES

Solihull, UK

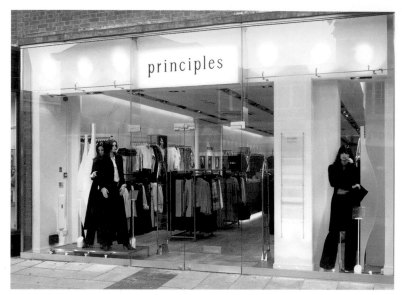

DESIGN: **Checkland Kindleysides,** London, UK
CO-FOUNDER & JOINT MANAGING DIRECTOR: **Jeff Kindleysides**
ASSOCIATE DESIGN DIRECTOR: **Clive Hunt**
PHOTOGRAPHY: **Courtesy of Checkland Kindleysides**

Checkland Kindleysides, the London based design consultancy, was also asked to create a new retail design and graphic identity for Principles. "The project includes a brand definition piece built around the key emotional and physical ingredients of the product itself."

The new design had to be "scalable" and work as a stand-alone shop or as a concession or shop within a shop. "The design had to be seen as part of the lineage and evolution of the brand and not as a massive departure, it should be contemporary in a way that is right for Principles' consumers. Therefore, the identity and feel of the store had to connect with and have relevance to existing as well as future customers, and at the same time be built on genuine points of difference and values of Principles."

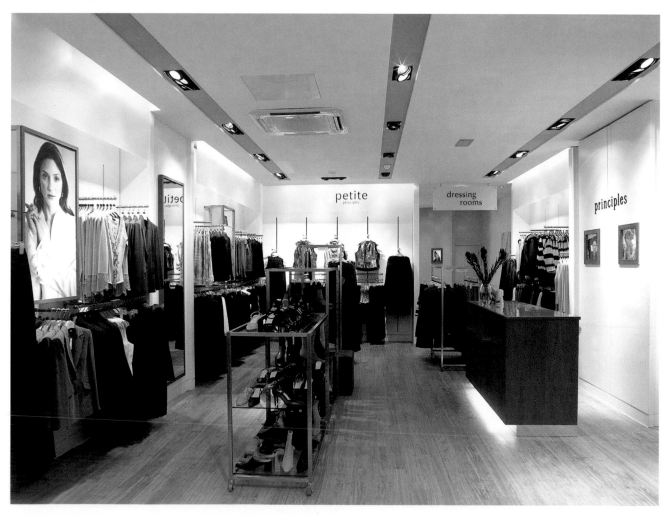

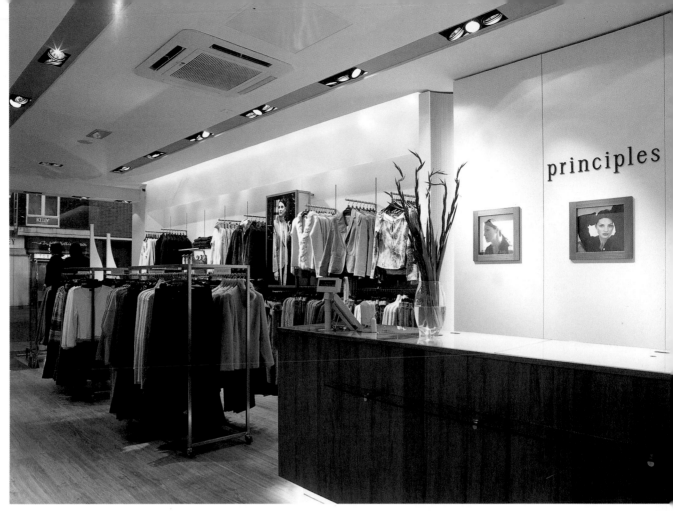

The store design concept revolves around clarity of product offer and how the various garment ranges can be grouped and flexed throughout the year. The presentation of the product is simple and uncluttered to create more move-about space for the shopper. The on-the-floor fixtures are simple frames of stainless steel and glass and show off the ranges in linear formations. "The design seeks to create crisp lines of fixturing to complement the flowing lines of the product." The perimeters are designed with larger bays that can be—as needed—subdivided by using specially designed movable break points. "The break features create display, merchandising and promotional opportunities as the movable frame is multifunctional being used with shelves, or as a simple image frame." Stainless steel and dark woods contrast with the white plaster walls. "Combining crisp forms and lines together with flowing curves and subtle detailing achieves a balance of design detailing which is evident in the product design." Frosted materials are layered and backlit—creating soft, gentle shapes while the white-on-white relief gives a subtle twist—using shapes and forms which echo product detail.

Jeff Kindleysides, principal at Checkland Kindleysides, said, "Overall the scheme projects Principles as a fresh and contemporary retailer who understands its customers' needs, presenting products in a clear and well considered way—in a style which is natural for the brand."

PLAYBOY

The Forum Shops, Caesar's Palace, Las Vegas, NV

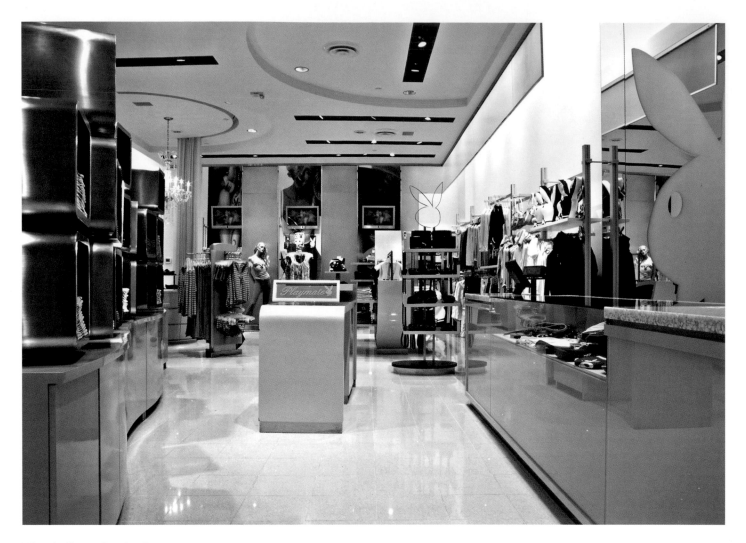

The challenge for the design team at The Walker Group of New York was "to leverage—on a macro scale—the legendary Playboy brand and the company's extraordinarily successful apparel line. As the design concept was conceived, the goal was to simultaneously appeal to a sophisticated and cultured female audience and to affirm and celebrate the internationally iconic brand."

Working closely with Christy Hefner, Jay Valgora of the Walker Group and his design team were able to fully realize her crystalline vision of a setting that "reflects the fun and fashion forward gestalt of the clothes." The design that evolved is "elegant, boldly sensual and utterly modern," and it

DESIGN: **The Walker Group,** New York, NY
DESIGN PRINCIPAL: **Jay Valgora**
STUDIO DIRECTORS: **Miho Koshido, Craig LasRosa**
DESIGNER: **Mohamed Gabr**
ARCHITECTURE: **IDS Architecture, Inc.,** Honolulu, HI
OUTSIDE DESIGN CONSULTANT: **SCA Design,** Henderson, NV

For the Client, **Waikiki Trading Group:**
PRESIDENT: **Jim Geiger**
CEO/CFO: **Al Cottral**
VICE PRESIDENT: **Frank Crowley**

PHOTOGRAPHER: **Eric Laignel,** New York, NY

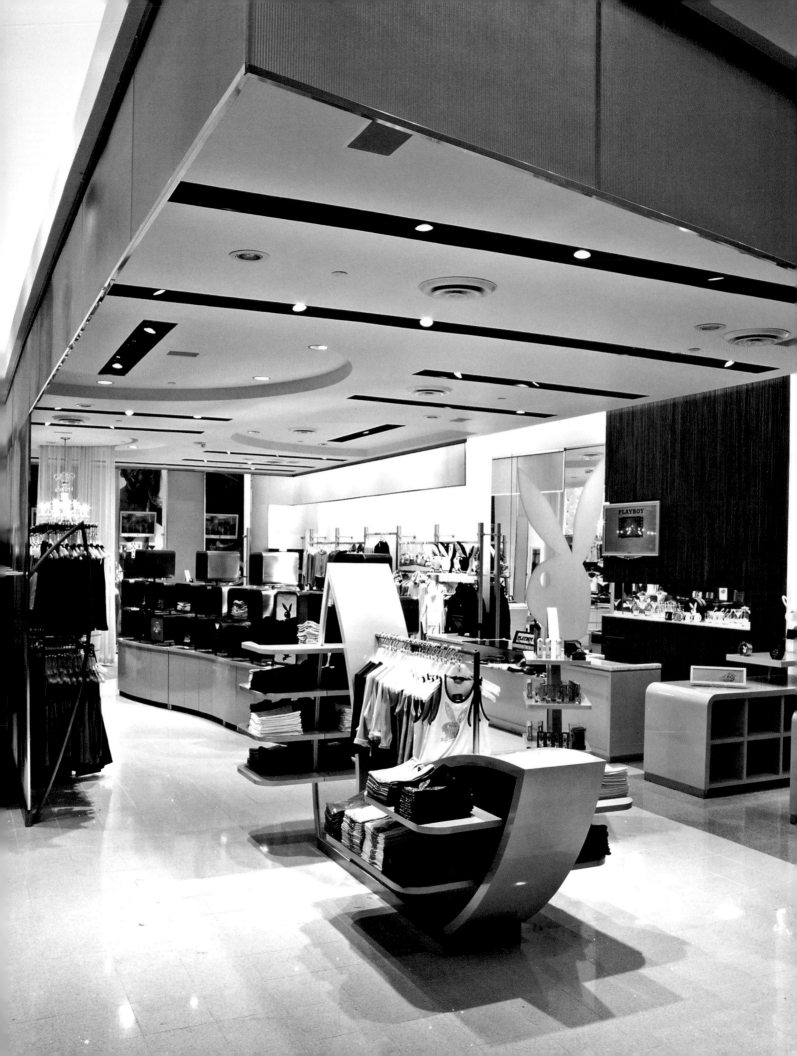

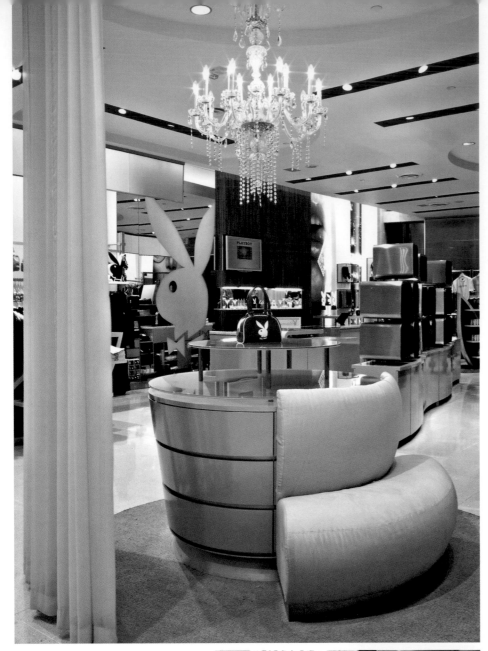

speaks to "a contemporary ethos of sexiness/sensuality that breathlessly invites and captivates both male and female audiences." This store's design will serve, in the future, as a prototype for freestanding and in-store shops with the lingerie targeted at trendy 18 to 25 year olds.

Since Playboy is a lifestyle brand, the designers felt that they needed to bring the Hugh Hefner/Playboy mansion and magazine culture into the design. "Environments offer one of the greatest ways to represent a brand, especially one like the Playboy that has such prominence and is so recognizable," said Valgora. The Playboy logo bunny is everywhere in the shop; appearing in various sizes, in various materials and often in unexpected places. From the Playboy archives there are graphic reproductions and even one-of-a-kind memorabilia.

The store is basically a composition of white on white contrasted with dark zebrawood that is currently "in" but that also recalls the 1960s and '70s—when the Playboy mansion was in its heyday. Also reminiscent of the mansion is the "window" behind the cash/wrap. It recalls the windows behind the Grotto Bar in the mansion—the pool area—and looking through that "window" one can see clips from Playboy's "After Dark" TV shows. Adding to the sexy/sensual atmosphere are the crystal chandeliers, the soft, see-through draperies, and a padded and quilted wall of white velvet. "The architectural elements that underscore the theme and augment the store's aesthetic include use of layers of frosted glass on the perimeter walls throughout the store; multimedia installations that provide customers with constantly changing images and morphing sounds; and cropped silhouettes and abstractions of the famously recognized Playboy Bunny employed to create an architectural language for the store's fixtures."

"The design incorporates a fresh and of-the-moment approach consistent with the sophisticated vibe of the Playboy retail brand."

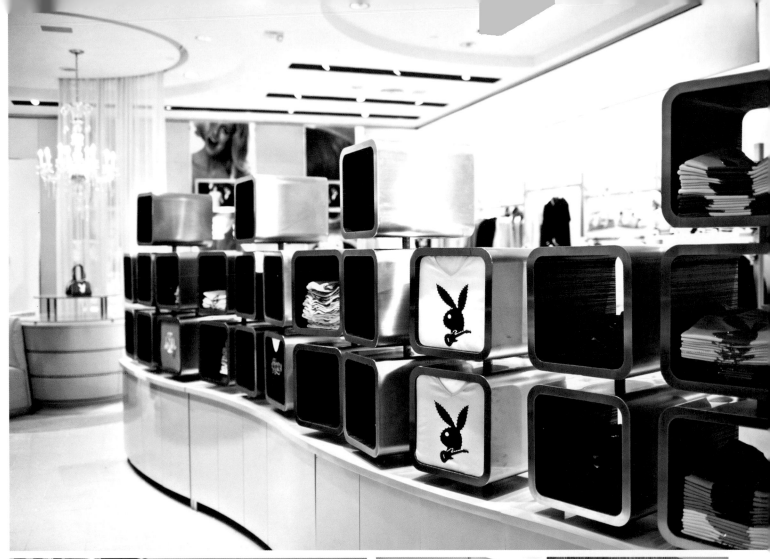

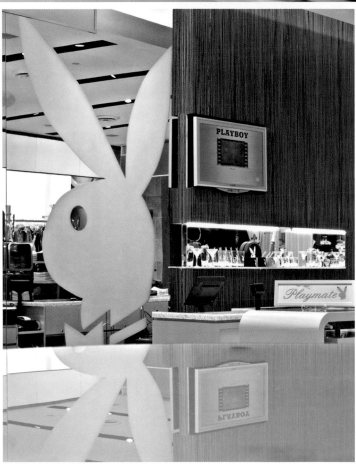

TIMBERLAND

Ginza, Tokyo, Japan

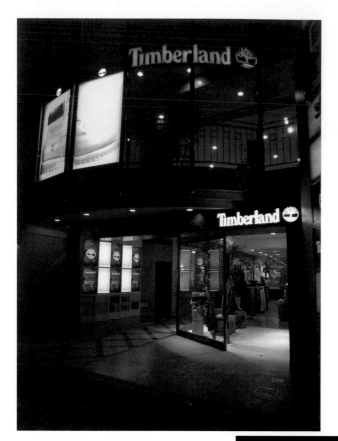

DESIGN: **FRCH Design World Wide,** Cincinnati. OH
PRINCIPAL IN CHARGE/CCO: **Paul Lechleiter**
VP DESIGN, CREATIVE DIRECTOR: **Christian Davies**
PROJECT DIRECTOR: **Scott Frazier**
INTERIOR DESIGN: **Mari Miura**
RESOURCE DESIGN DIRECTOR: **Lori Kolthoff**

For TIMBERLAND
SR. DIRECTOR GLOBAL CREATIVE SERVICES: **Bevan Bloemendaal**
SR. MARKETING DIRECTOR—ASIA PACIFIC: **Carol Young**
VISUAL MERCHANDISING EXECUTIVE—JAPAN: **Shizuka Aoki**
VISUAL MERCHANDISING MNGR.—ASIA PACIFIC: **Celine Teo**
RETAIL OPERATIONS MNGR—JAPAN: **Osamu Nakayama**
VISUAL MERCHANDISER: **Naoya Sakamoto**

PHOTOGRAPHY: **Masami Fukuda,** Tokyo

Timberland is a brand name known throughout the world and in all their business and communications, the company endeavors to promote the spirit of that brand. Craftsmanship, Community Responsibility (Social Justice) and Of the Outdoors are the cornerstones of the brand. When FRCH Design World Wide of Cincinnati, OH was commissioned to design this 2,500 sq. ft. Timberland Ginza flagship store—the first major flagship environment outside of the domestic market in ten years—it offered the design team the opportunity to visualize the "latest thinking in the evolution as a brand at retail."

The new design is a space in which Timberland's products are on display as well as a space that is a destination to be enjoyed. It is "a space for contemplation and reflection, tied to themes drawn from both the aes-

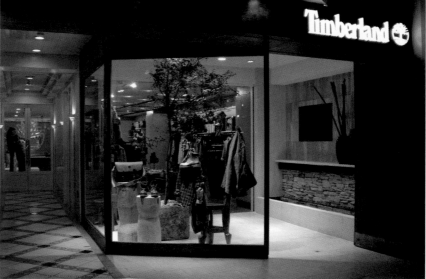

thetics and vernacular flavors that abound in this incredible country of Japan." Mindful that Timberland is a guest in that country and in that culture, the design firm not only respected their position but went further to reflect the company's commitment to

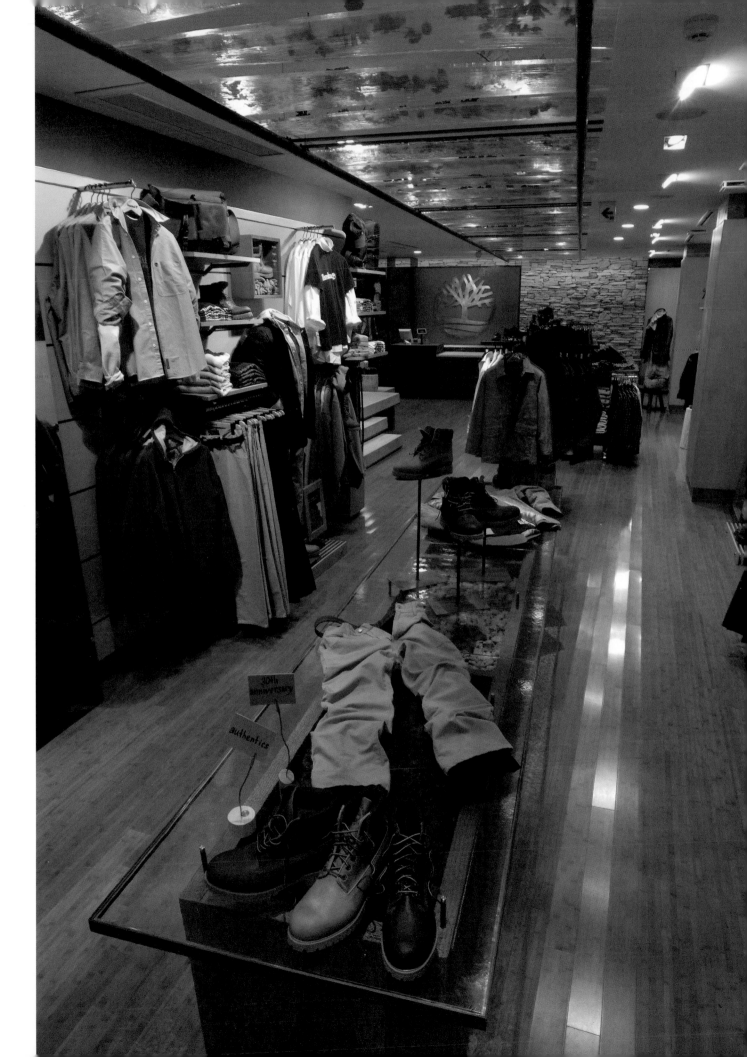

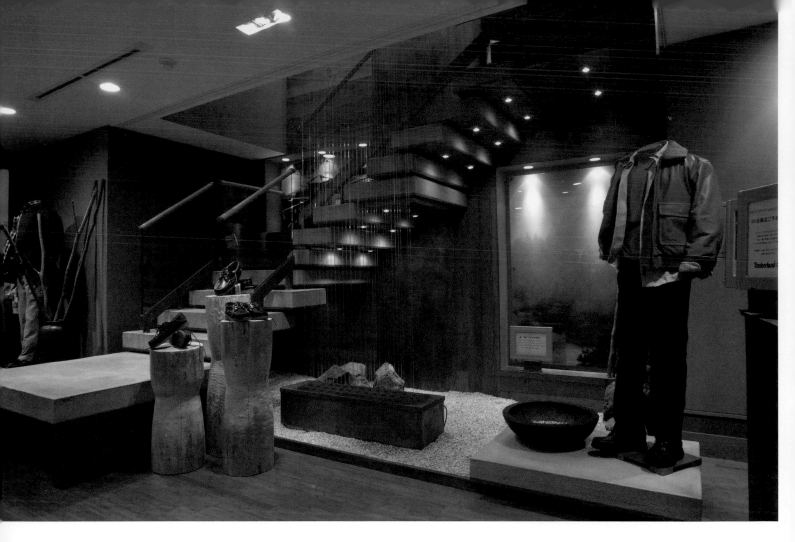

the highest standards of service, quality and experience.

Throughout the store the designers integrated Timberland's global campaign message—"Seek Out"—that has been used in marketing in Japan as well as in other Timberland retail outlets. The shopfront, located in the busy Ginza District of Tokyo, combines scale, form, and texture and from a distance the tone of the shopping experience is telegraphed by the backlit billboard out front. In the transition spaces—the entrance and the stairwell—water features, dramatic but simple forms and a material palette taken from nature reign. "In these zones sights and sounds combine to give a sense both of the outdoors and of the craftsmanship and attention to detail" in the Timberland brand and product. The simple stacked stone and river rock waterfall combines with a media presentation to establish a connection with nature. "After this decompression they (the

shoppers) are then ready to step into the world of the outdoors—the world of Timberland."

Kiln dried oak, recycled barn wood, amber glass panels and Roman Copper metalwork are all combined with craftsman-inspired details. There is a ceiling trellis of seeded glass and seasonal decorative elements are displayed on the focal wood table. The Timberland tree logo—in Roman Copper—is set against a wall of semi-translucent amber glass behind the cash/wrap at the rear of the space. It not only draws shoppers back into the store but it echoes the company's signature orange leather. Adjacent to the cash/wrap is the staircase. A two story filament water feature runs between the cantilevered, textured concrete steps. "A Zen inspired garden grounds the composition evoking order and balance in a natural context." A barn wood wall frames the stairwell and the inset Roman Copper display cases, lined with the orange

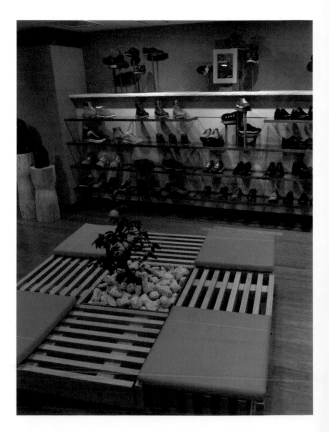

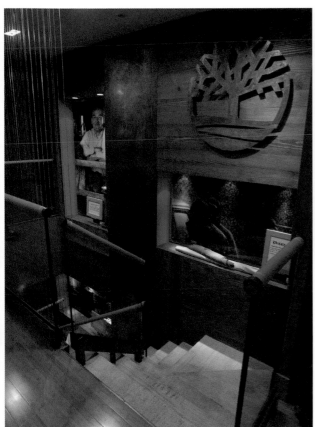

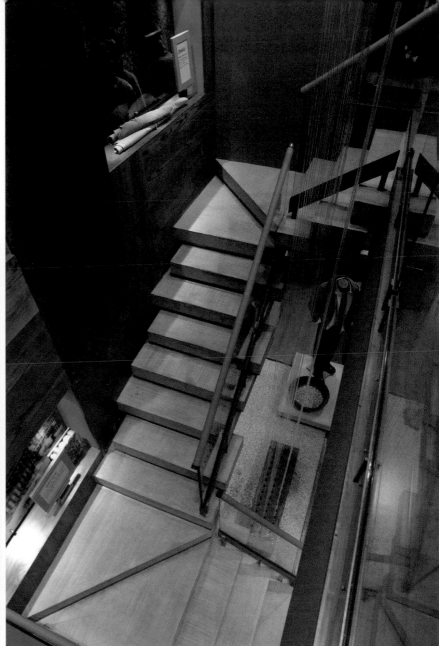

leather, are located in the stairwell and feature the Timberland products.

On the second level there are focal departments devoted to boots and shoes. The space is anchored by a custom bench seating element and it is simpler in design than the first level. The cleaner lines "act as a contrast in terms of pace and brand integrity. The mood of this more contemplative space is embodied by the final destination in the store." Throughout the store the circulation is paced to reveal new vistas through the spaces and the pace is varied between the various discreet zones of the interior. The "Seek Out" philosophy is revealed as shoppers take a journey through the "outdoors" as expressed in the waterfall, the natural materials and the "tone of voice" of the total design. "From the distinct graphics and imagery in the space, consumers are encouraged to pull their boots on and make a difference."

TIMBERLAND BOOT COMPANY

1 Fournier St., London, UK

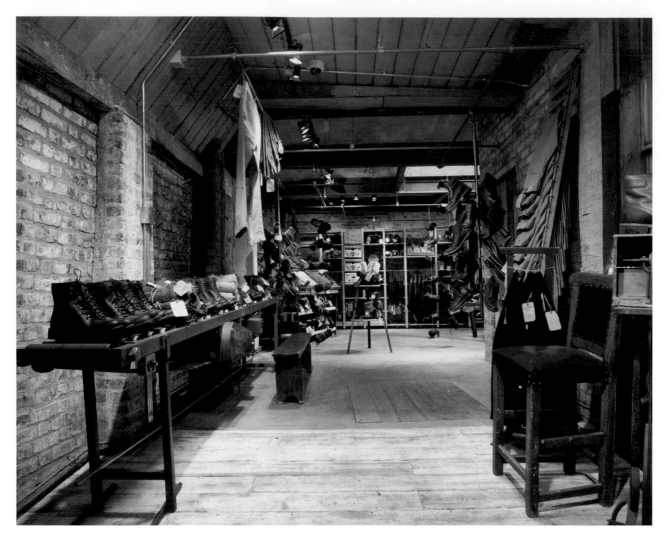

Checkland Kindleysides, the London based design consultancy, worked with the Timberland Boot Company to create a new type of "trading place." Checkland Kindleysides was challenged to design and realize a retail space that would reflect Timberland's new attitude. The opening of this trading space marks the first of many ventures around the world—each one adopting a 'place based' approach. As the designers at CK explain, "Every potential location has a signature made up of layers of local cultural, geographical, and architectural characteristics. The aim is to identify the 'spirit' of this signature so the concept for the new trading space

evolves out of its context, and expresses the company's desire to 'belong' to its locality." The first of these new concept "trading spaces" is located at 1 Fournier St., an old banana warehouse in London's East Side.

Russell Ashdown, Sr. Designer at Checkland Kindleysides, said, "This is much more the approach of the independent shopkeeper, and the antithesis of high street retailing. Our approach has involved respect for context, designing in a sustainable way, and seeking to fuse the store with its surrounding community while at the same time providing an effective base through which to trade. For the first site, its been about being inventive,

physically building as little as possible, and developing inexpensive but effective solutions by recycling, regenerating and repurposing."

Taking their design cues from the building's original use, boots are displayed from the ceiling—like bunches of bananas—and box rolling racks that were found in the basement are now used as unusual display tables. Cardboard banana boxes are stacked on specially designed racking to create a stock-holding wall at the rear of the store. There is a true "community space" in the store in which Timberland forges a real connection with the people of the neighborhood. Here local artists can show

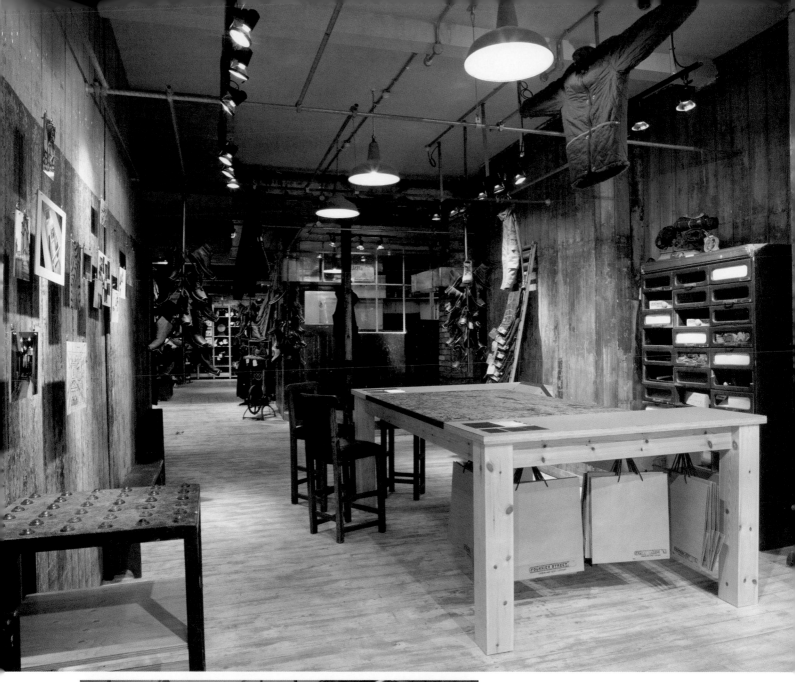

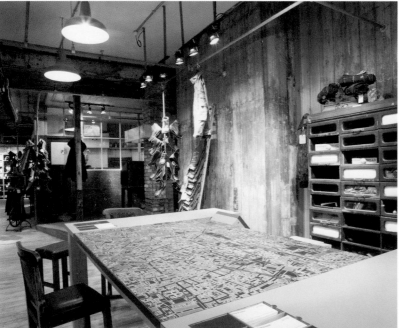

DESIGN: **Checkland Kindleysides,** London, UK
PHOTOGRAPHY: **Keith Parry,** London, UK

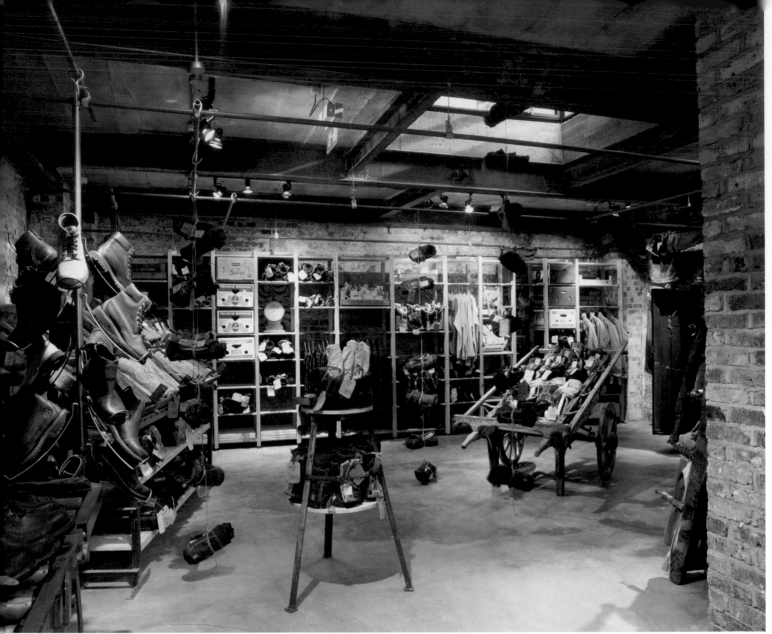

and sell their work and also collaborate on community based art projects. It becomes "a center for appreciation of art, culture, and local community." Combined with its community involvement, Timberland seeks to create strong and involving relationships with its consumers.

"The place based approach lead to solutions that would otherwise not have been explored. It provides a unique and iconic look for the Timberland Boot Company in this store."

TIMBERLAND

Macy's, Herald Square, New York, NY

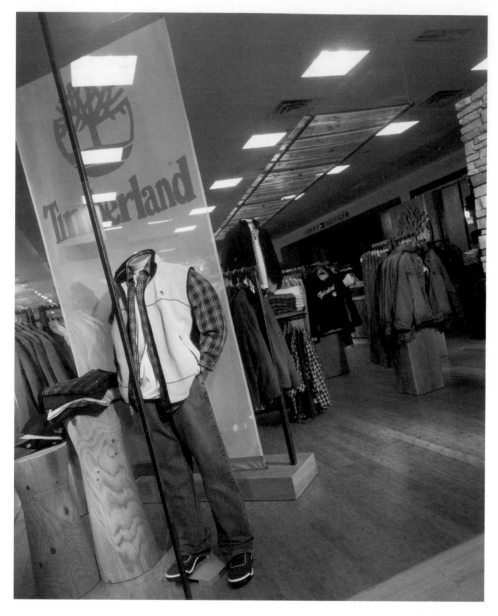

DESIGN: **FRCH Design World Wide,** Cincinnati, OH
PRINCIPAL IN CHARGE/CCO: **Paul Lechleiter**
VP/DESIGN, CREATIVE DIRECTOR: **Christian Davies**
VP/SPEC. RETAIL ARCHITECTURE: **Shane Kavanagh**
PROJECT DIRECTOR: **Scott Frazier**
PRODUCTION MANAGER: **Brandon Jansen**
INTERIOR DESIGN: **Mari Miura**
NEW MEDIA: **Dan Reynolds**
RESOURCE DESIGN DIRECTOR: **Lori Kolthoff**

For Timberland:
SR. DIRECTOR GLOBAL CREATIVE SERVICES: **Bevan Bloemendaal**
PROJECT MANAGER: **Jan Massey**
VM MANAGER: **Amy Tauchert**

PHOTOGRAPHY: **Mark Steele Photography,** Columbus, OH

The challenge for the FRCH design team was to capture the brand essence of Timberland and deliver that brand —consistent with its image—in a powerful, flexible yet cost-effective design that would function as a shop-within-a-shop in department and specialty stores. Shown here is the design as it appears in an 1,100 sq. ft. space in Macy's flagship store in New York City.

To maintain "the consistency and integrity of the Timberland brand image," the designers integrated signature elements from the prototype and flagship Timberland stores that communicate the brand attributes: Craftsmanship, Community Responsibility, Of the Outdoors. The "outdoors" are brought indoors through the use of natural materials. The floor is laid with highly replenishable and thus eco-minded bamboo and bulky blocks of wood serve as bases for some of the feature floor fixtures. Bark-less chunks of natural wood become multi-level risers for product display

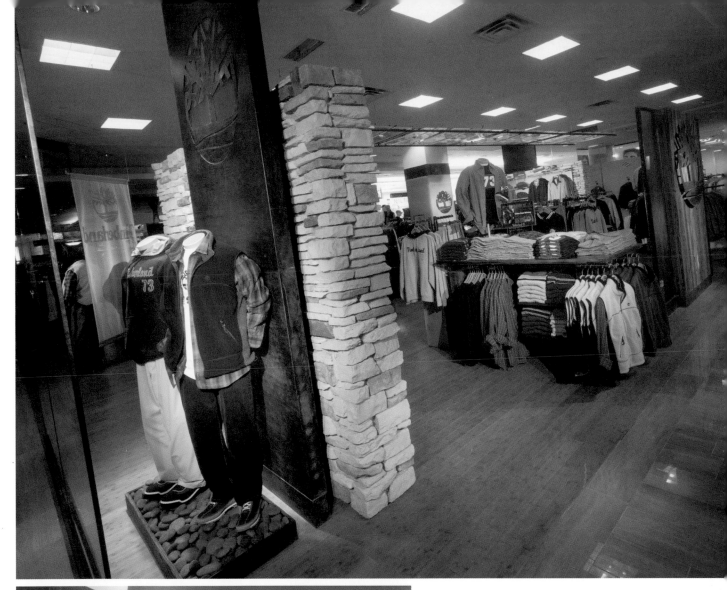

and stacked rocks create a remarkable background for the antiqued copper panel with the laser cut Timberland tree logo up in front of the vendor shop. The headless forms wearing the Timberland casual outfits stand in platform boxes lined with river stones. Throughout the space Timberland's signature orange leather is used to sheath the columns.

Behind the cash/wrap desk—constructed of rough, antiques barn timber and amber glass—is a timber-covered panel with a large copper cut-out of the tree logo. Suspended from the ceiling is a trellis of plastic panels embedded with twigs, foliage and other natural decoratives such as fall leaves, winter ice crystals, etc. "All these elements work together to create a lifestyle statement that reflects the aspirations—if not always the reality—of the Timberland consumer."

SPEEDO

Covent Garden, London, UK

DESIGN: **Dalziel + Pow,** London, UK

A new global retail design for Speedo was unveiled in their flagship store in Covent Garden in London. As designed by Dalziel+Pow, the design will eventually be rolled out across 300 retail outlets worldwide. The new concept has been developed to "reflect the personality of the brand while showcasing the full breadth of product available." Featured in the new design is the new designer collection, Speedo by Rosa Cha, as well as everyday beachwear and the high performance swimwear and equipment used by professional athletes/swimmers.

An illuminated blue ripple wall at the entrance echoes "recollections of water and sky." There are interchangeable display cases here that highlight Speedo's technical products and innovations and they are backed up by a sweeping graphic of a swimmer. The

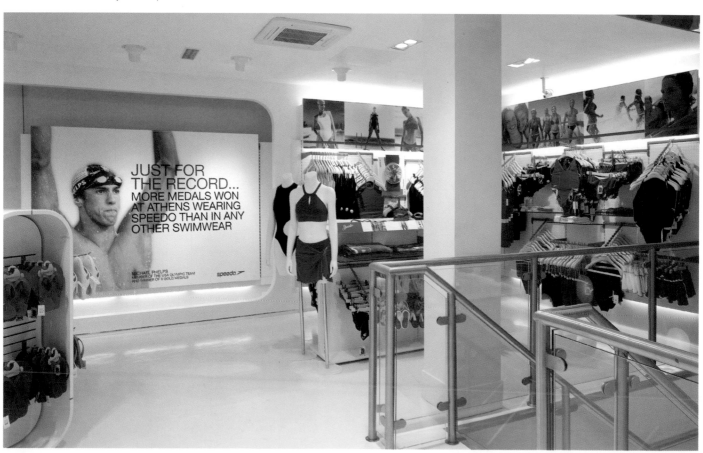

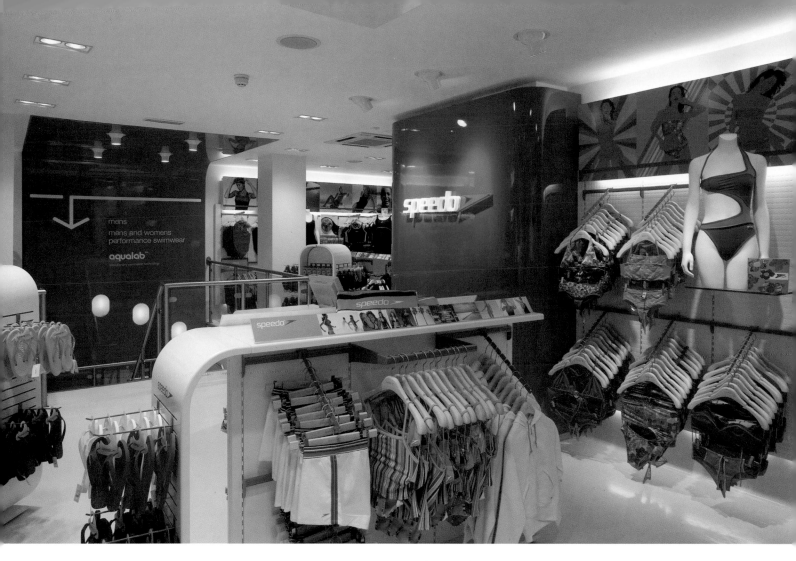

interior design is clean and contemporary with white textured walls and ceiling and white rubber sand resin coated floors. There are bold splashes of Speedo's signature red introduced on some accent walls of this two-level

store as well as graphics that highlight the range of merchandise in the shop. These graphics are constantly being updated—kept seasonally on target and they co-exist with the heritage imagery that "communicates the authenticity of the brand."

Starting on the white ceiling, making a right angle and continuing down the two-level wall that connects the ground level with the floor beneath is a bright red band of color. It serves to direct shoppers to the lower level. This connecting link is a strong focal point and is not likely to be missed. It is an architectural exclamation point. On the lower level, in an almost all-white ambience with the same sort of rounded end floor fixtures and the gentle curves seen on the ground level, is the Aqualab area. Here, on a centrally-located table with bull-nose edges, customers can receive information and expert advice on Speedo's technical and innovative products. There are two touch screens

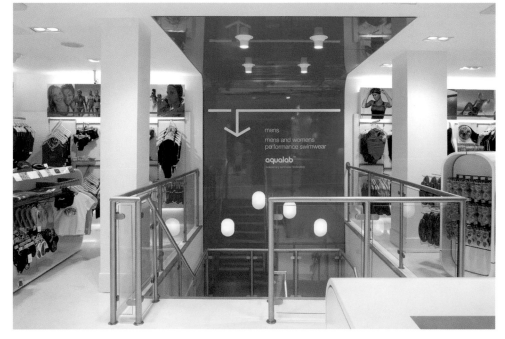

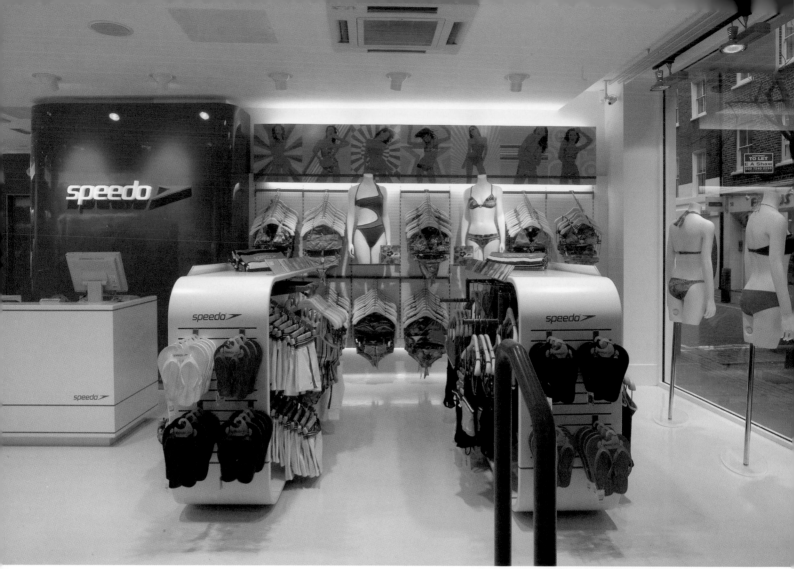

that are a fun way for customers to take a virtual tour around the Aqualab.

Tony Wood, President of Speedo International, said, "The new design concept is engaging to our customers and highlighting our swim heritage. We have chosen a contemporary, innovative design which reinforces Speedo as a source of authority in the swimwear arena." According to David Dalziel, a principal in Dalziel+Pow, "Our concept for Speedo creates a Flagship Boutique, but has a future life far beyond this application. It is designed with five or six memorable details that can be exploited in a roll out. The color and soft line reflect the sports heritage of the brand, and the merchandising and imagery bring out the fashion element."

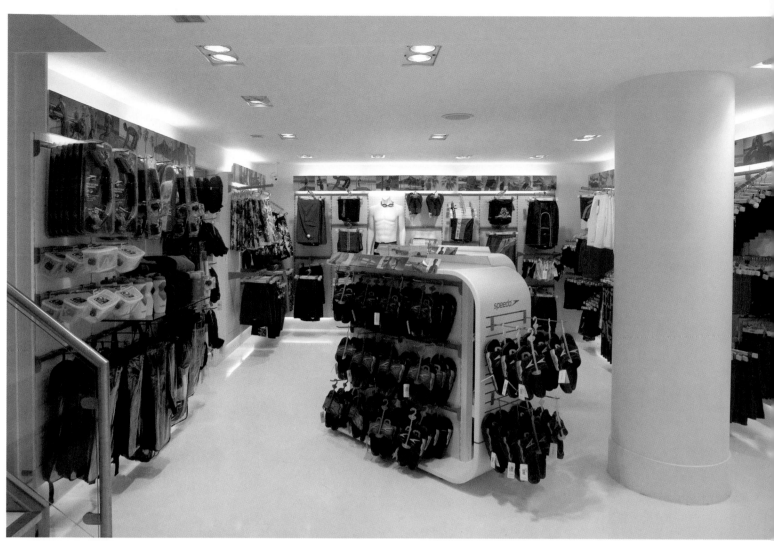

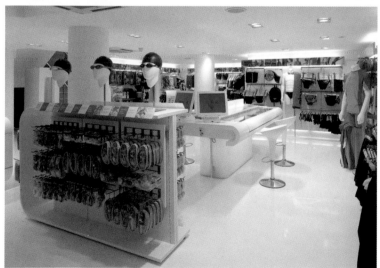

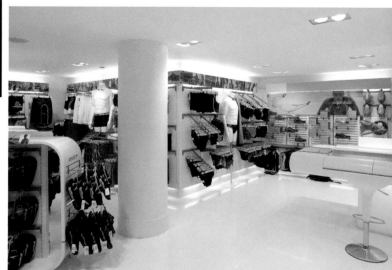

SPEEDO: VENDOR SHOP & FIXTURES

Selfridges, Oxford St., London, UK

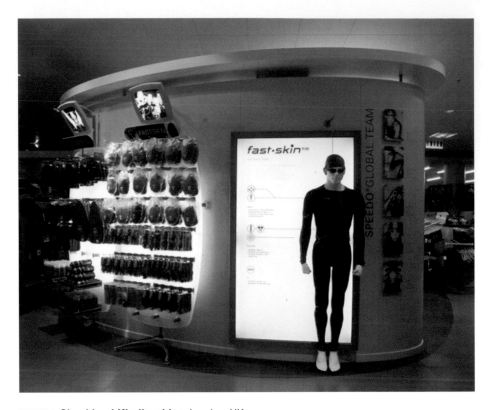

DESIGN: **Checkland Kindleysides,** London, UK

Speedo was only one of the three brands that was invited to set up a vendor's shop for "competitive sports" on Selfridges' new sports floor in the London flagship store on Oxford St. Checkland Kindlysides not only designed the small shop-within-the-shop but a line of fixtures for Speedo's Fast Skin product line that can be used in Speedo outlets around the world.

At the entry to the concession is a "water wall"—behind the cash/wrap —and this "captures the energy and spirit of the brand." The Speedo Fast Skin product is dramatically introduced on a mannequin to "show the scale and nature of the product" while graphics and interactive displays convey the technology behind the concept.

The specially designed white translucent plastic and metal fixtures with rounded edges are designed to be multi-functional. They can hold trays, shelves, hooks or pronged attachments. These fixtures are produced full round to be self-standing on the floor or half-round to be used against walls or partitions.

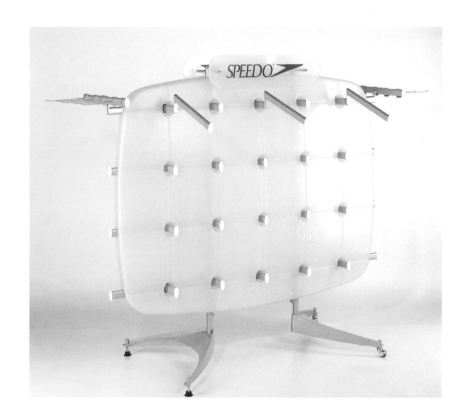

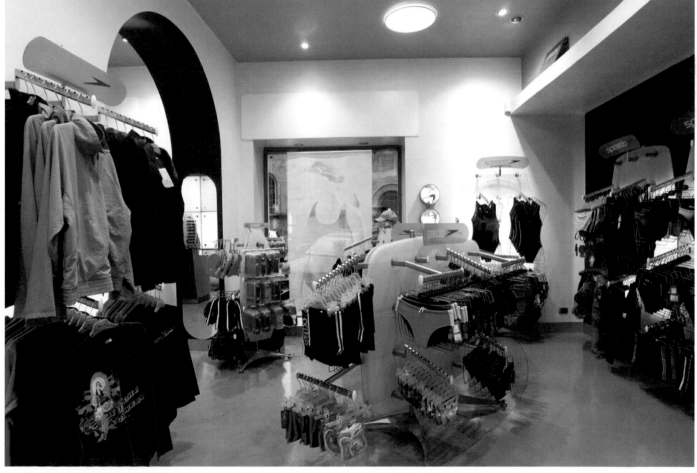

MICHAEL K

Broadway, Soho, New York, NY

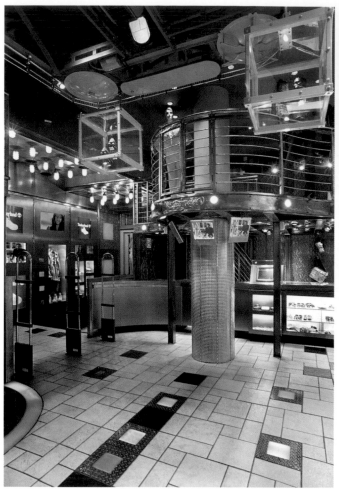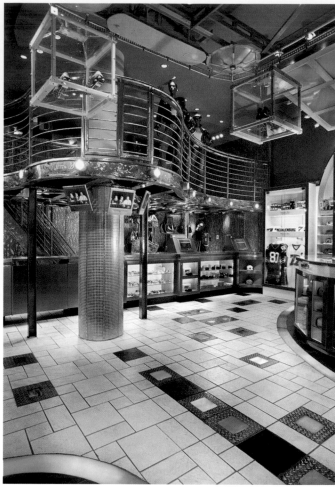

When is a retail store more than a retail store? When it is a mini-mall: a collection of brand-name boutiques beautifully coordinated and controlled under a single retail brand image. That describes the new Michael K operation on the booming horizontal mall that stretches along lower Broadway in Soho.

The 22,000-square-foot space is on two levels (street and below ground) of a seven story landmark building and is dedicated to "some of the slickest, coolest, urban hip-hop, upscale, out front and over-the-top Euro-chic and fusion fashions on the face of the earth." There are numerous noted brand names in this store including Ben Sherman, LaCoste, Polo Jeans, Adidas, Nike, Puma,

Blue, Fred Perry, Sean John, etc.
Upon entering the store one is immediately engulfed by the lights—the colors—the movement of the glass cubes rolling overhead and filled with featured footwear and accessories and the throbbing, thumping sound emanating from the DJ's booth. There are sights and sounds all around with 200 video screens ranging from giant projector screens to plasma monitors, LCDs and even small screens embedded into the tiled floor where they share the attention with the changing colored lights that lead shoppers through the long, narrow space. Overhead, canopies filled with squares of changing colored lights mark off the individual boutiques while adding a sense of oneness o the

DESIGN: **Tobin + Parnes,** New York, NY
PRINCIPALS: **Carol Tobin & Robert Parnes**
PROJECT ARCHITECT/DESIGNER: **Vlad Zadneprianski**

GENERAL CONTRACTOR: **VCS Corp.,** Irvington, NY
LIGHTING CONSULTANT: **Design One,** New York, NY
AUDIO/VISUAL CONSULTANT: **AV&C,** New York, NY
PHOTOGRAPHY: **Ruggero Vammi,** New York, NY

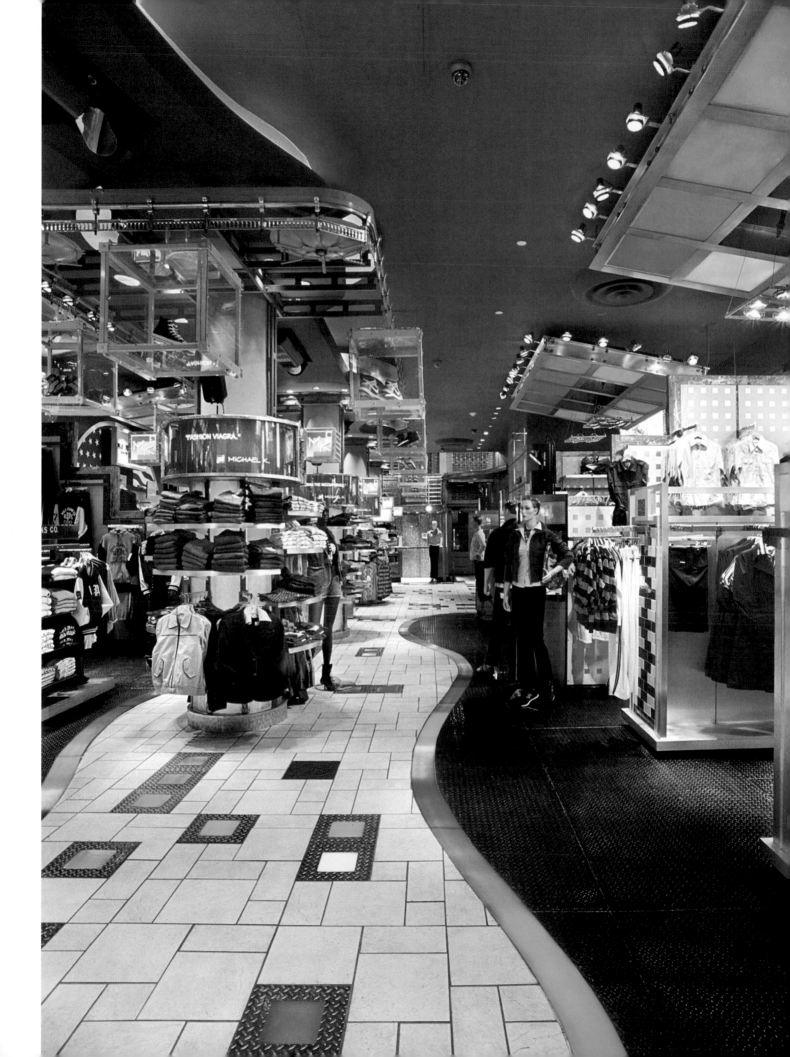

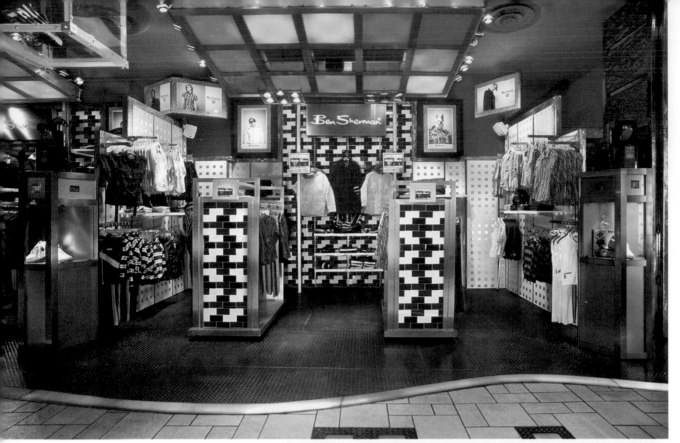

entire main floor. "There is no corner in which image, light and sound are not in play at Michael K." There is a casino-style overhead video camera system for "content creation"; programmable lighting with LEDs; strobes and laser lights; story walls with video screens; signage; recessed display cases and the previously-mentioned overhead conveyors. Since every surface is covered in metal (smooth, hammered, burnished, raw, painted, stressed) "light and sound are made to bounce—creating a chamber of irresistible sensory stimulation." Vlad Zadneprianski, the project architect/designer at Tobin + Parnes Design Enterprises—the store's designers—said, "The environment we have created invites the consumer to become a performer on some level. There is music everywhere, motion everywhere, light, color and excitement. You can't help but feel a part of it."

The shopper easily moves through the area and can readily "discover" the particular brand name boutique he or she is looking for. Each area is created to simulate the look or brand image of the particular manufacturer or designer. It is done by color, materials, fixtures, graphics—the key signature ele-

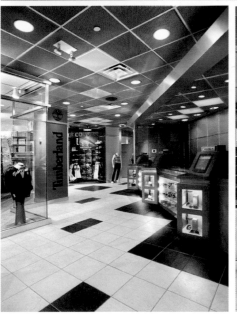

ments in the particular brand's own retail image. And yet, each of the boutiques blends into the overall look and feeling that is the Michael K look. The structural columns that punctuate the high-ceilinged main floor have been cleverly made into merchandising elements. Blue lighting emanates from behind translucent panels covered with steel mesh that envelop the columns. Shelves encircle the columns which are then capped with translucent drums carrying "messages" from Michael K such as "Fashion is for rookies. Style is the big league." There are stations along the way where watches, sunglasses and other fashion accessories are displayed. Behind one of these outposts, in the center of the space and near the dressing rooms, is a giant, 20-foot-high wall filled with TV monitors. Directly in front of this wall that pulsates with images and colors, is the high-tech stairway that leads to the lower level where Timberlake, Puma, Adidas and Nike re-create their own unique looks within the Michael K ambiance.

Michael K—actually Haim Michael Kedmi—owns and operates two fashion chains, Active Wearhouse and Transit. All of his 17 stores are devoted to the same kind of fashions and the same type of customer. Working closely with the team at Tobin + Parnes he was able—with this spectacular store—to "clarify his vision of what it means for the consumer to have a totally unique, exciting and satisfying shopping experience." This store is a tour de force!

VLAD ZADNEPRIANSKI
Project Architect/Designer of MICHAEL K

MARTIN M. PEGLER: I was quite impressed with the new Michael K and would like to discuss with you "how" it was all accomplished. It really is more than a store—more like a "mini-mall" of boutiques geared to the same demographic audience. How did you go about creating a unique character for each designer/ brand name in its own space?

VLAD ZADNEPRIANSKI: Michael K is truly a "store-within-a-store" concept where you can find very different brands under one roof. That was challenge number one—to find aesthetical balance between individuality of each vendor shop and integrity of overall design. We worked with different vendors. Some shops we designed ourselves (among them Ben Sherman, Akademiks, Onitsuka Tiger, Fred Perry and Blue by Sean John), on some we worked closely with vendor designers (Nike and Puma), and for some of the shops we reviewed vendor designer's drawings and gave our recommendations (Timberland, Lacoste and Adidas). Some vendors were willing to create something different for this kind of retail experience, some were comfortable with what they had. But no matter who was the vendor, we had to learn a lot about him, his product, philosophy and history behind product, preferences in displaying and merchandising, his customers and how his customers would conceive the shop inside the Michael K environment.

MMP: OK—as an example—let's talk about the design of the Ben Sherman shop that you designed.
VZ: I studied closely their flagship store on Carnaby Street in London. On my first sketches you can see lots of design elements from that store.

But after reviewing sketches and rough construction cost estimates, we agreed on a different space treatment and different finishes and display fixtures, keeping overall the Ben Sherman feeling but incorporating only the tile feature wall as a vendor "signature" design element. We also used Michael K store "tools" to enhance the Ben Sherman image —and all the other ground floor vendor shops— LCD screens on the main wall and display fixtures, overhead "trellis" with color changing LED lights— which could be programmed to play Sherman's red, white and blue colors—mini-scan light fixtures on each

side of the shop that can project a moving logo on the floor.

MMP: I wouldn't somehow expect to see either Lacoste or Fred Perry lines of sportswear in a store dedicated to a hip and urban teens-through-twenties market. How did you work their brand images to be compatible with the Michael K shopper?
VZ: Again—I started first just studying everything I could find and learning my way from Mods through Skinheads, Rude Boys, Punks... But after we sat down with the vendor and Haim Kedmi (the owner of

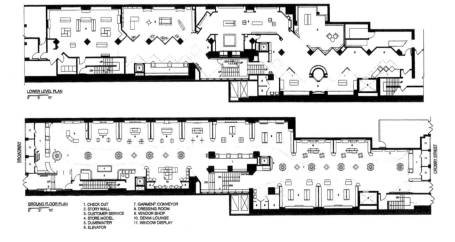

Michael K) we decided to steer into a different direction. So we designed it as a shop to sell "shirts that fit" and tailored it to fit into the environment of Michael K—made it compatible with its customer which includes customers in their 30s as well. Trying to tell a distinctive story about each brand using design and media tools, we wanted the shops at the same time to be an integral part of Michael K and feel natural next to the other shops.

MMP: There is lots of Action! Music! and Lights! flowing throughout the two levels of the store. And yet—there is a distinctly unified feeling—a oneness about the overall space. How did you accomplish that?

VZ: All the ground floor shops have the same "skeleton": back wall with an arch in the middle, stepped down side walls with display cabinets at the end, trellis with changing lights above the space, wall mounted boxes for vendor graphics and vendor flooring is the same black diamond plate. All this helps to unify the shops. The common back wall going through all the shops is painted a strong terra cotta color; all the vendor walls are

constructed using the same brushed steel frames and wall standards. We just had to find the right finishes to tell each vendor's story but not allowing one to break out of the overall Michael K environment. Other elements helped too— such as the tile-finished walkway in the middle—a sort of "yellow brick road"—not only

on the main floor but via the Grand Stair down to the lower level walkway. On the ground level there are LED strips at the perimeter of the walkway that also visually unify the store using color-changing light that helps move the customers while creating excitement. Echoing this floor-mounted light strips is another LED strip cove light installed high above on the continuous soffits. Also there is the moving overhead conveyor running through the entire space carrying display cubes. As far as "taming" the individual shops—we mostly played the right finishes and colors— carefully designed vendor sign boxes, display fixtures, etc.

MMP: The DJ is not only audible throughout the store but he is visible and obviously part of the ambiance. What's that all about?

135

VZ: The entertainment factor plays a major role at Michael K. We designed the retail space with a fully functional event space in mind: theatrical lighting and sound technology contribute to a DJ's written "show" that is performed on an hourly basis. Lights dim, haze and stage scan machines produce theatrical smoke while moving laser lights project vendor logos, graphics and media messages throughout the space. And the DJ is in the middle of all this. Even though there are almost 200 screens around the store, we placed them carefully: inside the floor tile to create accents, in the floor near checkouts and the elevator so that the customer can watch while waiting, on the walls in the vendor shops to tell the story about the brand— using videos or slide shows—and even near the DJ's booth.

MMP: But what about the noise level?
VZ: A problem. We had to protect residential units above the store from unwanted loud music. Working with an acoustical engineer we now have layers and layers of soundproofing materials above the visible store ceiling.

MMP: You were working in a century old, cast iron landmark building with 20-foot ceilings and cast iron columns running down the length of your floor. How did you integrate these elements into your design and turn obstacles into assets?
VZ: We turned the columns into assets: built display kiosks around each column—creating little shops for smaller vendors. Each kiosk has unified standards for shelving, light box on top for graphics and smaller boxes on the sides for logos. Each kiosk was pre-wired for possible video installation and has blue light behind the perforated metal background. There was also an existing skylight— also landmark—so we exposed it into the store and placed changing color LED lights behind it to create a dramatic effect and tie it in with the rest

of the store technology—and the overall look.

MMP: It is obvious—and retailers don't like to talk about it—but how do you get a shopper to come down and shop underground? I saw how you opened up the area leading to the basement but why don't you tell us what you did—and why?
VZ: At the beginning we considered escalators but ended up putting the Grand Stair in the middle of the store and closing up an existing building courtyard. To help bring customers into the Grand Stair area we played a bit with floor tile patterns and we created the 30-foot Grand Story Wall

that consists of metal panels with color changing LED boxes and different sizes LCD screens—all arranged in a Mondrian-ish pattern. On the wall opposite the Grand Story Wall we used a mirror finish to visually widen the space. Also there are five projection screens here and if necessary they roll down to cover the wall and serve as a background for videos from two projectors hidden in the checkout soffit. This also draws crowds and helps to bring them down to the lower level after the show ends.

MMP: I was especially taken with the Nike Active shop on the lower level. I loved the merchandising con-

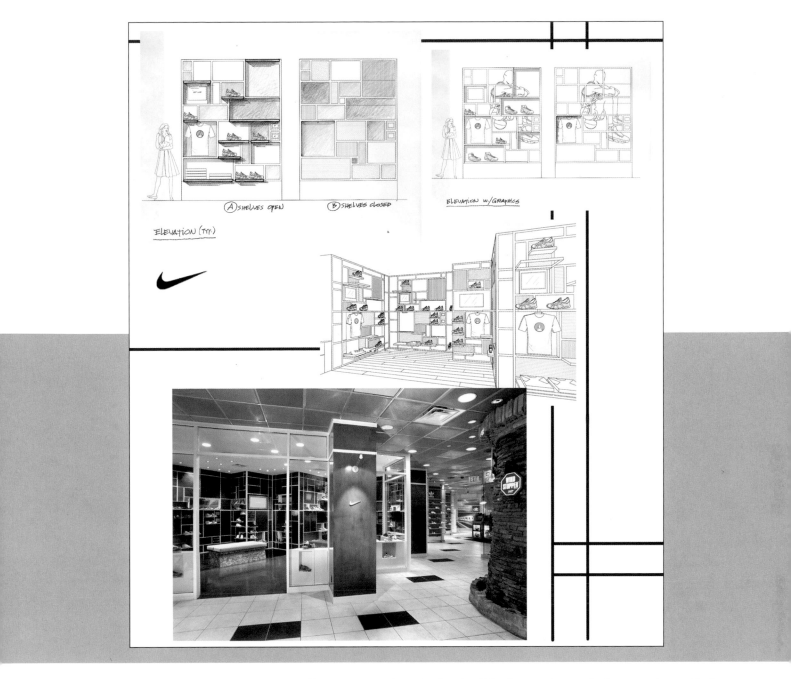

ELEVATION (TYP.)

(A) SHELVES OPEN (B) SHELVES CLOSED ELEVATION w/GRAPHICS

cept. Shelves drop down to show off shoes or flip flat against the wall and hold stock hidden from view. Tell us about that.

VZ: We designed that shop with the Nike designers. They came up with the idea of flipping panels that could be used as display shelves or backgrounds for graphics. So I developed this idea and created this sort of Mondrian or Malevitch pattern—with various size multi-functional panels—and prepared shop drawings—drew some panels with magic marker right on the shop's walls—chose locations for video screens and went over everything with the woodworker. The trick was to find the right hardware.

MMP: Explain the "ice box" look you created for the Puma shop on the lower level.

VZ: The reason behind the "refrigerators" simulated in the fixturing in the Puma shop is that some of their shoes are so "hot" they have to be kept cool in refrigerated displays.

MMP: Now that Michael K is open and operational—do you think your firm fulfilled the client's vision?

VZ: Haim's design objective was to create an exciting, unique and shopper-friendly retail environment that would involve and engage all aspects of the customer's senses, emotions and lifestyle. We did spend a lot of

time with Haim, trying to find ways of materializing many of his ideas, coming up with new ideas—constantly changing things as the store was shaping up—pushing the envelope—researching new technology—learning about brands and customers.

This store is truly all about his expectations.

MMP: Thanks for your time—and for a store that I'm sure sets new parameters for other stores opening up on Lower Broadway. Michael K has raised the level of expectation for the teen-to-twenty—even into-thirty crowd that shops down here.

KEY WEST ALOE

Key West, FL

DESIGN: **Pavlik Design Team,** Ft. Lauderdale, FL
PRESIDENT/CEO: **RJ Pavlik**
DIRECTOR OF PROJECTS: **Armando Castillo**
CREATIVE DIRECTOR: **Sherif Ayad**
SR. DIGITAL ARCHITECTURAL DESIGN: **Byoung-KooLee**
SR. 3D ARTS & GRAPHICS DESIGN: **Roberto Mercado**
PROJECT DESIGNER: **Caroline Diaz**
GRAPHIC DESIGNER: **Ximena Navarrete**
GRAPHIC DESIGNER: **Jennifer Veltre**
LIGHTING DESIGN: **Amy Ann Ehmke**

For the Client
CEO: **Rich Gorman**
PRESIDENT: **Mike Gorman**
RETAIL MANAGER: **Cynthia Tynes**
MERCHANDISE MANAGER: **Jacques Bordage**

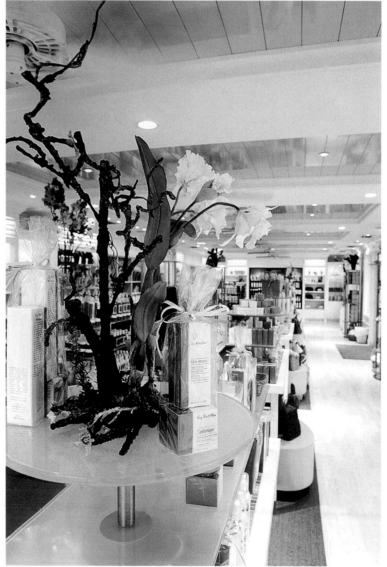

The challenge for the Pavlik Design Team of Ft. Lauderdale, FL was to design a flagship prototype store for Key West Aloe that would establish it as a "new cohesive branding experience." Working in a rather small footprint, the designers had to provide flexibility and a structural organization program to represent Key West Aloe's extensive variety of skin, hair and beauty products, and that meant a modular fixture system that would be suitable for roll-outs—but still look like a "one off" destination. Since Key West figures prominently in the name, they wanted to "capture the distinctive charm of Key West with its tropical and relaxed island attitude through the use of architectural details, materials, colors, patterns, visuals, lighting and graphic representations."

The finished store, shown here, is organized into three zones through the floor covering layout and the coffered

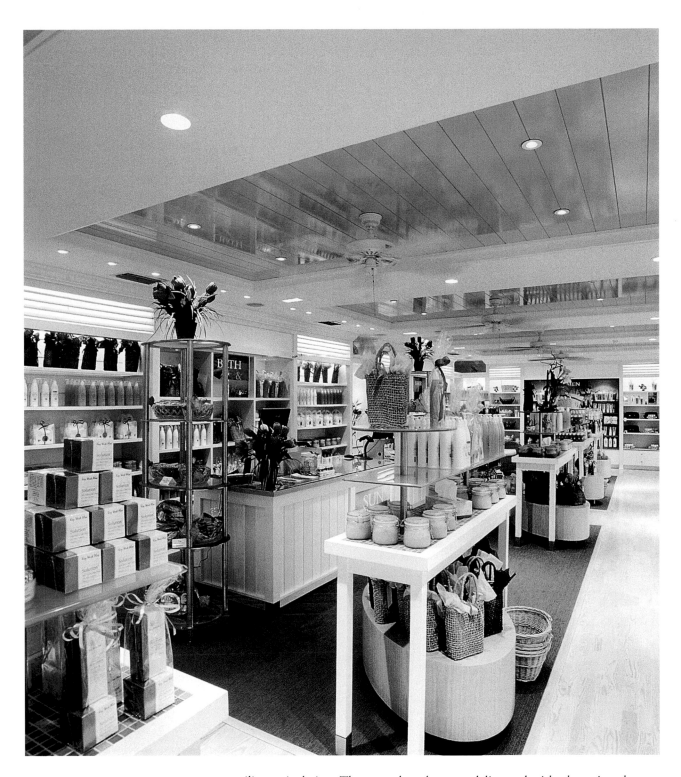

ceiling articulation. The warmth and charm of the Key West shop is introduced in the cool color palette, the natural wood floors and the sisal carpeting. A Bahamian influence in historic Key West residences is the inland slatboard that is here used on the low ceiling coffers. The insets are finished in a highly reflective blue lacquer. The perimeter wall fixtures are modular but appear to be "built in."

These "cabana" style wall fixtures are delineated with plantation shutter valances, miniature drawers, frosted glass shelving and striped bead board. To create a "signature" look the fixtures have a "hand painted" finish. The lacquer is actually brushed on. Another signature look has the back panel liners made of island bead board painted with a distinctive lime green and white stripe pattern. Throughout, three shades of off-white were used with subtle color accents

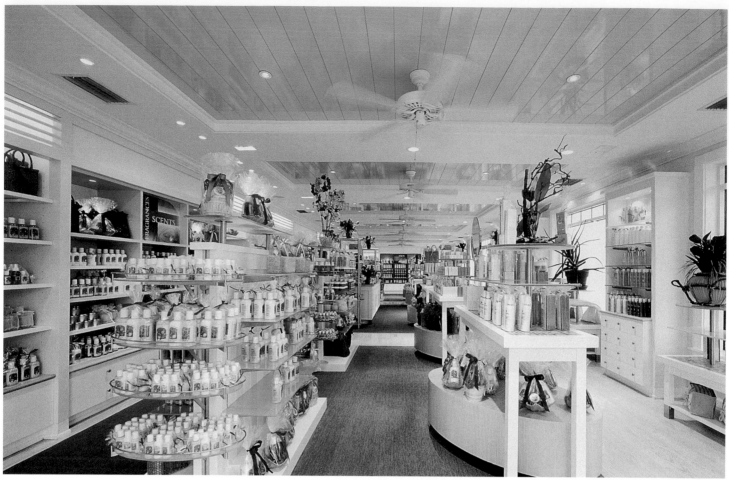

that complement the package designs.

Pavlik designed special floor fixtures for this shop including frosted glass towers, oval shaped drum-like bunkers, mosaic tiled country tables and workhorses with bead board back panels and frosted glass riders. They also developed the new logo to complement the repositioning of the brand as well as a new, in-store modular signage system and departmental graphic colors to promote and identify the various categories of product.

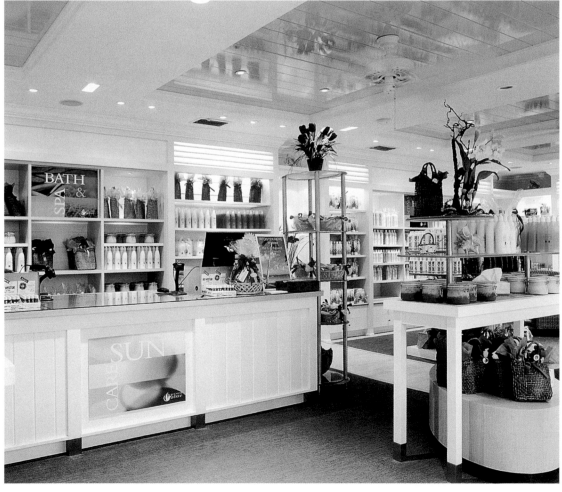

JACQUES DESPARS

Place Rosemere, QC, Canada

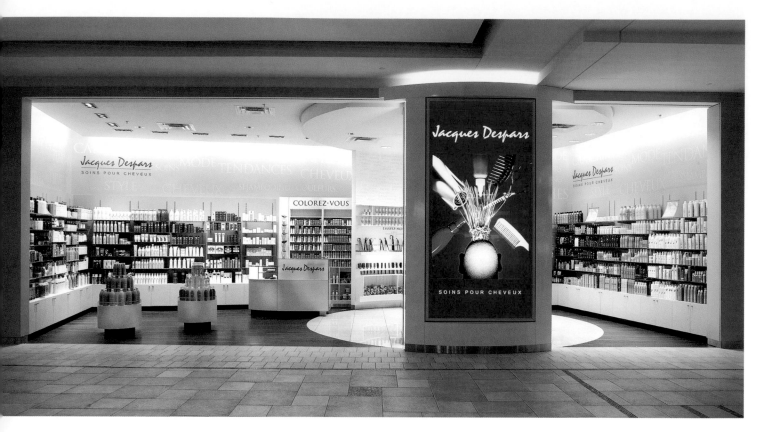

Jacques Despars is a successful chain of 16 full-service hair salons normally located in the side corridors of regional malls. The client wanted to develop "high profile, quality locations in better traffic areas of the malls for the sale of exclusive lines of hair care and beauty products." Thus, the evolution of the Jacques Despars Store. The prototype, developed by GHA Shoppingscapes of Montreal, appeared in Place Rosemere in Quebec and the design took into consideration the ease and practicality of rolling out these stores in other malls while maintaining the high-quality retail image and further enhancing the Jacques Despars Salon brand image.

The design concept suggests the environment of a quality spa. A strong design statement with restrained detailing integrates the three distinct areas of the shop: the exclusive cosmetics line, the hair products and the

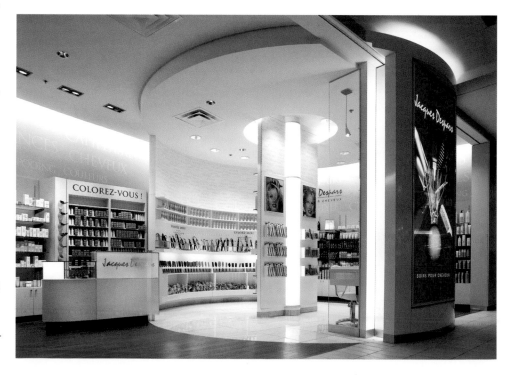

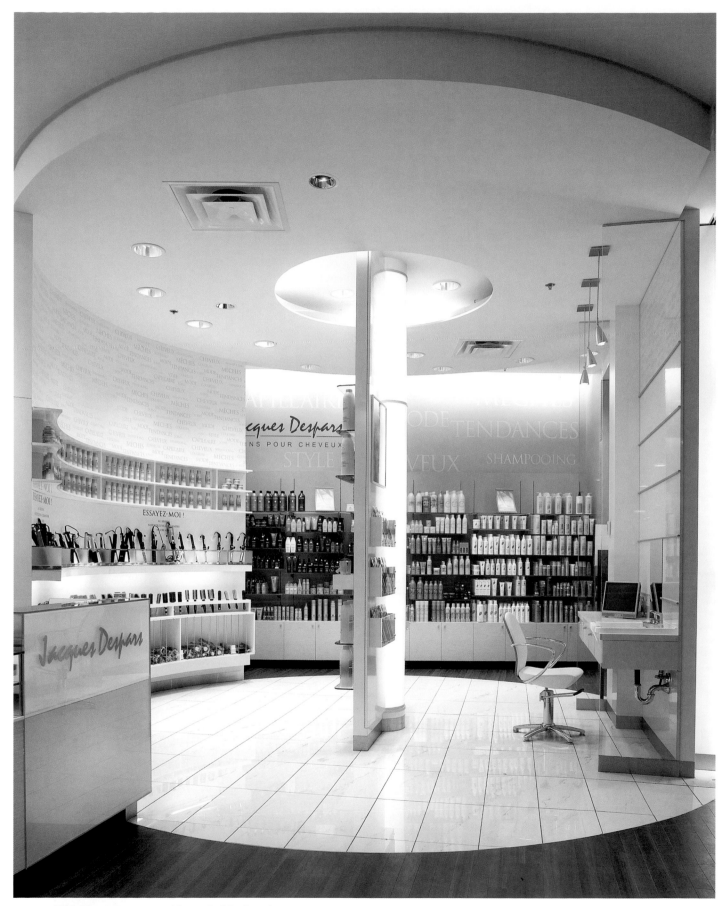

DESIGN: **GHA Shoppingscapes,** Montreal, QC, Canada
VP: **Steve Sutton**
SR. DESIGNER: **Samuel Steimer**
PHOTOGRAPHY: **Yvan Lefebvre**

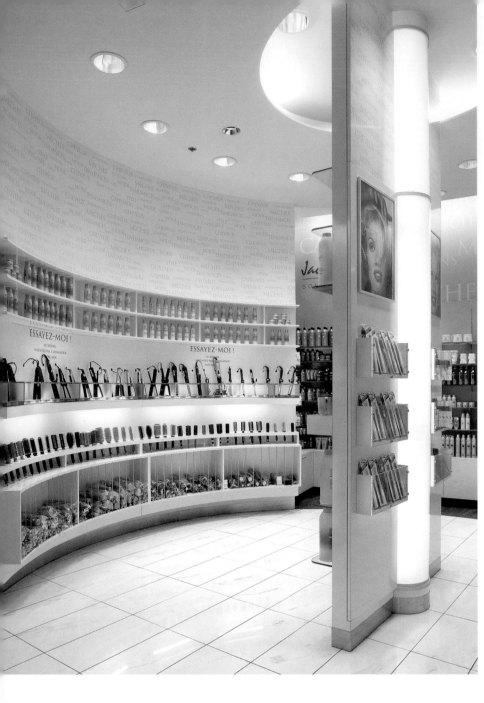

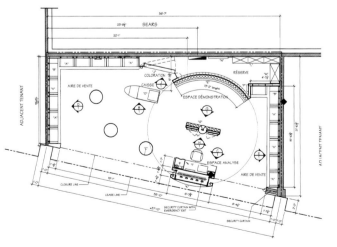

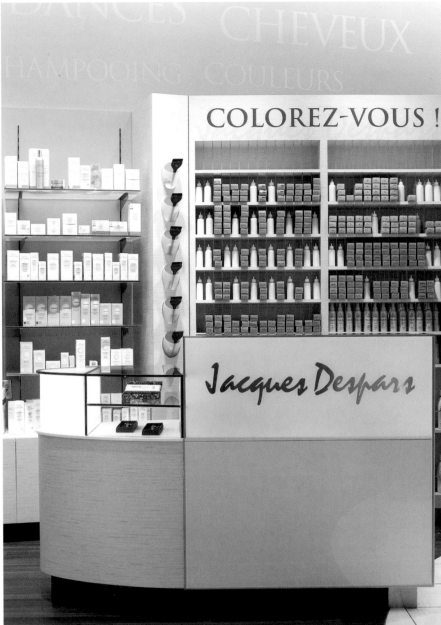

"lab." "The very wide openness of the storefront as well as the placement of the lighting in the "lab" at front-and-center challenge our usual expectation—arousing interest and interaction." A rotunda "lab" is featured in the center of the space and the area is accentuated with brighter lighting, distinct flooring "and a cool, clinical contrast to the seductive coloring of the store around it." Here the beauticians/hair specialists have a "discrete area" for consultations, product advice and with the integral video/internet station the consultants can introduce new services and techniques available in the salons. Hair-dryers, brushes,

combs and other hard good equipment are available in the "lab" while consumable hair and beauty products are displayed in the balance of the space. The "lab" serves as an icon for the store with its illuminated front panel and the glowing ambience of tempered glass, stainless steel and shiny laminates. While the floor in the "lab" is cast stone, the balance of the floor is striped vinyl simulating two tones of wood. A fresh verbena green color permeates and fills the space and backs up the products presented on steel and glass merchandising units with light wood laminate shelving and storage units. A tone-on-

tone graphic pattern of words and phrases gently textures the walls of the "lab" and the selling areas.

"Throughout the look is simple, clean ands cool with subtle graphic text elements and no distracting P.O.P. material." Lines and items are identified with custom signage. The new concept provides more shelf space for the display of the company's hair and beauty products than is available in the salons. The client is delighted with the reception and the results produced by this new concept which, in a way, is an extension of the kiosk they use in high-traffic areas.

JACQUES DESPARS KIOSK

Malls in Canada

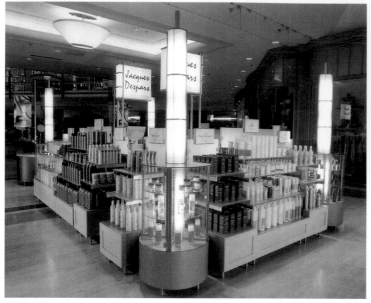

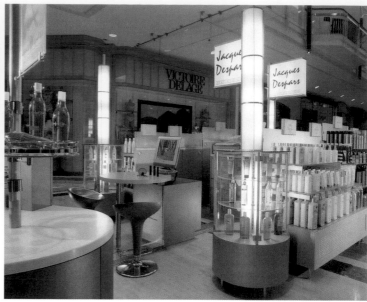

DESIGN: **GHA Shoppingscapes,** Montreal, QC, Canada
VP: **Steve Sutton**
PHOTOGRAPHY: **Yvan Lefebvre**

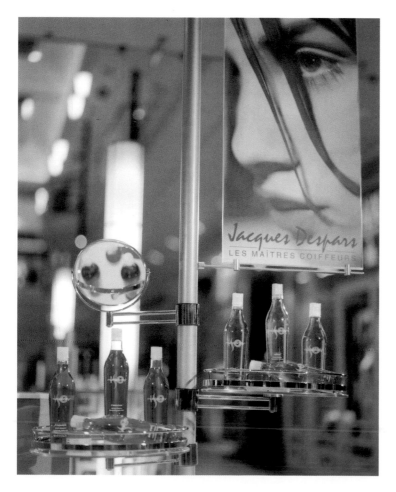

Before the Jacques Despar store was in effect, the company wanted to develop satellite kiosks that would appear in high traffic areas in malls and serve as sales spaces for the company's hair care and beauty products The design concept as conceived by GHA Shopping-scapes of Montreal suggests a high-quality spa within the confines of a kiosk space. In this limited arrangement of modular pieces there is a "discrete area" where the Despars associates can offer personal consultations and market the services available in the salons.

The kiosk is divided into three areas:
• A kidney-shaped island featuring exclusive cosmetic lines
• A U-shaped modular configuration of hair products.
• A personal consultation area, secluded from the mall circulation and equipped with seating and a table. A video/Internet station is integral to this area and with it the sales associates can

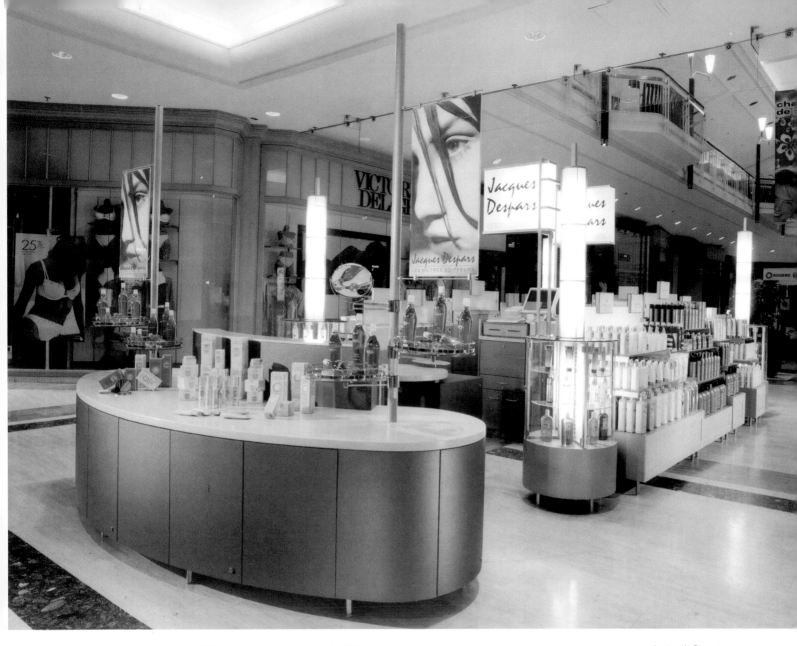

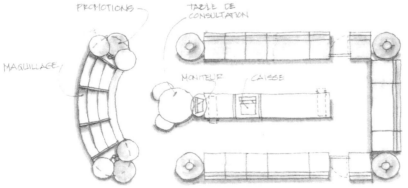

PROMOTIONS

TABLE DE
CONSULTATION

MAQUILLAGE

MONITEUR CAISSE

cent, wave-textured vinyl flooring material is used as insert panels and they are combined with a pale green Corian surround. Vertical graphic panels provide more opportunities to recommend visits to the salons. "By establishing a strong design statement, the kiosk succeeds in integrating these various elements as well as the presentation of a multitude of product lines. Lighting, colors and fixtures suggest the fittings of a luxury spa—a refuge for the senses ion a high traffic area. "The openness promotes communication between the staff and the customers. Since all the pieces are modular, units can be added as needed to re-configure or adapt the kiosk to different locations and different shape spaces.

explain product and technologies.

Four illuminated columns descend into and illuminate the display cases and create a "glowing ambience" that becomes the kiosk's signature. Fresh, velvety, mint green laminates, brushed aluminum and etched glass are used for the fixtures and an irides-

It was well over a year ago that I was sitting around with some of my colleagues at the Fashion Institute of Technology in New York and we were—once again—bemoaning the "death" of display. Display had been declared "dead" so many times that one would wonder why we were even discussing the corpse except that it is one of the disciplines we teach.

For many of you—much too young to have lived through or personally witnessed the "Golden Age of Display"—the 1950s and '60s—you must wonder what we are grieving over. You never really experienced the excitement, the glamour and the drama of walking down Main Street, or Market Street or High Street and seeing vignette after vignette—window after window blooming with individual presentations of merchandise, decoratives and backgrounds. Each store had a personality, a look, a brand-image decades before retailers

and advertisers began all this talk of brand imaging the retail store. The display people may have been—and were—paid poorly by management but they were allowed free reign to express themselves and we had real stars—real celebrities and names that were recognized and acknowledged

by the industry. It was the sort of recognition that Simon Doonan and Linda Fargo get today and they are two or the stars who have never given up on display.

That period of heady visual excitement in retail ended in the early 1970s when the era of "bean-coun-

ters," management experts and efficiency people began and they decided that retailers were spending too much on display and they decided that display was passé. So, display people, here in the U.S., who long felt that they were not given their proper respect and recognition as "displaypersons"—along with the then industry "bible"—*Display World*—said goodbye to display and morphed into visual merchandisers.

And yet, year after year after year opulent, theatrical and over-the-top Christmas spectaculars draw standing-room-only crowds. Every so often some of the aware and hip retailers would hire young and eager talent and allow them to express the store's image or uniqueness with novel, intriguing and imaginative visual presentations. Often they were fun and as fun they would get attention from the shoppers on the street. However, it was

the efficiency experts that really won out as more and more department and chain specialty stores became reorganized under single purchasing agents and creative window designs became secondary to the ease and economy of installing the same trim across the country. Individual com-

munity eccentricities and ethnicities gave way to a universal company look. Someone in an office in Ohio or California prepared a generic display that was "reproduced" across the chain. Along with that came minimalizing: mannequins left the window scene to be replaced by forms; decoratives were replaced by graphics and universal sameness became the solution. Walking down shopping streets it was difficult to discern where The Gap left off and Club Monaco started. J Crew blended in with Banana Republic. Small retail operations jumped into this "draped form + graphic" formula and that made the sameness even more pronounced.

As the author/editor of the Store Windows books I can tell you that it became more and more difficult to find interesting and imaginative display expressions to fill the books. Thankfully there

are always some few intelligent and forward thinking retailers—even some department stores or specialty stores—that bucked the flow of sameness and hired creative designers to do windows that are different, that add drama to the merchandise and do add to the store's fashion image while glorifying the customers. The talent has always been there: the talent needed the space, the merchandise and the wherewithal to blossom out with shopper-stopping displays. Thus, after this last "death-watch" at F.I.T. as I walked down Fifth Avenue in New York—I was jolted. Something had changed. Something new—or old—was happening. I was seeing mannequins instead of forms. I was aware of decoratives creeping in and nudging out the tired, overdone, oversized graphics. Stores that had

been part of the sameness were stepping forward with new/old concepts. Ambience and atmosphere were being developed in these up till now neglected windows. A new spirit was evolving and that new spirit was old-fashioned display once again resuscitated—revived and resurrected. Window designers who had been Visual Merchandise Directors were now becoming Directors of Visual Presentations.

One of the proponents of this movement is Harry Bader, Creative Director for the Banana Republic flagship store on Fifth Avenue. What he had to say about the reversal/revival of window displays follows:

"In the past two years Banana Republic has evolved from a company that is product focused to one that is a brand focused company—with

the desire to entice customers to love our brand. As part of this strategy, Banana Republic is elevating consumer perceptions about the brand that is collection based with a designer sensibility. All key consumer touch points, therefore, must align to reinforce this position—including the product itself, advertising, in-store experience and windows.

To be perceived as a designer brand, one must act like a designer brand. This meant elevating the in-store experience and enticing customers to want to spend time in Banana Republic stores. A balance of high quality props and creative elements, unique display techniques, sophisticated styling, and the innovative use of art, imagery and music combine to create an engaging customer experience.

Windows were redefined to act as brand billboards and provide high brand impact to our customers passing by. Banana Republic has evolved from simply hanging advertising posters in windows (like most brands) to treating them differently each season. The inspiration comes from interior design, art and theater.

These enhancements were applied somewhat across the fleet of Banana Republic stores, while greater enhancements were implemented at our Flagship store. The five Flagship stores—located in chic, urban areas of New York, San Francisco, Los Angeles, and Chicago—represent the best expression of the Banana Republic brand. This is an important strategy for the brand since the customer in these areas is generally savvy and sophisticated and has many choices for shopping. Banana Republic must be at its best in order to compete."

If the national chains are waking up to the value of window displays as brand image presentations and if real displays—rather than "visual merchandising" exercises—start taking over center stage in the windows on shopping streets and in malls, how long will it be before retailers everywhere realize that they must start creating brand image making tableaux in their windows? It is devoutly to be wished for. Meanwhile—thanks to far-sighted companies like Banana Republic and stores such as Barneys, Bergdorf Goodman, Marshall Field's and others who never gave up on the value of display—display is back where it belongs.

For many years we have been pleased to be able to present the work of Peter Rank of Deko Rank, a display design service in Munich, Germany. Not only does Peter design and install windows for such prestigious shops such as Tiffany & Co., Cada and Froehlich Furs—all in Munich—but he often designs and makes his own props that give his displays such a unique quality.

Peter Rank started with an apprenticeship that evolved into an assistant to the window trimmer back in the 1960s. By the 1970s Peter felt he was ready to spread his own wings and show what he could do on his own. Rather than take the more secure department store route—which he felt would be confining—he ventured into freelancing in various and assorted areas of retail. According to Peter, "I am still working freelance and loving it. I am also doing lots of jewelry—fashion—shoe—furniture windows as well as creating decorative concepts for Escada, Laurel, Rodier and other designer boutiques. From time to time I do an event and part planning and décor. Anything new and interesting is a challenge that I relish. I just love putting things in the right light—in the spotlight—I should say. I guess that that's enough about me—just look at my work and see what you think!"

Well, we think that Peter Rank has been doing exciting and creative things for a long time. What we thought might be interesting is to show how he designs for a particular client—Froehlich Furs. Furs are not "dissed" in Europe as they are here in the U.S., and in Germany furs are often given lavish treatments in the windows. Froehlich Furs has been one of Peter Rank's oldest clients and he has "moved" along with them as they grew. He is currently working in their fifth store. "That means adapting to five different window situations—just for them." Peter is given carte blanche to do what he likes in the windows and we hope that you will be pleased to see how he treats the same space—keeps the store's retail brand image in the forefront and yet finds a variety of ways to express it—while attracting viewers to come closer and study the fabulous fur creations.

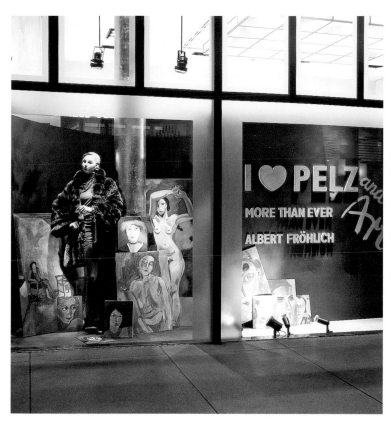

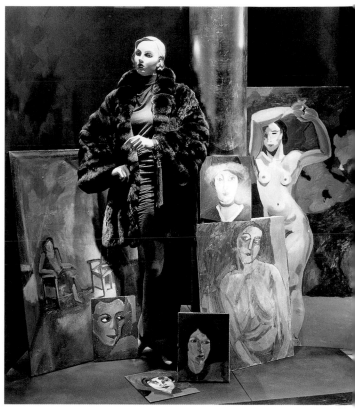

FROEHLICH FURS, Munich, Germany
DISPLAYS: **Peter Rank of Deko Rank**

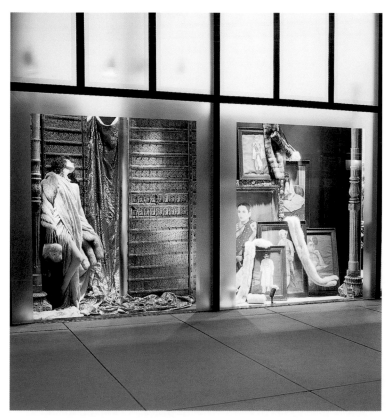

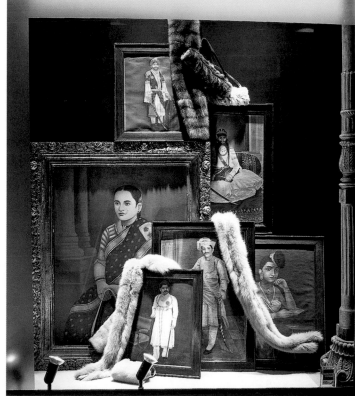

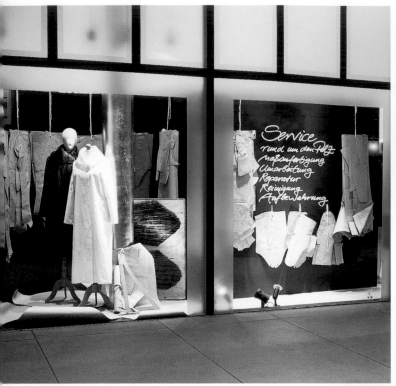

FROEHLICH FURS, Munich, Germany
DISPLAYS: **Peter Rank of Deko Rank**

FROEHLICH FURS, Munich, Germany
DISPLAYS: **Peter Rank of Deko Rank**

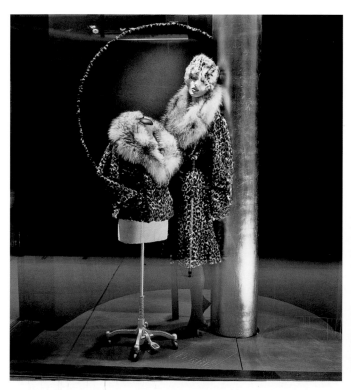

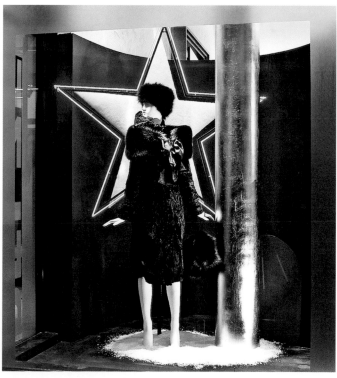

ART DIRECTION by KATY ENGLAND

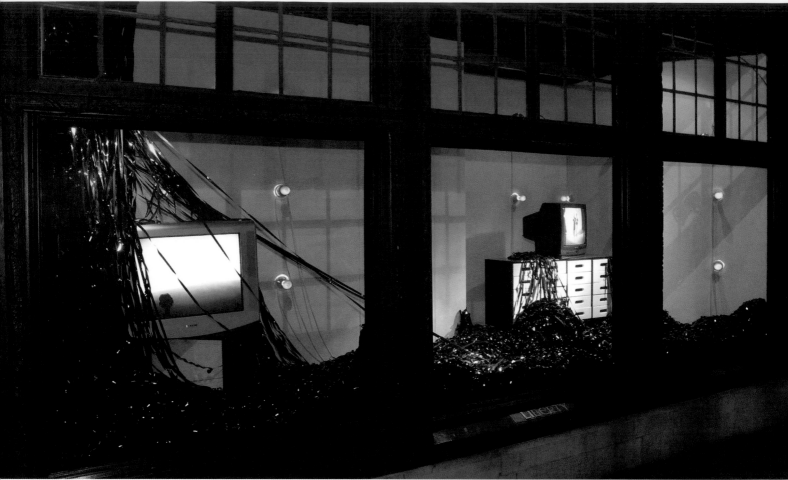

Liberty of London is an old/new store that goes back well over 100 years and it has staked the corner of Regent Street and Great Marlborough as its own. In the windows of the newer part of Liberty on Regent Street and extending around the corner into Great Marlborough and the historic building, the visual presentation team under the guidance of Faye McLeod create shopper-stopping displays that are new, with-it, and very much in sync with its avant garde fashions, heritage prints and fabrics and the trendy and touristy shoppers that are on the street.

ART DIRECTION by KATY ENGLAND

These "shockers and rockers" were created and art directed by Katy England, the stylist. Presented in this run of windows are some of the other products—the non-wearable ones—that make Liberty of London a "must shop" store. The running theme or connecting link is the TV set: one appears in each of the windows casting blue, flickering images. The product presentation varies from books and stationery, to home furnishings and fashions to china and glassware.

Art directed by Katy England
Books on G

ART DIRECTION by KATY ENGLAND

It is the unexpected, messy, haphazardness of the displays that catches the viewer's eye: crumpled fabric and a lop-sided chair; a mess and a tumble of white dinnerware; the helter skelter mix of clear glassware and the volcanic eruption of film around a multi drawer cabinet. Throughout it is almost an entirely black and white exposé except for Ms. England's master touch of red. There is a puddle of red sand beneath the red-jacketed books and red candles appear in the unique wall scones patterned on the wall. Red light bulbs are polka-dotted on the white walls in the window with the black and white cabinet and the tangle of film strips. A red TV set sits atop the pile up of crockery and red water fills some of the glassware in that window. It's that master touch that helps make these displays so fetching.

by Katy England

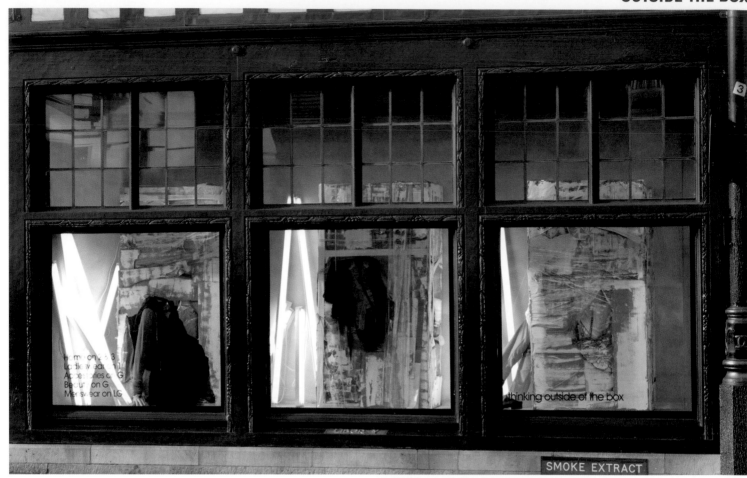

For a department store trying to appeal to a hip and trendy market that likes to think that they think "outside the box," the design team at Liberty of London did just that. They presented a variety of garments on realistic mannequins shown inside and outside the box.

Here again we see the "shock" approach. It is controlled mayhem! Simple, rectangular boxes are deconstructed and revealed. The 1x2 wood framework is covered with layers or strips of corrugated board, kraft wrapping paper, foil, acetate, wrapping tape and then ripped, shredded, torn apart as though the receiver couldn't wait to see what wonderful things may be hidden from view. The white environments are further enlightened by the naked fluorescent tubes precariously "jack-strawed" in the windows.

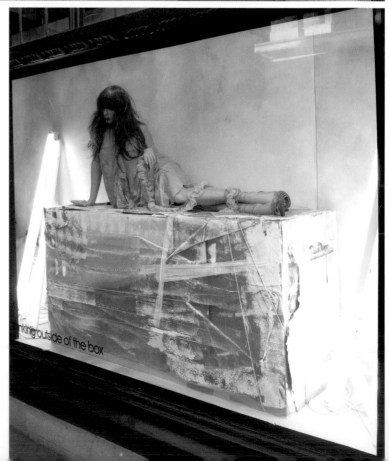

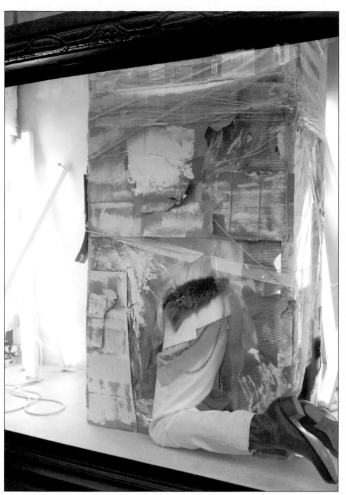
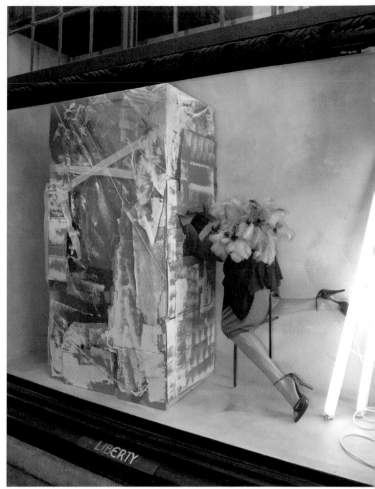
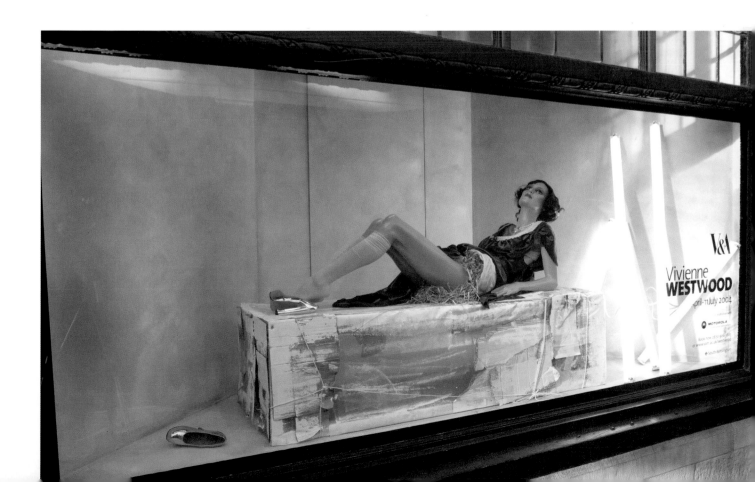

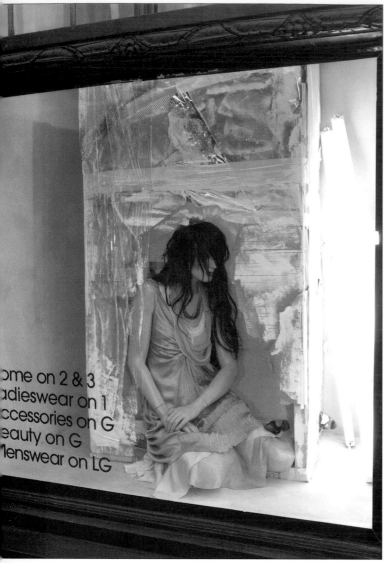

Humor plays a great part in the success of this promotion. Sometimes what gets the shoppers' attention is what they can't see like a missing face or head—or part of a body or maybe even the whole body and only a hand is visible. The designers have managed to create a great many variations on the theme by having the mannequins on the box, next to the box, in the box or getting out of the ripped and white paint smeared box.

The source of inspiration for this "Thinking Outside the Box" promotion was the collection of Vivienne Westwood fashions and accessories.

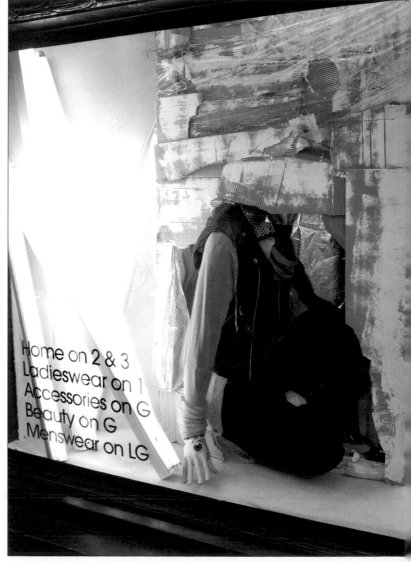

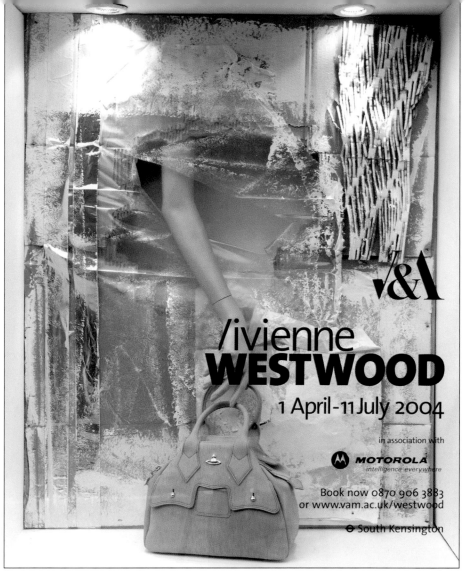

As a toast to London Fashion week, the stylist Katy England and photographer Nick Knight brought their "innovative partnership to a new level" with these Liberty of London windows.

"In celebration of the art of styling Katy has styled on top of the photographic images to push the concept of image presentation a notch further—super charged shots of red mixing Liberty prints with plastic, papers and rubber to draw out key elements and turn up the volume on each image." The models for Nick Knight's photos are all recognized London icons and they were selected for their "unique ability to harness and imbue pieces with a very individual sense of style and ownership."

Sweeping round into Great Marlborough St., the windows "showcase the raw genius involved in the creative process behind the final images." It is that "touch of red" on the giant, window-filling photographs that does it.

Photography Nick Knight
Styling Katy England

Ladieswear on 1
Menswear on LG
Beauty on G
Home on 2
Accessories on G

In describing his approach to the design of the Moschino Boutique, the designer, Sean Dix, said, "It was agreed that anything could be possible as long as I remained true to the spirit of irony and humor of Franco Moschino." JoAnn Tan, who designs the windows that grace this boutique, is the visual interpreter of that same "sense of irony and humor" as she also introduces some of the designer's latest creations.

Illustrated here are some of her most recent designs. They are the introduction to the retail brand image. The dress and shoes were from the fall/winter collection (2003-2004) but the "Music Man" was produced in-house to celebrate Moschino's 20th anniversary. The vintage gramophone added to the light-hearted quality of the display as did the cardboard music notes stapled together to carry through the theme.

The "Ice Queen" referred to the haughty, cool, cold, aloof women and the cast resin mannequin wore a jacket from Moschino's pre-spring 2004 collection. The skirt was made up of hundreds of plastic "ice cubes" and, as one can see, some "melted" down at the floor. The crown was also made of "ice."

Even though many of Moschino's clientele may indeed be slender, it doesn't stop him from giving his opinion on people's obsession with being thin. As executed by JoAnn Tan there are no Moschino garments on display. The wafer-thin, cardboard people were made in-house and the room setting was produced by Scenart. The furniture was "borrowed" from various parts of the studio.

Hair Pets is another Moschino observation as interpreted by Tan. It is about the

MOSCHINO, Milan, Italy
DESIGNER: **Jo Ann Tan**
PHOTOGRAPHER: **Stefano Pandini**

vanity of some women who continuously fuss with their hair. The clothes and accessories were from the Spring/summer 2004 collection and the dogs were made in-house by wrapping synthetic hair around dog forms made of polyester lining fabric and then stuffed. The extra long wigs, for the mannequins, were produced by Il Parraccaio of Milan

The "Christmas Present" is simply a fun statement about how people are always curious about what is in a box and try to figure out what it is by the size and shape of the wrapping. The "dinosaur" was made by Scenart but "wrapped" in-house with decorative holiday papers. The outfit was from the fall/winter 2004 collection.

MOSCHINO, Madison Ave.New York, NY

Shown here are some of the displays that have attracted, amused and sometimes confused shoppers on Madison Avenue in New York City. Though the work of several designers—including David Griffin—they have all carried through the Moschino concept of "irony and humor" as well as social commentary. The photography is by Ari of the Sandy L. Studios.

PRIAPE: LAUGH AND BE GAY!

Some people say that "marriage" for this group cost John Kerry the last election in the U.S. Some say that it is the lifestyle that is "immoral" and that the "moral" majority doesn't approve of that way of life. And yet, turn on the TV and see how many homosexual characters are getting high ratings and notice how many people are buying tickets to movies and plays with gay themes. "Alexander the Great" was bi-sexual, Kinsey the noted sexual behavior researcher sort of played it to either side and both are now legends and bringing in the tolerant, the curious and the prurient into the movie houses.

So, how does gay play out in retail and in merchandise presentation? "Straights" line up to be "made over" by the "Queer Eye for the Straight Guy" and many top designers, fashion critics and arbiters lean towards the gay side of things. However, how does one present merchandise aimed directly at and targeted at the frankly gay/lesbian shopper? There is a market out there of consumers who do like their fashion more on the cutting edge—more sensual—more sexual—more "out" than closeted.

Recently I received some truly exciting displays from Etalage B Display, a display design and installation firm in Montreal, QC and one of their clients is Priape. For those not up on their classic mythology Priapus was the god of male sexuality and is represented by the phallic symbol. This company was founded in 1974 in Montreal and has grown over the years to become the biggest store serving the gay community in Canada. There are now three stores: Montreal whose windows are featured here, Toronto and Calgary. These shops are not hidden away in some dark alleys or in off-the-beaten-path sideways but on Main Streets where shoppers of all lifestyles and moral concepts shop and view the windows facing the highly trafficked streets. How does one straddle the fence? How does a retailer make the message clear to the targeted market with merchandise ranging from DVDs, books, magazines, sexy clothing, underwear, jeans, custom leather outfits, lotions—"and other queer stuff" and not ruffle the

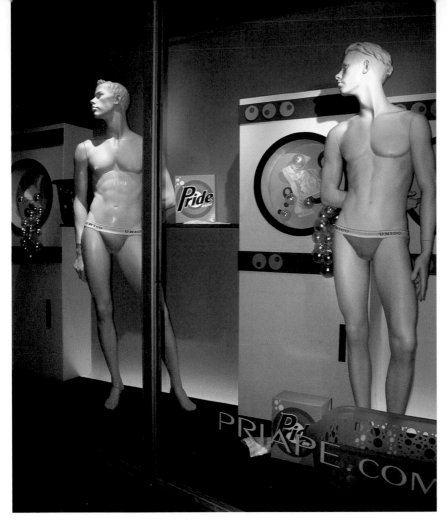

men's retail shop. Popular also amongst the hetero club culture, due to the wide variety of club wear, underwear and leather merchandise. We reflect this in the window displays by promoting every category of merchandise sold in the store.

MMP: How closely do you work with the client(s)? Do they offer ideas? Do you get any feedback from the Priape customers? How and where do you start a display? The season? The garments? Something in the news?
BM: The Priape team usually lets us know what articles they want to promote about a week or two in advance and we have *carte blanche* to come up with a concept for the window.

We might get inspiration from events, artists, books, travels, movies, erotic fantasies and politics. Or even by just going through our warehouse of props.

We get mostly positive comments

feathers of the other birds doing their thing on the same street? It takes good taste, talent and a sense of humor. It also helps when the "other birds" are more tolerant and accepting of that lifestyle.

In a conversation with Bruno Marcoux—speaking for Yves Brodeur, President, and Constant Bibeau, Vice-President of B Etalage, this is how he responded to some of the questions I had.

MARTIN M. PEGLER: How do you maintain the "taste" level that makes these window displays so successful with the target market (gays) and also acceptable to the general public?
BRUNO MARCOUX: For the Priape windows, we always try to develop displays, that are suggestive without revealing too much, always remaining in good taste as not to offend anyone, gays or heterosexuals.

MMP: How would you describe the "retail brand image" of Priape and

how do your displays carry out that "image."
BM: Priape has been a big part of the gay culture in Montréal for many years. Starting out as a men's sex shop it has grown over the years to become not only a sex shop, but a popular

from customers who have seen the evolution of our windows. We usually have an audience while we're working in the window, anticipating the final result.

MMP: How often are windows changed?
BM: The Priape window is usually changed every four weeks, so you can imagine after 14 years, it is quite a task to come up with an original concept every time for their window.

Management trusts us to properly represent them in their window.

MMP: I noticed that most of the displays use semi-abstract (all white) mannequins. Whose do you use? What is there about that particular mannequin that you think makes them "right" for this audience. You also used realistic mannequins in some. Whose are those—and again—why did you pick them?
BM: We try to use mannequins that have the most attractive faces and bodies, be it abstract or realistic ones. Rootstein, Nissen and Gemini are our usual choices for the Priape win-

dows as they carry the most realistic muscular bodies.

MMP: Do you "enhance" the mannequins in any way? Make up? Stuffing?
BM: Polyester snow comes in handy when it comes to stuffing underwear, because this is the only part of the

male anatomy that mannequin companies are not generous with. We also use temporary tattoos, and special make-ups depending on the concept of the window.

MMP: The reason for the article is that—as you probably know—John Kerry lost the election in the US

and "gay marriage" was part of the reason. Though many, many American watch "Will & Grace" and other TV shows with gay characters—and love them—there is still a homophobic attitude in this country. Canada seems to have come to terms with it. Priape is not hidden on un-trafficked streets or down dark alleys but out in the open on main shopping streets. The displays—I assume—are accepted. What makes it so? The taste level and the restrained presentations and the sense of fun seem to pervade in most?

BM: In general, the French Canadian population is quite liberal and open-minded, so as long as we develop tasteful concepts and try to have fun with them, we never get negative feedback. Montreal is also a very cosmopolitan city with European influences so the mentality is quite differ-ent from the U.S., very tolerant.

MMP: Anybody on your staff that should get "design credit"? How about the photographer?
BM: For the credit photo, only write Etalage B Display. For the design credit, it goes to all our team. We develop the ideas as a group.

MMP: Thank you for the images and your insights. We look forward to showing off more of your company's creative work.

B ETALAGE DISPLAY, Montreal, QC, Canada
PRESIDENT: **Yves Brodeur**
VICE PRESIDENT: **Constant Bibeau**
DESIGNER: **Bruno Marcou**

The *Visual Reference Library*

of Store Design, Visual Merchandising, Architecture, Advertising and Graphic Design